Claude Monet

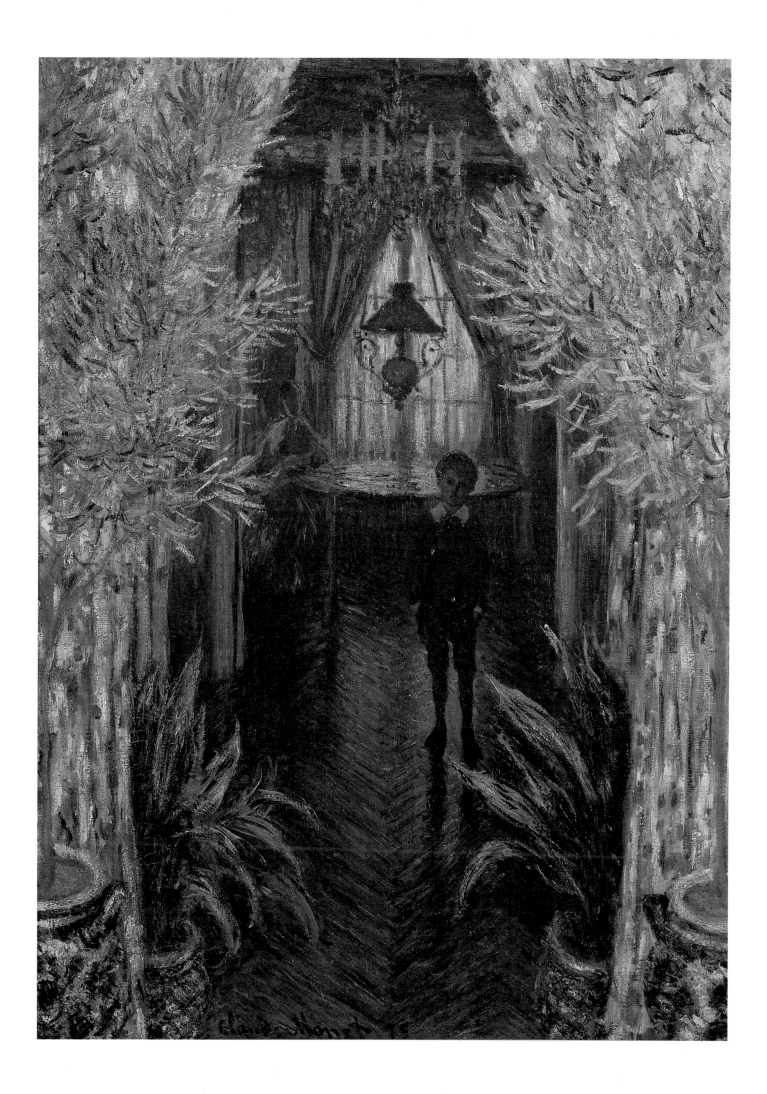

Karin Sagner-Düchting

Claude Monet

1840-1926

A Feast for the Eyes

Benedikt Taschen

FRONT COVER:
Water Lilies, Formerly Agapanthus (Detail), 1916-26
Nymphéas, jadis Agapanthus
Oil on canvas, 200 x 425 cm
Wildenstein IV. 1976
St. Louis, The Saint Louis Art Museum

FRONTISPIECE:
Un Coin d'appartement, 1875
Oil on canvas, 80 x 60 cm
Wildenstein I. 365
Paris, Musée d'Orsay

© 1990 Benedikt Taschen Verlag GmbH & Co. KG,
Hohenzollernring 53, D-5000 Köln 1
© 1990 VG Bild-Kunst, Bonn, for the illustrations
Editing and layout: Brigitte Hilmer, Cologne,
English translation: Karen Williams, Cologne
Cover design: Peter Feierabend, Berlin
Biographical summary: Odo Walther, Dießen am Ammersee
Picture procurement: Frigga Finkentey, Cologne
Color reproductions: ReproColor, Bocholt
Black-and-white reproductions: ReproService Werner Pees, Essen
Overall production: Neue Stalling, Oldenburg
Printed in West Germany
ISBN 3-8228-0541-6

Contents

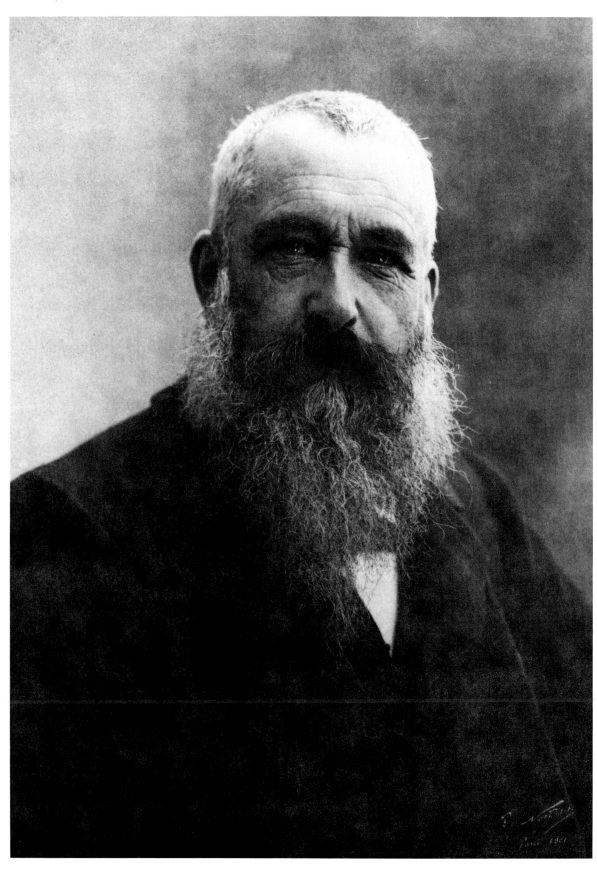

Claude Monet, 1901
Photograph by Gaspar Félix Nadar

Preface

When, in the 1870's, the Impressionist artists grouped together to hold their first public exhibitions, it was with a new type of painting. Their formats were small, their composition free, their style spontaneous and their subjects scenes from everyday life. At the time, this new Impressionist style appeared too closely based on feeling; indeed, since it abandoned some of the fundamentals of traditional painting, it appeared the very antithesis of contemporary art. By the turn of the century, however, Impressionism had established itself as a revolutionary development in the history of painting and its earliest pioneers had earned fame and prosperity. Today, our understanding of landscape painting and our perception of the world about us are profoundly influenced by the Impressionist way of seeing, one which we accept – without question – as natural and immediate. Claude Monet was, more than any other artist, the vehicle of this new form of painting. His views of Argenteuil, for example, are often seen as synonymous with popular definitions of Impressionism. But these works represent just one of the many facets of his work. Throughout an artistic career lasting over sixty years, Monet pursued his art with an originality which has yet to be equalled. In 1926 he summarized his guiding principle thus: 'I have always had a horror of theories.' It was in this spirit that Monet conducted the experimentation which led to the enormous range of expressive means with which he rendered his impressions of nature. It was above all through his study of fundamental questions of landscape painting that Monet discovered, during the course of his painting life, the masterly means of making the moods, forms and forces of nature come alive on the canvas, in solutions born both of his experience of objects and his use of colour and brushwork. He thereby followed increasingly independent paths which made him, in his late works, an important forerunner of modern art.

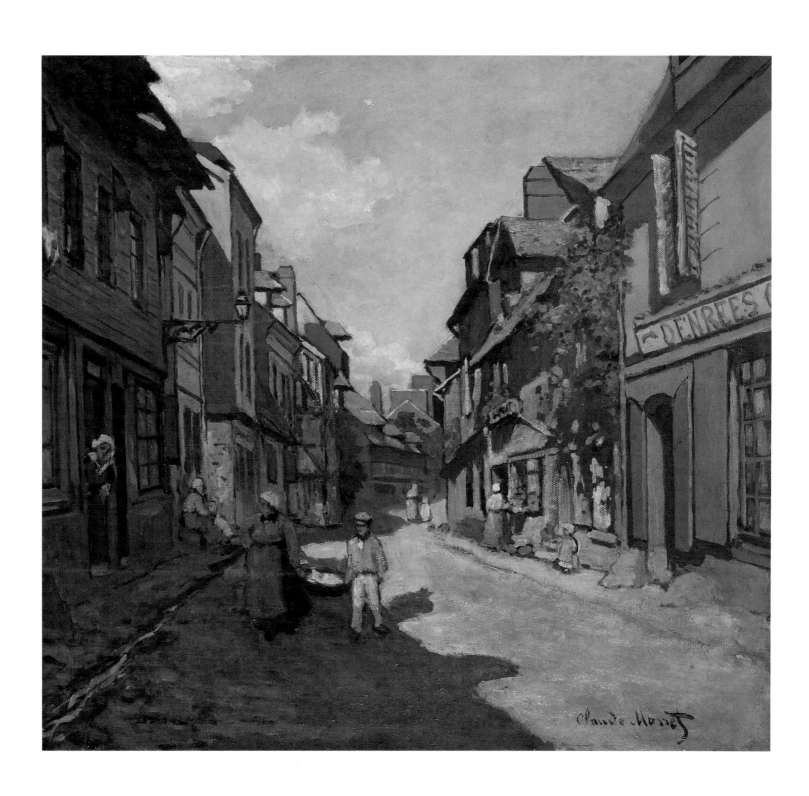

Childhood and artistic beginnings

Oscar Claude Monet, second son of grocer Claude Adolphe Monet and his wife Louise Justine Aubrée, was born on 14 November 1840 at 45, Rue Lafitte, Paris. France at that time was enjoying a period of relative economic and political stability under its Citizen King, Louis Philippe (1773-1850). His July Monarchy, as it was known, lasted from 1830 to 1848 and produced – in its first decade in particular – outstanding achievements in French art which reflected the liberal spirit of the times. Famous authors included Honoré de Balzac and Victor Hugo. In line with the growing influence of the middle classes, artistic trends were increasingly being set by bourgeois taste, a factor which precipitated the landscape painting of the Barbizon School.

But this same decade was also to see the birth of almost every member of the future group of Impressionists. Camille Pisarro was born in 1830, Edouard Manet in 1832, Edgar Degas in 1834, Paul Cézanne and Alfred Sisley in 1839 and Pierre-Auguste Renoir in 1841. The mid-forties brought a serious economic crisis and apparently a fall in trade for Monet's father, Adolphe, for the family decided to move to Le Havre on the coast of Normandy, where Monet's father joined his brother-in-law Jacques Lecadre in his successful wholesale business. The prospects for the future looked healthy. The Lecadres were locally respected and prosperous. In addition to a large house in the town they also owned a summer residence not far from the seaside resort of Sainte-Adresse. Monet later recalled that his childhood in Le Havre, where the Seine flows into the Atlantic, set a pattern for the rest of his life: 'The Seine. I have painted it all my life, at all hours of the day, at all times of the year, from Paris to the sea . . . Argenteuil, Poissy, Vétheuil, Giverny, Rouen, Le Havre . . .'

Monet grew up in a commercially-oriented household. Only his mother showed an interest in the arts. Her early death in 1857 was a severe blow to the 17-year-old Monet. He found sympathy for his artistic leanings with his aunt, Marie-Jeanne Lecadre, who now took up his cause with a solicitude which was to increase after the death of her husband in 1858. Monet remained in lively correspondence with her even in later years and consulted

Banks of the River, 1856
Bord de Rivière
Pencil drawing, 39 x 29 cm
Paris, Musée Marmottan

Village Street in Normandy, near Honfleur, 1864
La Route de la Bavolle à Honfleur
Oil on canvas, 58 x 63 cm
Wildenstein I. 34
Mannheim, Städtische Kunsthalle
Mannheim

her on artistic matters. Madame Lecadre was not only in contact with the Parisian painter Armand Gautier, but had her own studio where she painted for pleasure and in which Monet was a welcome visitor.

Monet's relationship with his father deteriorated appreciably and was not improved by his decision in 1857 to leave school shortly before his final exams. At school he received his first drawing lessons from François-Charles Ochard, a former pupil of Jacques-Louis David, the paragon of contemporary artistic taste. These lessons appear to have had no profound influence on Monet, however. His recollections of the period refer exclusively to the witty drawings and caricatures of – among others – his teachers, with which he filled his exercise books: 'I decorated the blue covers of my books with fantastic ornaments, and drew on them, in the most irreverent fashion, the caricatured faces and profiles of my teachers . . . I quickly developed quite a skill for it. At the age of fifteen, I was known all over Le Havre as a caricaturist . . . I started charging for my portraits, asking 10 or 20 Francs per head . . .Had I carried on, I would have been a millionaire by now.'

Monet's caricatures of the citizens of Le Havre, which rapidly earned him 2000 Francs, brought him a relative degree of local celebrity. Of over one hundred such drawings, only a handful survive today (p. 10). Gravier, a retailer of artist's materials, exhibited Monet's caricatures in his shop window. Even though a large part of Monet's output was based on models in contemporary magazines, such as the *Journal amusant* (which he even copied for a while), his drawings nevertheless attracted attention. They struck Eugène Boudin, an unconventional painter of landscapes and seascapes who was living in Le Havre at the beginning of 1858. Boudin's simple and calm studies of nature, painted in the open air in front of the motif, bore no relation to contemporary

Author Jules François Félix Husson, Called Champfleury, after Nadar, c.1858
L'Ecrivain Jules François Félix Husson, dit Champfleury, d'après Nadar
Pencil and gouache, 32 x 24 cm
Paris, Musée Marmottan

Jules de Prémaray (Editor-in-Chief of "La Patrie"), after Nadar, c.1858
Jules de Prémaray (Rédacteur en chef de "La Patrie"), d'après Nadar
Pencil, 32 x 24 cm
Paris, Musée Marmottan

Dramatist Louis François Nicolaie, Called Clairville, after Nadar, c.1858
L'Auteur dramatique Louis François Nicolaie, dit Clairville, d'après Nadar
Pencil, 32 x 24 cm
Paris, Musée Marmottan

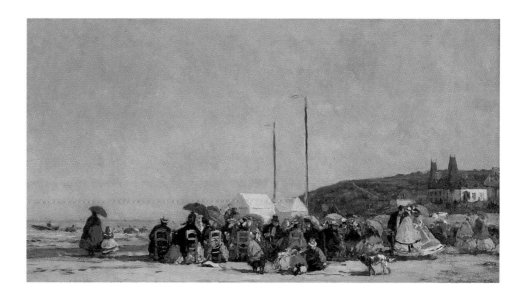

Eugène Boudin
The Beach at Trouville, 1864
La plage de Trouville
Oil on panel, 26 x 48 cm
Paris, Musée d'Orsay

taste. Monet himself initially reacted with aversion to the Boudin seascapes also on display at Gravier's. The two were nevertheless eventually introduced. Boudin praised Monet's drawings: he had talent and shouldn't just stop at these. It was a turning-point. Boudin now took the young man with him on painting excursions into the surrounding countryside. He convinced Monet that objects painted directly in front of the motif possessed a greater vitality that those created in the studio.

Painting in oils outdoors was still a relatively new technique; it had first been made possible in the forties by the introduction of portable tubes of oil paint. According to Boudin, it was the only way of capturing a first impression, because 'everything that is painted on the spot has a strength, an intensity and a vividness which cannot be recreated in the studio'. The exploration of these ideas and of landscape as a subject were fundamental to Monet's work from this time on. In the course of the summer of 1858 he produced two landscapes at Boudin's side; these were subsequently exhibited in Le Havre but have today sadly disappeared. Monet also accompanied Boudin to Honfleur, where Boudin taught him the handling and observation of tonal values, perspective and light. Monet later ascribed his decision to become a painter to this encounter with Boudin, with whom he remained in close contact throughout his life. 'The fact that I've become a painter I owe to Boudin. In his infinite kindness, Boudin undertook my instruction. My eyes were slowly opened and I finally understood nature. I learned at the same time to love it. I analyzed its forms, I studied its colours. Six months later . . .I announced to my father that I wanted to become a painter and went off to Paris to study art.'

So Monet wanted to become a painter. It was an idea which his father accepted only with difficulty and after much persuasion from Aunt Lecadre. He nevertheless submitted two applications

11

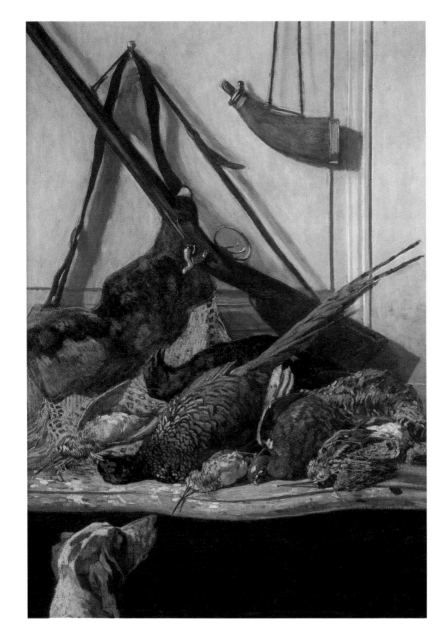

Hunting Trophies, 1862
Trophées de chasse
Oil on canvas, 104 x 75 cm
Wildenstein I. 10
Paris, Musée d'Orsay

to the Le Havre municipal authorities in the hope of obtaining an art scholarship for his son in Paris. Monet did not wait for the second to be refused; at the beginning of April 1859, he set off for Paris despite his father's opposition. His savings now proved very welcome, since they made him – at least for a short while – financially independent. He visited the recently-opened Salon, that institution of an exhibition which so emphatically represented official taste and which at that time took place every two years. Monet's letters to Boudin reveal his lively reactions to the progressive paintings of the Barbizon School which were also among the exhibits.

At the recommendation of both Boudin and Madame Lecadre, and with two still lifes under his arm, he visited Boudin's former teacher, the painter Constant Troyon whose works he had seen beforehand in the Salon and whom he had praised highly to Boudin. Troyon recognized the talent in Monet's work, but advised him as a first step to learn to draw and to copy works in the

Farmyard in Normandy, c.1863
Cour de ferme en Normandie
Oil on canvas, 65 x 80 cm
Wildenstein I. 16
Paris, Musée d'Orsay

Louvre. This suggestion fell in line with conventional paths of academic training, whereby students were required to start with drawing from inanimate models and antique busts. The idea must have sounded ridiculous to Monet even then, since – as Troyon had recognized – his own starting-point was essentially colour. Troyon recommended he should join the *atelier libre* run by academic painter Thomas Couture, where Manet was also enrolled.

The training which Troyon proposed met with the approval of Monet's father, so that nothing appeared to stand in the way of his remaining in Paris. To his father's dismay, however, Monet refused to follow the 'academic' path. He attended instead the Académie Suisse, an atelier which had been founded by Charles Suisse, a former pupil of David, during the liberal-minded July Monarchy. Suisse offered his pupils the opportunity to work from living models in complete freedom, without being subjected to constant corrections by a professor. This independent atelier

13

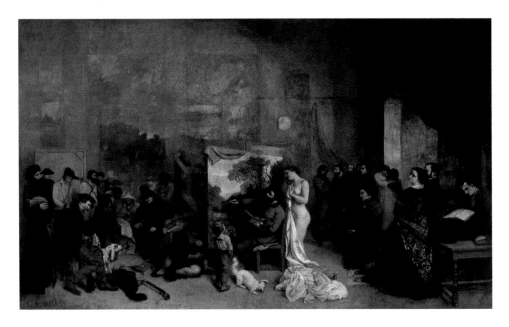

remained highly popular among avant-garde artists until its closure in 1911. Honoré Daumier, Gustave Courbet and Eugène Delacroix had all worked here; Pissarro joined in 1855 and Cézanne in 1862. Monet's friendship with Pissarro began here. 'I am surrounded by a small group of landscape painters,' he wrote to Boudin, 'who would love to meet you. They are real painters . . .' Another letter to Boudin indicates Monet's growing enthusiasm, as from 1860, for the works of Delacroix and Charles-François Daubigny. His aunt, who owned a painting by Daubigny, subsequently gave it to Monet as a present.

It was now that Monet established his first contacts with the so-called Realist painters and writers, although he was not to meet the head of the Realist movement, Gustave Courbet, until several years later. These acquaintances were made at the Brasserie des Martyrs, an artist's café where Monet financed his studies by drawing caricatures of the guests. In addition to Jules Champfleury, author of the keynote book *Le Réalisme*, the poet Charles Baudelaire, art critic Edmond Duranty and doctor and art-lover Paul Gachet could all be found here. Monet later felt he had wasted much time in such company. Monet was at no stage attracted by the life-style of the Bohemian artist, as evidenced in his thoroughly bourgeois homes in Argenteuil and, later, Giverny. 'I used to go sometimes to the famous Brasserie in the Rue des Martyrs', he wrote, 'which cost me a great deal of time and was extremely bad for me. It was there that I got to know almost everyone mentioned in Firmin Maillard's book, T*he Last Bohemians*, and in particular Firmin Maillard himself, Albert Glatigny, Théodore Pelloquet, Alphonse Duchesne, Castagnary, Delvau, Daudet and other bad sorts like myself in those days. I also saw Courbet there, but made his acquaintance only after my return from regimental duty.'

Tree-trunks, 1857
Troncs d'arbre
Pencil drawing, 28 x 20 cm
Paris, Musée Marmottan

Courbet's art, which marked a break between official painting and that of the future, played a decisive role in the development of Impressionism. Three of Courbet's most important paintings, *The Artist's Studio* (p. 14), *The Burial at Ornans* (1849/50; Paris, Musée d'Orsay) and *The Bathers* (1853; Montpellier, Musée Fabre) were rejected by the Salon Jury on the occasion of the World Fair of 1855. Courbet therefore decided to set up, at the gates of the official exhibition building, his own pavilion of Realism in which to show his work. This independent exhibition was enthusiastically received by the younger generation of artists and was to set an important precedent. Courbet turned against the idealizing, prettified reproduction of nature then characterizing official Academy art. His demands included truth, contemporaneity, social comment and the rejection of idealism: 'Realist means being a friend of real truth.' Correspondingly, he held even themes as unsophisticated as a bunch of vegetables to be worthy subjects of painting. Monet's early still lifes, dating from the beginning of the sixties, similarly take pieces of meat, fruit and vegetables as their unassuming subjects. Courbet's ideas also reflected the democratic tendencies which had emerged during the February Revolution of 1848 with the abdication of Louis Philippe, the proclamation of the Second Republic and the call for general and equal voting rights. In 1852, however, the start of the Second Empire under Napoleon III spelled an abrupt end to such sympathies. Courbet's democratic views on art and life were now monitored and recorded.

In spring 1861 Monet drew an unlucky number in the military service lottery made law since 1855. He was drafted to Algeria for seven years with the African Legion. Initially no more than a thoroughly undesirable interruption to his newly-begun career, Monet later judged this period abroad to have benefitted his painting. In his later recollections, Monet constantly sought to cast his artistic life in the right light: 'I spent two fascinating years in Algeria. I was constantly seeing something new, which I attempted to render in my free time . . . The impressions of light and colour I received there only sorted themselves out later, but the germ of my future researches lay here.' The African climate did not suit him, however. By spring 1862 Monet had fallen seriously ill with typhoid fever and was sent home to Le Havre for six months' convalescence.

In the summer of 1862, Monet zealously devoted himself to painting in and around Le Havre. Boudin was working not far away in Honfleur and Trouville on the Normandy coast. If one of Monet's anecdotes is to be believed, an Englishman now introduced him to the Dutch painter Johan Barthold Jongkind, who was also staying in Le Havre at the time. Monet had already admired his work at the Salon of 1860. Jongkind's paintings focussed above all on the sea and the coast, and sought to render subtle atmospheric effects through a sensitive use of colour. His

luminous and airy landscapes built of brief strokes of paint made him a forerunner of Impressionist painting; Monet later acknowledged that Jongkind 'was my true teacher, and I owe to him the final education of my eye.'

Jongkind was indeed the model for one of Monet's first seascapes from the year 1864, painted while the two were working together on the coast. Monet's family disapproved of his friendship with the antisocial Jongkind, who lived with a common-law wife and was already ravaged by alcohol. It was with one eye on Jongkind that Monet's aunt bought her nephew out of military service for 3000 Francs on the condition that he continued his studies in Paris with a recognized teacher. The family was agreed that the genre painter and Salon medallist Auguste Toulmouche, who was married to a cousin of the Lecadre family, was the right man to supervise the rest of Monet's education. Monet therefore returned to Paris in autumn 1862 in order to show Toulmouche some of the works he had produced in Le Havre. Toulmouche praised his talent, but recommended that he join the atelier run by the academic painter Charles Gleyre. Monet, the stubborn Norman, acquiesced. He worked there – from what he says, with relatively little enthusiasm – probably until spring 1864, when Gleyre was forced to close his atelier on the grounds of eye trouble.

Gleyre was republican-minded and, following the overthrow of the Second Republic by Napoleon III, stopped exhibiting at the Salon. Shy and quiet as he was, he allowed his pupils relatively large freedom in order to avoid overly hurting or inhibiting them. Being himself an advocate of an idealized, beautiful style of painting, he was pained by the interest shown by many of his young students in the theories of Realism. He nevertheless encouraged his pupils to develop their own style and recommended open-air studies from nature, a testament to his own interest in landscape painting. Monet was later to cast an ironical eye over this period. On the occasion of a study from a living model, Gleyre offered Monet the following criticism: '"That's not bad, but it's too like the model. You have an ugly man before you and you paint him ugly. He has enormous feet and you reproduce them as such. The whole thing is ugly. Always remember, young man, that when executing a figure you must always think of antiquity. Nature, my dear friend, is all very well for study purposes, but is otherwise of no interest. What really matters is style." I was outraged. Truthfulness, life, nature, everything that moved me, everything I prized most highly . . .simply didn't exist for this man.'

Gleyre shared the official Academy view that reality in painting should be sacrificed to a beautiful ideal. In the atelier, however, Monet found friends who felt the same as he did: 'Renoir and Sisley were there, who became life-long friends. And there was Bazille, who also became a close friend of mine.'

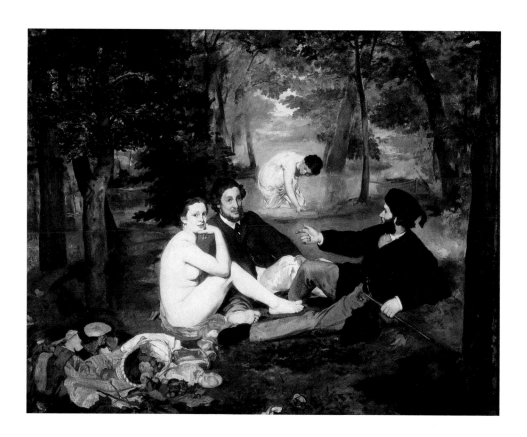

Edouard Manet
Déjeuner sur l'herbe, 1863
Oil on canvas, 208 x 264 cm
Paris, Musée d'Orsay

Monet's chief characteristics were already asserting themselves. He was headstrong, stubborn and tenacious and always followed his own beliefs; he openly declared himself an atheist and trusted the findings of his own experience. He even made the best of opposition – it spurred him on. His strength and self-confidence repeatedly inspired the other painters in his circle with new resolve. Renoir later recalled: 'Without Monet, who gave us all courage, we would have given up.' The flair and mannerisms which he displayed in Gleyre's atelier were a cause of wonderment. As Renoir reported: 'When he arrived at the atelier, the students – all envious of his magnificent appearance – called him the "dandy." He didn't have a penny, but he wore shirts with lace cuffs . . . With the exception of friends of the "group," Monet viewed the students as an anonymous mass, as "narrow minds." To one female student who made advances to him, a pretty but vulgar girl, he said: "Forgive me, but I only sleep with duchesses or maids. Everything in-between revolts me. My ideal would be the maid of a duchess."'

Monet never lost sight of the advantages of solid middle-class life, particularly where food was concerned. It was said of his appetite that he ate for four. In family affairs Monet was conservative, with a strong sense of tradition. His letters to friends and collectors reveal some less pleasant traits, however. Monet could be mean and vindictive, particularly where money was concerned. Reticent and curt, he could offend friends with the rudeness of his manner, while negotiating with collectors and dealers with the shrewdness of a thorough businessman.

Monet became particularly good friends with Frédéric Bazille,

17

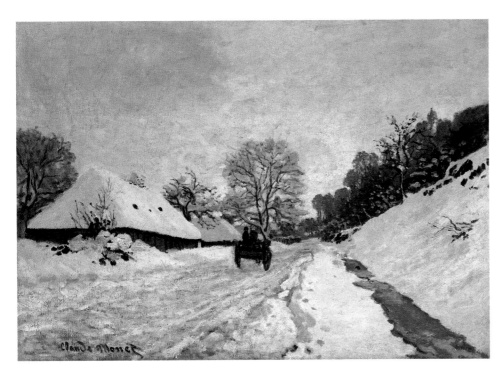

Cart on the Road to Honfleur, Snow, 1865
La Charrette, route sous la neige à Honfleur
Oil on canvas, 65 x 92 cm
Wildenstein I. 50
Paris, Musée d'Orsay

a student from the south of France who was studying art and medicine at the same time in order to appease his family. Bazille greatly admired Monet and subsequently supported him in every conceivable way. In spring 1863 the two visited the forest of Fontainebleau in order to paint directly from nature. Back in Paris, Monet visited the newly-opened Salon, which was accompanied for the first time by a *Salon des Refusés.*

The Salon, first introduced in the 17th century as an exhibition of works by living artists, dominated artistic life until well into the 19th century. It represented virtually the only exhibition of serious standing. It was also the occasion of purchases by the State. The Salon Jury was composed of members of the French Academy of Fine Arts, a fact which extensively determined the principles of selection. The Academy cultivated a tradition which was opposed to realism and which placed a higher value on historical painting than on genre or landscape painting. It was an attitude which had been increasingly resisted by younger generations of painters since the first quarter of the 19th century. One reaction had been the founding of independent academies. The Salon, held biennially since 1848, had to make its selection from thousands of pictures. Where less conventional works were accepted at all, they were hung so high up that – in view of their relatively small format compared to historical paintings – they could barely be seen. In 1863, the Jury surpassed itself in the

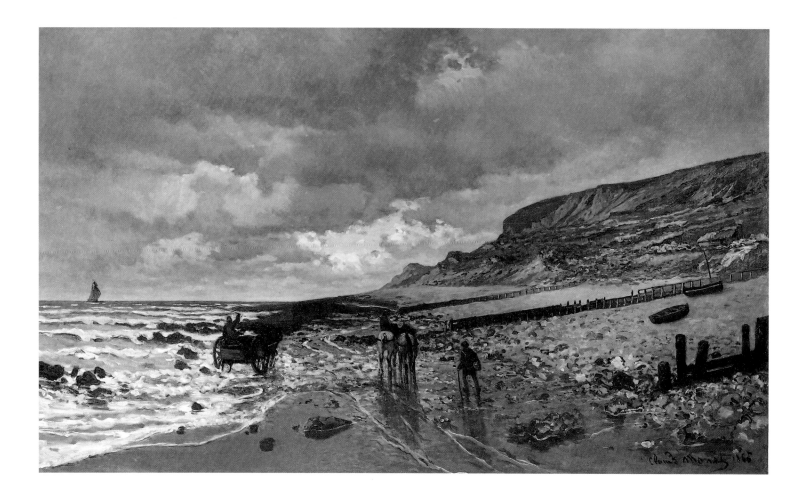

number of paintings it turned down, leading to a volley of angry protests. Napoleon III felt obliged to view the refused works of art in person and was himself surprised by some of the rejections. He subsequently had a separate exhibition of refused works organized in rooms adjoining the Salon proper. It was also agreed that the Salon should in future be held annually, with each artist only allowed to submit two works. The Jury was also reshuffled to incorporate independent, medal-winning landscape artists, including Daubigny, Corot, Jongkind and Troyon. These argued for the acceptance of independent works by the emerging Impressionist group and thus – at the start of the seventies, at least – carried the debate surrounding the new movement into the Salon itself.

The growth in landscape painting from this point on corresponded to a development which had started under Louis Philippe. The expansion of the middle classes brought greater respect for their tastes. Their education was different to that of the older aristocracy, and mythological subjects were now less prized. Lay opinion believed painting should be intelligible to everyone. Appropriate solutions were provided by simple rural themes linked to real life; these found their expression in the generation of Camille Corot, Daubigny, Boudin and Troyon in the Salon of 1863.

Even Courbet had never provoked public outrage on the scale

La Pointe de La Hève at Low Tide, 1865
La Pointe de la Hève à marée basse
Oil on canvas, 90 x 150 cm
Wildenstein I. 52
Fort Worth (Tex.), Kimbell Art Museum

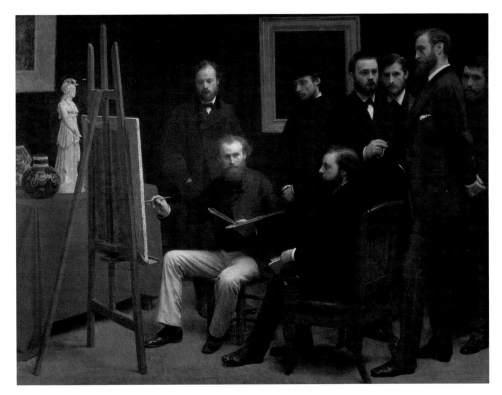

which accompanied the showing of Manet's *Déjeuner sur l'Herbe* (p. 17) at the Salon des Refusés. Two fully-clothed men are seated in an outdoor setting in the company of an entirely naked woman, who is looking out of the picture at the observer in a provocatively unashamed manner. Although Manet based his composition on classical antecedents, such as Titian's *Pastoral Concert* (Paris, Musée du Louvre), he deprives the scene of the mythological and allegorical references which were used in academic painting to justify depictions of nudes. The academic painter Alexandre Cabanel had made masterly use of this device in his *Birth of Venus* (p. 21), exhibited at the Salon of 1863 and purchased by Napoleon III during the exhibition itself. In line with one of the demands of the Realist movement, however, Manet's figures belong to his own times. The prude public was shocked. Manet had overstepped the limits of hypocritical bourgeois morality. To the generation of young painters, however, he represented an outrider ahead of their advancing forces.

Monet spent the summer months of 1863 with his family in Le Havre. During this period he painted *Farmyard in Normandy* (p. 13), the earliest surviving landscape painted after his return from Algeria. Its colouring is still very earthy, with little show of independence. In October Monet returned to Paris. The following spring, after the closure of Gleyre's atelier, he set up his own studio at 20, Rue Mazarine, very near to Bazille's.

At Easter 1864 he returned from a short stay in Chailly in the forest of Fontainebleau with *The Road to Chailly* (United States, private collection), which he was subsequently able to show in the Salon of 1866. Shortly afterwards he set off again, this time

LEFT:
Henri Fantin-Latour
Studio in the Batignolles Quarter, 1870
Un Atelier aux Batignolles
Oil on canvas, 204 x 273 cm
Paris, Musée d'Orsay

RIGHT:
Frédéric Bazille
The Artist's Studio in the Rue Furstenberg, 1866
L'Atelier de la rue Furstenberg
Oil on canvas, 80 x 65 cm
Montpellier, Musée Fabre

for the coast of Normandy with Bazille, where they took lodgings at the Saint-Siméon guesthouse, which Monet captured in *The Road to Saint-Siméon Farm* (p. 21). This hillside location to the east of Honfleur offered a spectacular panorama of the Seine estuary. The area attracted a large number of landscape painters during the sixties, including Boudin, Jongkind, Courbet, Daubigny and Troyon. Bazille soon returned to Paris, but Monet stayed on and subsequently profited from the arrival of Boudin and Jongkind. In addition to landscapes such as *Village Street in Normandy, near Honfleur* (p. 8), Monet now also turned to portraiture. Compared to his earlier works, the brushwork in these paintings was now freer. By the end of the year, Monet's funds were so low that Bazille had to bail him out in order for him to return to Paris in November. Since Monet's financial situation failed to improve, the two decided to share a studio at 6, Rue Furstenberg. This studio, like those of most of the later Impressionist painters, lay in the Batignolles quarter; this led to critics provisionally naming these artists the 'Batignolles group.' Bazille's *Artist's Studio in the Rue Furstenberg* (p. 20) shows a corner of this studio, which consisted of two rooms and a washroom. The paintings depicted on the walls include *The Road to Saint-Siméon Farm* (p. 21). Many of the later Impressionist painters were regular visitors here, including Renoir, Sisley and Pissarro, along with Courbet and Henri Fantin-Latour; Delacroix had also had his studio on the floor below until his death two years earlier.

The Salon of March 1865 was the first to which Monet submitted two pictures, painted in 1864 in Honfleur and Sainte-Adresse. *The Seine Estuary near Honfleur* (Pasadena, Norton Simon Museum) and *La Pointe de La Hève at Low Tide* (p. 19) were both accepted. 'It was a great success . . .I threw myself into open-air painting.' The works were favourably received by the critics. Although larger than contemporary works by Jongkind, their fluid but nevertheless sensitive and fresh treatment of nature and light depended heavily on his style. Manet was mistakenly praised in place of his almost identical namesake – much to his annoyance. 'Who is this chap Monet? He appears to have appropriated my name with a view to benefitting from my reputation.' Monet frankly admitted even many years later that 'Yes, Manet was a discovery for myself and my generation.' Manet undoubtedly gave decisive impetus to the further artistic development of both Monet and the other members of the 'Batignolles group.' In Fantin-Latour's *Studio in the Batignolles Quarter* (p. 20), which portrays the artists Manet, Monet, Otto Scholderer, Renoir, Emile Zola, Bazille, musician Edmond Maître and critic Zacharie Astruc, who used to gather in the Café Guerbois, some of the members of that group live on today.

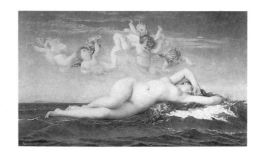

Alexandre Cabanel
Birth of Venus, 1863
La Naissance de Vènus
Oil on canvas, 130 x 225 cm
Paris, Musée d'Orsay

The Road to Saint-Siméon Farm, 1864
La Route de la ferme St. Siméon
Oil on canvas, 82 x 46 cm
Wildenstein I. 29
Tokyo, The National Museum of Western Art, The Matsukata Collection

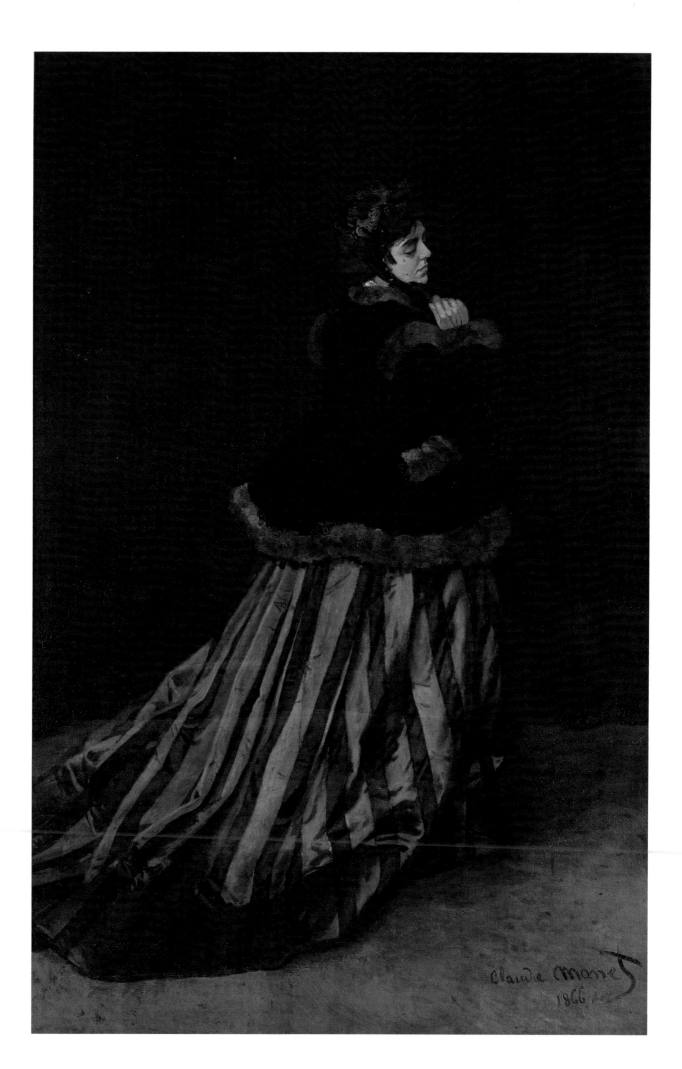

A new way of seeing
First successes and setbacks in the Salon

Manet was to be particularly important for a highly ambitious project which Monet, spurred by his recent Salon success, now decided to attempt. Inspired by Manet's *Déjeuner sur l'Herbe* (p. 17), Monet planned a large-format painting of a country picnic for the Salon of 1866 which was to be five to seven metres wide and contain twelve life-size figures. While the theme, reflecting the charms of rural life, was a commonplace subject of contemporary French painting, Monet wanted to base his picture on sketches made in the open air. The work was to be a truthful depiction of modern life as Courbet would have it, and it was Monet's conscious wish to reject – unlike Manet – any reference to the conventions of art history.

In April 1865 he went to Chailly in the forest of Fontainebleau and took lodgings at the Lion d'Or inn. An unbroken spell of rainy weather at first prevented him from working outdoors. A leg injury further confined him to bed (p. 23); he was nursed by Bazille, who had arrived in August upon Monet's insistence. Courbet and Corot also visited him upon his sickbed.

Over the course of the summer Monet painted a number of landscapes relating to this large composition, such as *The Road to Chailly* (p. 24), which specified the rural setting. He was totally absorbed in work on the project: 'I think only of my picture; if it isn't a success, I'll probably go mad.' Bazille posed for the life-size, full-figure studies which show him at the side of Camille Doncieux, Monet's later wife (p. 24). In the preliminary study preserved in Moscow (p. 25), the following figures have been identified: Sisley, the bearded Courbet, Albert Labron des Piltières (another Gleyre pupil), Bazille and Camille Doncieux.

Monet never completed this work. When he moved to Argenteuil in 1878, he had to leave it behind in pledge of rent owed. The picture was subsequently stored in a damp cellar; upon its redemption in 1884, the right-hand side was found to have rotted. Monet removed this section and took the central part of the picture (p. 27) to his studio in Giverny, where he proudly showed it to visitors. It was long believed to be a complete picture, until the left-hand section (p. 26) was rediscovered after Monet's death.

Frédéric Bazille
The Improvised Ambulance, 1865
L'Ambulance improvisée
Oil on canvas, 47 x 65 cm
Paris, Musée d'Orsay

Camille, or The Woman in the Green Dress, 1866
Camille ou Femme à la robe verte
Oil on canvas, 231 x 151 cm
Wildenstein I. 65
Bremen, Kunsthalle Bremen

While, up to 1865, Monet had chiefly concerned himself with landscapes, seascapes and still lifes, he now had to address the problem of integrating life-size figures into the landscape. The full-figure portrait of the water-colourist and engraver Jules Ferdinand Jacquemart (p. 28) undoubtedly represents one such exercise. In academic style, Monet places his figure within the perspective depth of the landscape. At the same time, however, there is a move towards abstraction. Foliage and sky are thus rendered in loaded, intrinsic jabs of colour, although nevertheless retaining their descriptive function. The sunlight, which structures the painting in luminous, impastoed splashes, thereby plays a vital role. In the interplay of light and shadow, Monet applies his paint now broad and flat, now loaded and broken. Although the preliminary studies for this work were made in the open air, and were thus based on actual conditions of light and shade, the finishing of this monumental picture had to be carried out in the studio. This pattern corresponded to academic tradition, which similarly started from preliminary studies, themselves often executed outdoors. But these studies were never more than a preparation for elaboration and finishing in the studio.

This posed Monet with his greatest problem. How was he to transfer the characteristics of the sketch, namely the spontaneity, immediacy and vitality which were so important to him, to a large-scale work? Monet abandoned detailed drawing, as can be seen particularly clearly in the lower left-hand part of the picture. The greater planarity, the loss of three-dimensionality which resulted led critics to conclude that the work was unfinished. In the following years, the view that Monet's pictures were simply sketches rather than fully-developed works in the academic sense

The Road to Chailly, 1865
Le Pavé de Chailly
Oil on canvas, 43 x 59 cm
Wildenstein I. 56
Paris, Musée d'Orsay

The Promenade (Bazille and Camille), 1865
Les Promeneurs (Bazille et Camille)
Oil on canvas, 93 x 69 cm
Wildenstein I. 61
Washington (D.C.), National Gallery of Art, Ailsa Mellon Bruce Collection

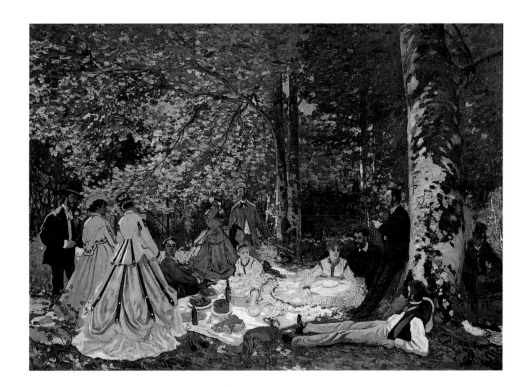

The Picnic (Study), 1865
Le Déjeuner sur l'herbe (Etude)
Oil on canvas, 130 x 181 cm
Wildenstein I. 62
Moscow, Pushkin Museum

was expressed with increasing frequency in conservative circles. It was to become a fundamental criterion in the judging of Impressionist works.

From October 1865 onwards Monet devoted his energies to finishing the picture in the Rue Furstenberg. Here it was seen and praised by Courbet. But shortly after Monet had moved, in January of the following year, into his own studio at 1, Rue Pigalle, he abandoned the project, since it was clearly not going to be finished in time for the opening of the Salon on 1 May. In its place he submitted both *The Road to Chailly* (1863; private collection) and a full-figure, life-size portrait of a woman, which had been painted within the space of just a few days, and for which the 19-year-old Camille Doncieux had posed as the model. Both works were accepted.

In *Camille, or The Woman in the Green Dress* (p. 22), a young woman is seen from behind. Her head is turned to one side over her right shoulder, but she does not look directly at the observer. It is a pose which hints at coquettishness, even ambiguity. With her luxuriantly trailing skirts, she seems to vanish rather than recede. Her green-and-black striped taffeta skirt and hip-length black velvet jacket indicate a modern taste in fashion. It was this costume, and the pictorial brilliance of its appearance, that commanded Monet's main attention; he dispensed with a differentiated reproduction of his model's facial expression, not least because of the profiled angle of her head. Although the picture was badly hung at the Salon, it nevertheless attracted a great deal of interest. Critics drew particular attention to the material feel of Camille's dress. The naturalistic author Zola, a childhood friend of Cézanne from Aix-en-Provence and an admirer of Manet's

The Picnic (Left Section), 1865
Le Déjeuner sur l'herbe (partie gauche)
Oil on canvas, 418 x 150 cm
Wildenstein I. 63a
Paris, Musée d'Orsay

OPPOSITE:
The Picnic (Central Section), 1865
Le Déjeuner sur l'herbe (partie central)
Oil on canvas, 248 x 217 cm
Wildenstein I. 63b
Paris, Musée d'Orsay

PAGE 28:
Portrait of J.F. Jacquemart with Parasol,
1865
Portrait de J.F. Jacquemart au parasol
Oil on canvas, 105 x 61 cm
Wildenstein I. 54
Zurich, Kunsthaus Zürich

PAGE 29:
Women in the Garden, 1866
Femmes au jardin
Oil on canvas, 255 x 205 cm
Wildenstein I. 67
Paris, Musée d'Orsay

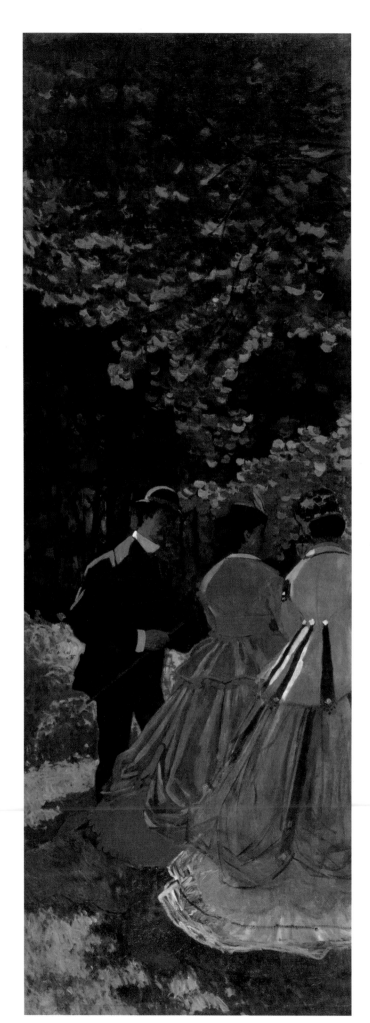

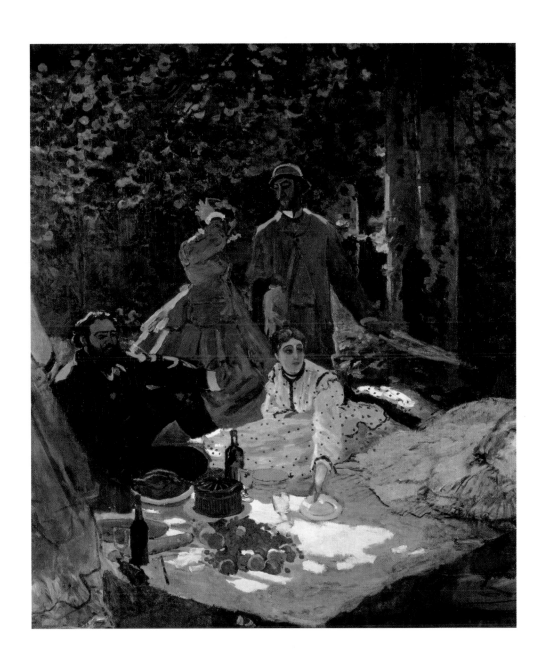

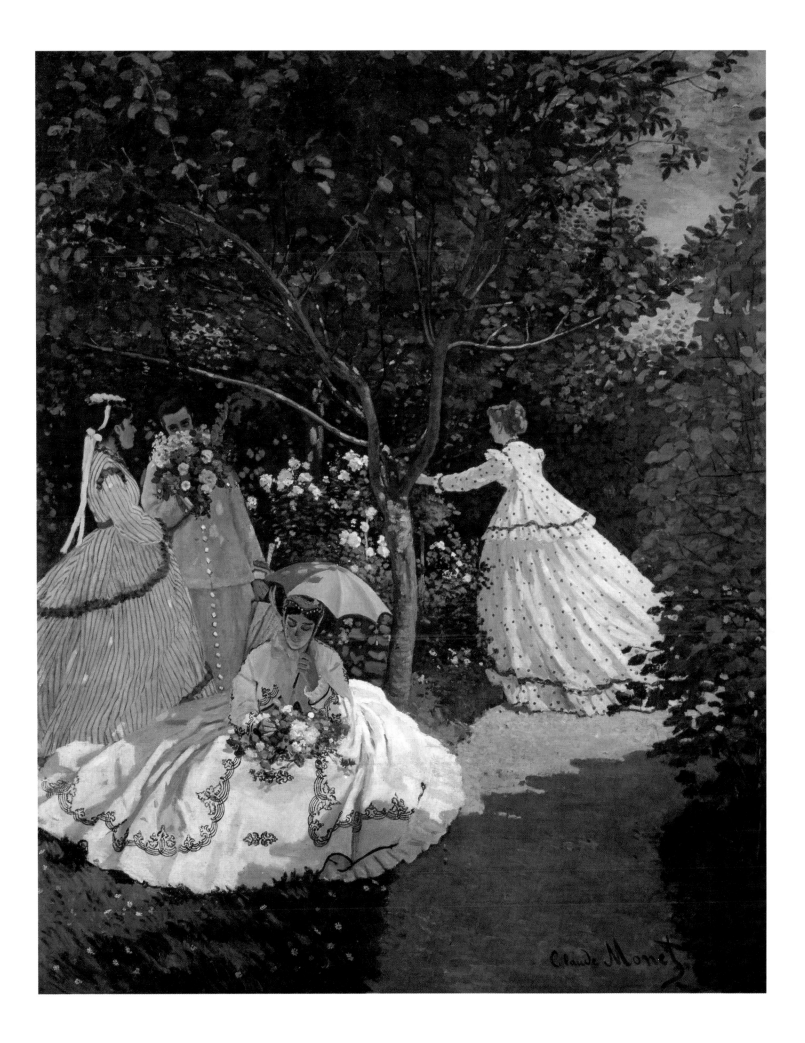

painting, wrote enthusiastically: 'The picture which held me longest is the *Camille* by Claude Monet. It is an energetic and vivid painting ...*Voilà un tempérament...* Take a look at the neighbouring canvases and see what a poor showing they make next to this window onto nature. Here we have something more than a Realist, we have a sensitive and powerful intepreter who knows how to render every detail without deteriorating into unfeelingness.' Just as Courbet wanted to be both a painter and a man at the same time, so that he would be able to create *living* art, so Zola felt that a canvas which lacked temperament was dead. *Camille* appeared to him to be the very symbol of modern life.

Monet's painting differed from female portraits of academic convention in that it was a representation not of a type, but of an individual. Technically speaking, Monet showed himself here, as earlier in *The Picnic* (p. 26/27), to be a pupil of Courbet. While conventional portraits in the Salon employed layers of glaze, Monet used a firm, bold and impastoed *alla prima*, particularly in the region of the face. *Camille* is nevertheless the most traditional of all the works produced by Monet during this period. In comparison to the subject of *The Picnic, Camille* represents a move back towards conventional painting. In the half-turned pose of his model, Monet refers to the female figure in Courbet's *Artist's Studio* (p. 14). It is equally apparent that Monet was familiar with the strongly-silhouetted figures of Manet, as well as with his centralization of characters and the chiaroscuro qualities of his palette.

Camille was from now on not only his favourite model, as in *Camille, or The Woman in the Green Dress* (p. 22), but also his mistress. Upright provincials that they were, Monet's family opposed and condemned this relationship. Both Monet's father and aunt and Camille's parents demanded they separate. When this instruction was not obeyed, Claude's family refused to continue any significant financial support. The joy and pride produced by Monet's success in the Salon was short-lived. Although his breakthrough in the Salon had enabled him to sell a number of pictures, including a replica of *Camille,* Monet was still far from able to cover his debts. Finally, to escape his creditors, he fled to Ville-d'Avray near Paris, where he devoted himself to a new project which was commissioned and subsequently purchased by Bazille for 2500 Francs, payable in monthly instalments. Monet learned something thereby, for *Women in the Garden* (p. 29) was painted entirely in the open.

Courbet and Manet laughed at the idea. Despite their insistence upon realism, even they had never gone this far. It was to be years before Monet's influence led Manet to take up open-air painting. Although Monet's early work may still have owed much to these two painters, *plein-airisme* remained his peculiar speciality. In the garden of the house he had rented, Monet had a special construction built which allowed him to gradually lower

Flowering Garden, c. 1866
Jardin en fleurs
Oil on canvas, 65 x 54 cm
Wildenstein I. 69
Paris, Musée d'Orsay

the bottom part of his painted canvas into a trench – a highly complex undertaking considering the large format he was employing. He even stopped working when the light went. His figures were no longer life-size. Camille, who had followed him to Ville-d'Avray, was once again the model for at least three of the four female figures.

Monet introduced a dimension to his open-air studies which his contemporaries must have seen as an innovation. His palette in this picture is much lighter than before; the majority of colours are mixed with white, while rhythmical patterns of rapid dashes, dots and dabs of paint appear in place of modelling transitions. In his new use of colour Monet was to set the trend for the sixties. He shifted from a relatively subdued palette to brighter colours and stronger contrasts. Monet was later to acknowledge the importance of Delacroix both for himself and for the development of the Impressionist palette. Delacroix's powerfully colourful paintings, and the writings which survived his death, taught Monet how juxtaposed, contrasting colour planes such as red and green could be employed to brighten and animate the composition as a whole. Delacroix did not share the academic view that shadows could be depicted using grey or black in chiaroscuro. For him, grey was the 'enemy of painting.' Rather, he had observed that the shadows of strongly-coloured objects take on their complementary colours, whereby a red object contains green in its shadows. Delacroix also discovered that an area of colour gains in intensity when other shades of the same colour are added. He translated these observations into his painting. The diaries in which Delacroix recorded his artistic legacy were among Monet's favourite reading.

Monet spent the summer of 1866 at the Normandy coast, where he met Courbet and Boudin. He visited the Lecadre family at their home in Saint-Adresse; here he painted the picture *Flowering Garden at Saint-Adresse* (p. 30). In Honfleur, where he had rented a room in a hotel, he started a large view of the *Port of Honfleur* which he intended for the 1867 Salon. He returned to Paris laden with pictures but penniless, and he and Camille were forced to move in with Bazille at 20, Rue Visconti, where Renoir was already staying.

The rejection of his *Women in the Garden* by the Salon jury of 1867 was a great blow to Monet. But since Renoir, Bazille and Sisley had also all been rejected, the possibility of organizing a private exhibiting society was discussed for the first time. The initiative was subsequently shelved for lack of money, however. In spring 1867, together with Renoir, Monet tried his hand at a few Parisian cityscapes; *The Quai du Louvre* (p. 34) shows him using a very light palette. Pictures of life in the metropolis were to reflect the new attitude to life formulated by Baudelaire: the modern artist was to render contemporary life in all its facets, changes and transitions; nothing was too banal or too ugly to be

an artistic motif. The colourful and lively city atmosphere offered more than enough inspiration.

In contrast to Degas and Manet, urban themes played only a minor role in Monet's work. Monet, who came from the country and who loved nature, was never a big-city person. His dislike of town life can also be read in the fact that his later homes were all in the country. Particularly in the early years of his artistic career, however, Paris was for Monet the ideal setting for a confrontation with the avant-garde ideas emerging from the field of Realism and independent *plein-air* landscape painting. As from 1866, Monday nights at the Café Guerbois in the Rue des Batignolles became the chief forum for often heated discussions in which Manet took a leading role. As Monet remembered: 'In 1869 . . .Manet invited me to accompany him to a café in the Batignolles, where he and his friends met and talked every evening after leaving their studios. There I met Fantin-Latour, Cézanne and Degas, who joined the group shortly after his return from

Saint-Germain-l'Auxerrois, 1867
Oil on canvas, 79 x 98 cm
Wildenstein I. 84
Berlin, Staatliche Museen Preußischer
Kulturbesitz, Nationalgalerie

The Quai du Louvre, 1867
Le Quai du Louvre
Oil on canvas, 65 x 93 cm
Wildenstein I. 83
The Hague, Collection Haags
Gemeentemuseum

The Jardin de l'Infante, 1867
Le Jardin de l'Infante
Oil on canvas, 91 x 62 cm
Wildenstein I. 85
Oberlin, Allen Memorial Art Museum,
Oberlin College

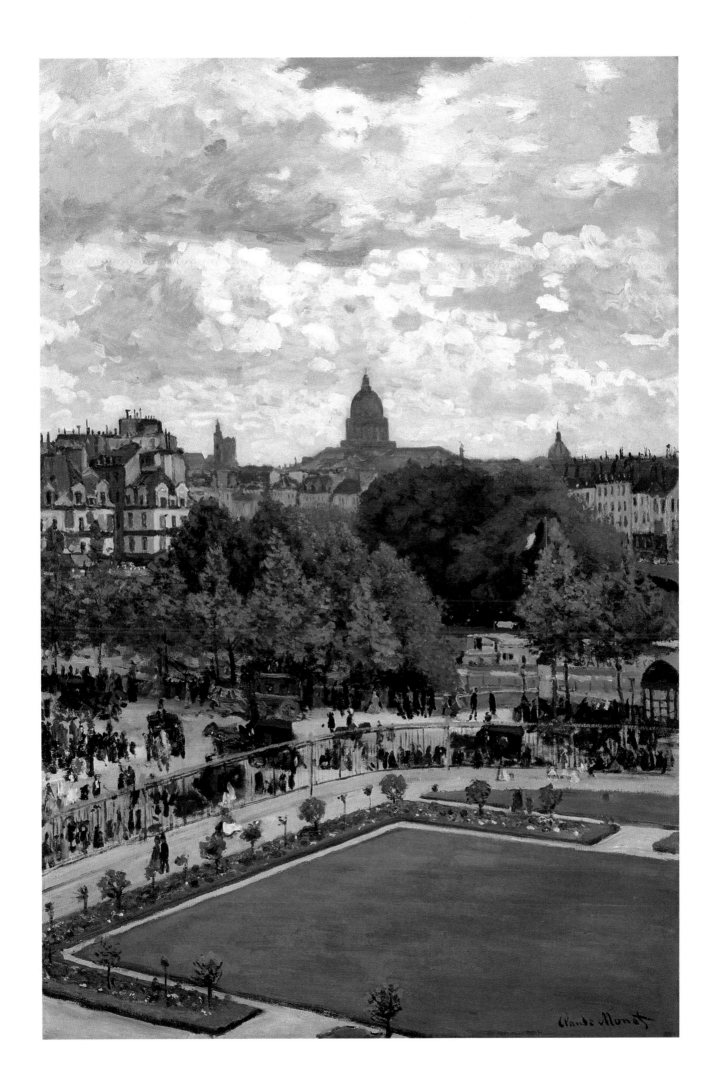

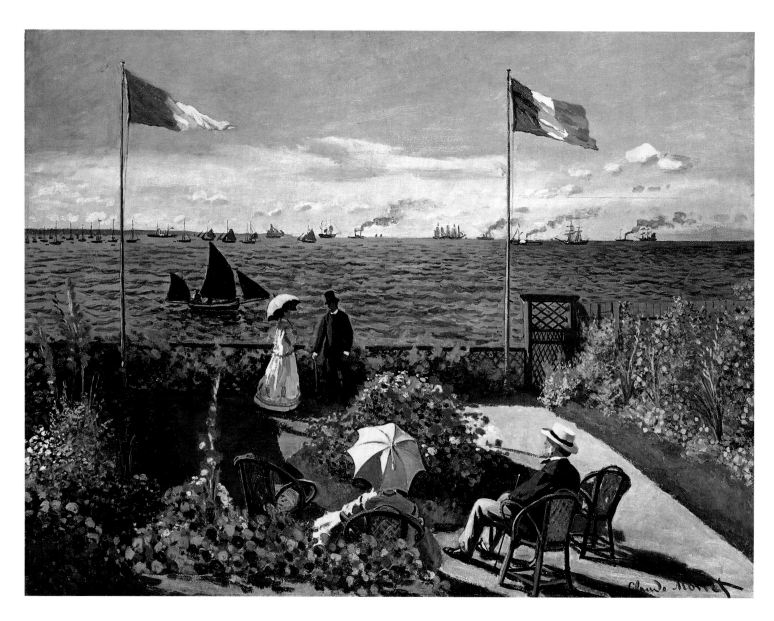

Terrace at Sainte-Adresse, 1867
Terrasse à Sainte-Adresse
Oil on canvas, 98.1 x 129.9 cm
Wildenstein I. 95
New York, The Metropolitan Museum of
Art, Purchased with special contributions
and purchase funds given or bequeathed
by friends of the Museum, 1967 (67.241)

ABOVE RIGHT:
Regatta at Sainte-Adresse, 1867
Les Régates à Sainte-Adresse
Oil on canvas, 75 x 101 cm
Wildenstein I. 91
New York, The Metropolitan Museum of
Art, Bequest of William Church Osborn,
1951

BELOW RIGHT:
The Beach at Sainte-Adresse, 1867
La Plage de Sainte-Adresse
Oil on canvas, 75.8 x 102.5 cm
Wildenstein I. 92
Chicago, The Art Institute of Chicago,
Mr. und Mrs. Lewis Larned Coburn Memo-
rial Collection, 1933.439

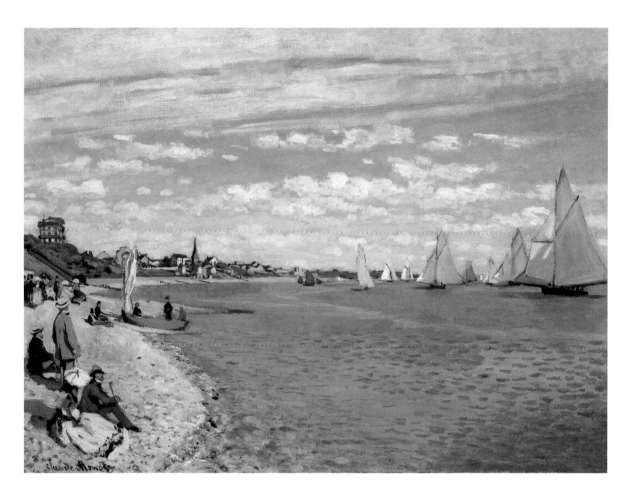

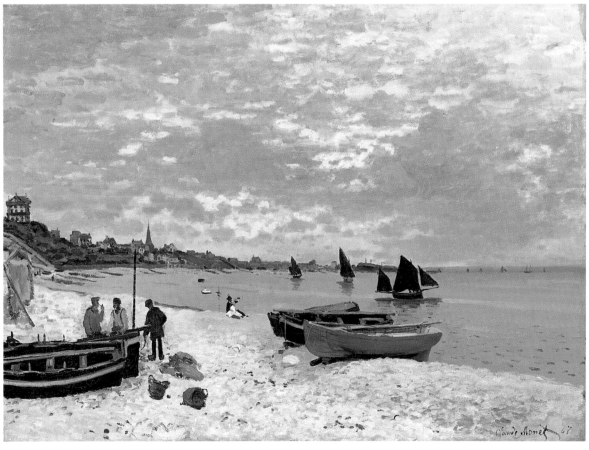

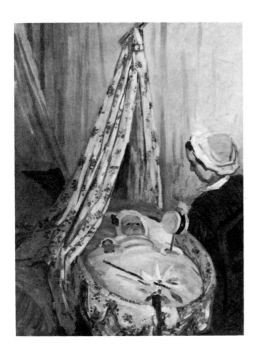

Jean Monet in His Cradle, 1867
Jean Monet dans son berceau
Oil on canvas, 116.8 x 88.9 cm
Wildenstein I. 101
Washington (D.C.), National Gallery of
Art, Mr. and Mrs. Paul Mellon Collection

Italy, the art critic Duranty, Emile Zola, whose literary career was just beginning, and many others. I myself took along Sisley, Bazille and Renoir. Nothing could have been more stimulating than these debates, with their constant clashes of opinion. They kept our wits sharpened, inspired us to unbiased and honest experimentation and supplied us with a stock of enthusiasm which kept us going until our ideas had been finally realized. We always came away with a sense of greater determination, our thoughts clearer and more sharply defined.' In 1874, when the idea of organizing an independent Impressionist exhibition became reality, this rendezvous was abandoned. Discussions were relocated to the Nouvelles-Athènes at Place Pigalle and later, over Impressionist dinners, to the Café Riche. Monet continued to attend these gatherings even after taking up permanent residence in the country.

In summer, Monet found himself obliged to inform his family of Camille's pregnancy. The response was an invitation to Sainte-Adresse, which Camille expressly refused. She was the victim of hypocritical condemnation; Monet's own father had had an affair with a maid, who had subsequently borne him a child. In Monet's absence, Camille gave birth to their son Jean on 8 August 1867. Monet had meanwhile flung himself into painting in a blind fury. He produced seascapes such as *The Beach at Sainte-Adresse* (p. 37), still lifes and finally *The Terrace at Sainte-Adresse* (p. 36).

Monet here portrays a comfortable scene whose centre is occupied by the standing figure of Monet's father in the right-hand foreground. The position which Monet thus gives his father is evidence – despite all the family tensions – of a certain respect. From a raised viewpoint, the terrace is seen from above, while the balustrade and flagpoles overlapping the horizontal planes of sea and sky give the events in the foreground a two-dimensional, stage-like character and negate the conventional perspective. For the first time, Monet employs coloured shading in the sense of Delacroix's violet shadows and complementary colours, such as red and green, which account for the extraordinary freshness of the picture and look ahead to later Impressionist work. A thoroughly realistic subject is given impressionistic qualities which start from a visual sensation gained directly from nature.

Monet was back in Paris in spring 1868 to submit, among other things, a seascape which is today lost, but which Zola praised as an example of a new style of painting based on real life. The new ways of seeing and interpreting nature which lay behind Impressionist techniques and whose beginnings were felt in Sainte-Adresse Monet now took a stage further in *On the Seine at Bennecourt* (p. 42), painted during a stay in Bennecourt on the Seine. The picture is thoroughly planar and leaves the perspective depth of conventional painting far behind. The link with three-dimensionality is achieved almost solely by the trees on the left,

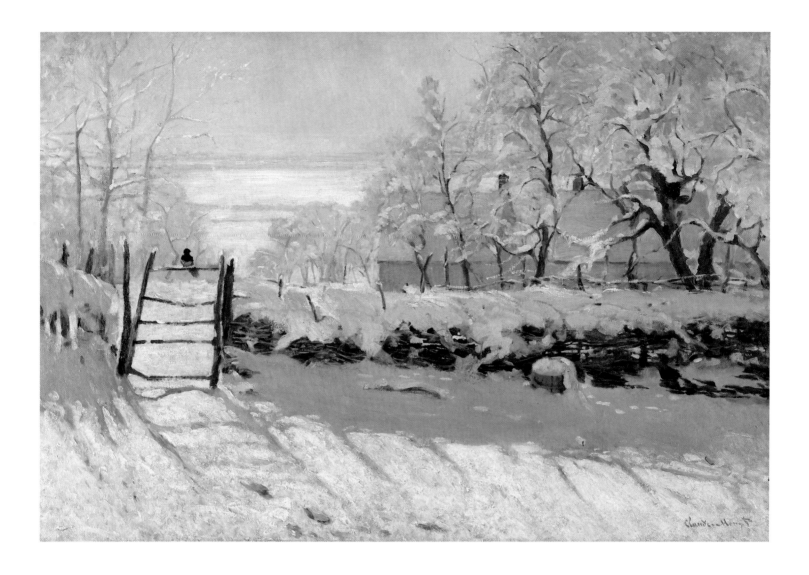

which crosscut the composition to join foreground and distance. Monet at the same time exploits the observable feature of nature, whereby dark colours protrude and convey nearness, while light colours recede and – as in the far shore, river and sky – create a feeling of distance. Correspondingly, the foliage of the trees, dissolved into countless dabs of paint, appears more detailed because of its proximity, while forms in the distance are flatter. A precise description of objects is nevertheless ultimately abandoned in favour of an overall visual impression created from patches and dabs of paint. For the first time, too, Monet assigns an important pictorial role to the reflections in water which especially enabled him to link the artistic idea with actual perception. His real-life subjects are thus transformed through reflections into abstract colour shapes.

In summer 1868 Monet, Camille and Jean travelled to the Normandy coast, where Monet participated with great success in a exhibition in Le Havre and where he painted the portrait of *Madame Gaudibert* (p. 41), a commission which put him back on a somewhat sounder financial footing. This life-size picture of an elegantly-dressed woman is freshly and powerfully painted. Although it recalls *Camille*, it is nevertheless very much more

The Magpie, 1869
La Pie
Oil on canvas, 89 x 130 cm
Wildenstein I. 133
Paris, Musée d'Orsay

PAGE 40:
The Luncheon, 1868
Le Déjeuner
Oil on canvas, 230 x 150 cm
Wildenstein I. 132
Frankfurt, Städtische Galerie im Städelschen Kunstinstitut

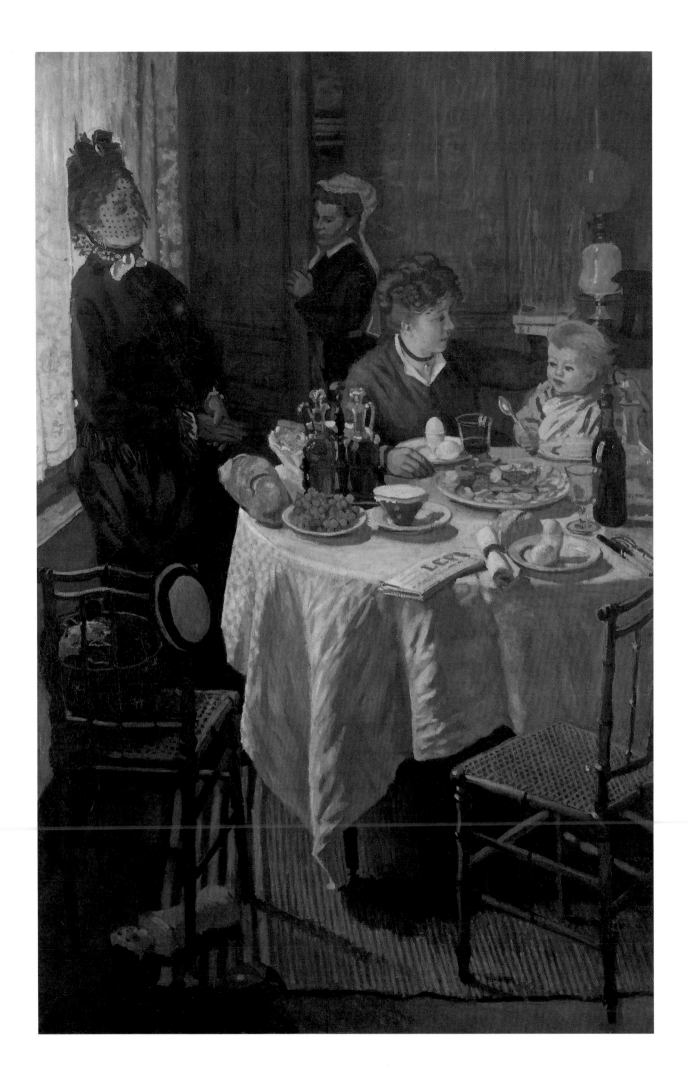

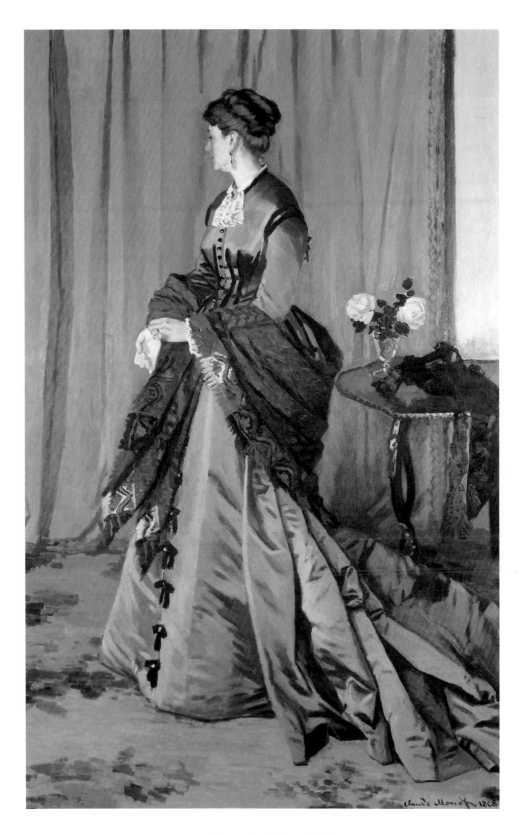

Madame Gaudibert, 1868
Portrait de Madame Gaudibert
Oil on canvas, 217 x 138 cm
Wildenstein I. 121
Paris, Musée d'Orsay

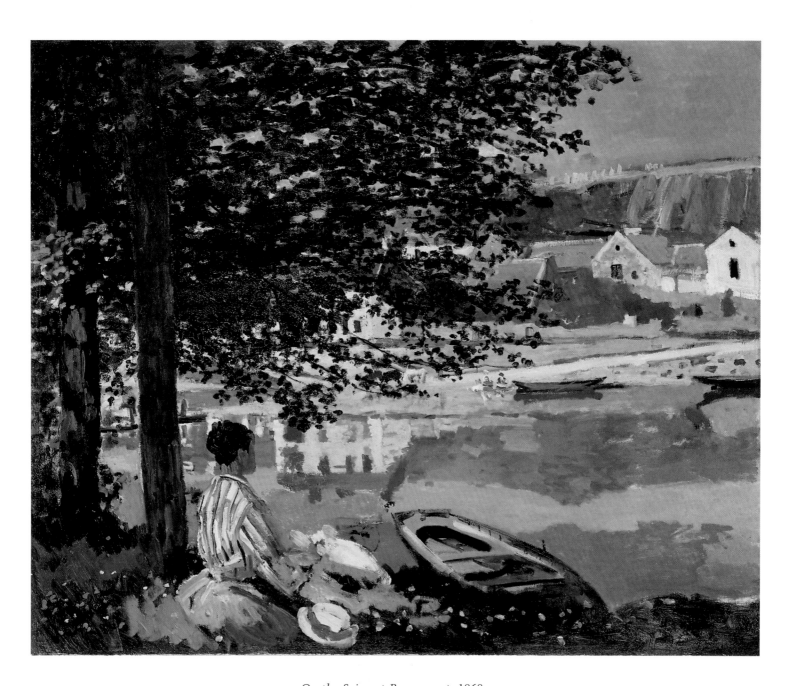

On the Seine at Bennecourt, 1868
Au Bord de l'eau, Bennecourt
Oil on canvas, 81.5 x 100.7 cm
Wildenstein I. 110
Chicago, The Art Institute of Chicago,
Potter Palmer Collection, 1922.427

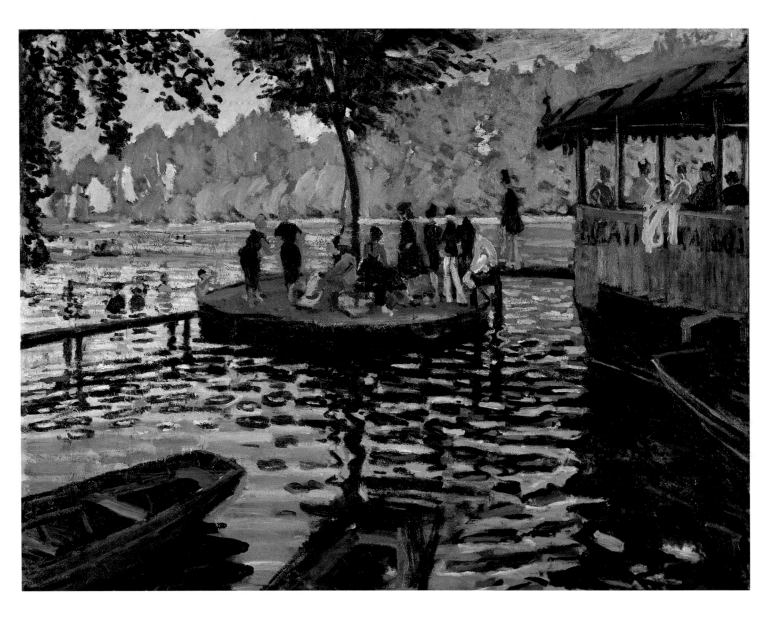

La Grenouillère (The Frog Pond), 1869
La Grenouillère
Oil on canvas, 75 x 100 cm
Wildenstein I. 134
New York, The Metropolitan Museum
of Art, Bequest of Mr. and Mrs. H.O.
Havemeyer, 1929, H.O. Havemeyer
Collection (23.100.112)

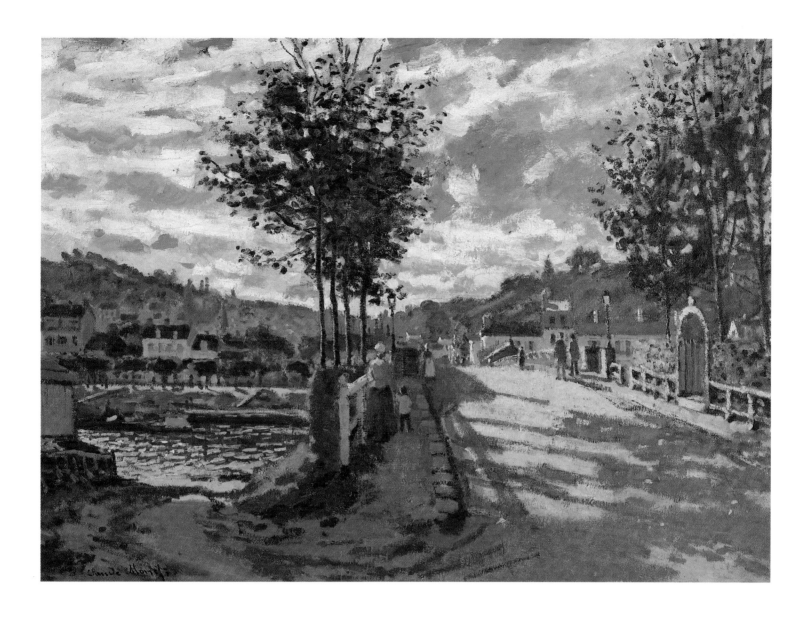

The Bridge at Bougival, 1870
Le Pont de Bougival
Oil on canvas, 63 x 91 cm
Wildenstein I. 152
Manchester (N. H.), The Currier Gallery
of Art

complex and differentiated in its treatment of surface. Monet remained on the Normandy coast with Camille and Jean throughout the autumn and winter, turning to domestic interiors which, as in *The Dinner* (Zurich, E.G. Bührle Foundation) and *The Luncheon* (p. 40), lovingly capture his small family. He also tried his hand at snowy landscapes outdoors in the bitter cold, including *The Magpie* (p. 39), a captivating scene of wintry sunlight.

When Monet returned to Paris at the end of the year, not only had his aunt cut off all further maintenance because of his relationship with Camille, but unpaid bills had led to a number of his pictures being impounded. In this crisis, as before, he took shelter with Bazille. The following year brought no great improvement. The Salon refused *The Luncheon,* and by the time he arrived with his family at Saint-Michel near Bougival there was barely enough money to look after the child. They had long had neither lighting nor heating. The situation was desperate. Renoir, living with his parents in Louveciennes very close by, brought bread for Monet and his family. The two artists worked

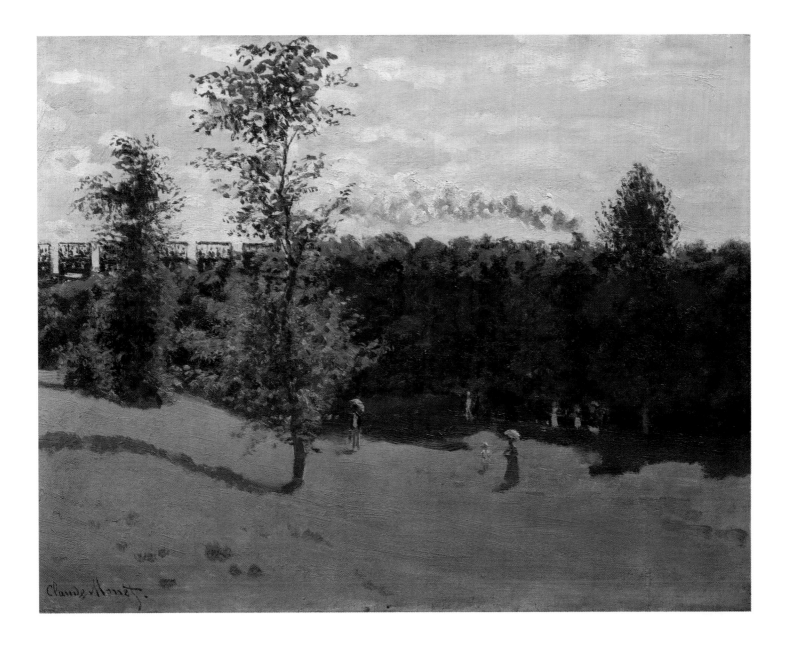

together. In bad weather they turned to still lifes, but otherwise they set up their easels outdoors, as for example by the river resort of La Grenouillère on the Seine near Bougival.

This popular destination with its nearby restaurant used to attract large numbers of Sunday pleasure-seekers, who passed the time with swimming and boating. Monet made several studies of this motif, intending to use them later for a large composition for the Salon. This project was never completed. The New York version (p. 43) shows the boat hire on the right, from which a narrow catwalk leads to the circular floating jetty called 'Camembert.' The entrance to the – here not visible – bathing cabins lay to the left.

These pictures have been rightly identified as the origins of the free, spontaneous manner of Impressionist brushwork which reduces objects to an infinite number of individual, separate dots, dabs and dashes of paint. Although their style continues on from *On the Seine at Bennecourt* (p. 42), Monet is now considerably freer in his interpretation. The bathers and their reflections in

Train in the Countryside, 1870-71
Train dans la campagne
Oil on canvas, 50 x 65 cm
Wildenstein I. 153
Paris, Musée d'Orsay

45

the left-hand field of the picture are so dissipated as to be barely distinguishable from each other. Sunlight and shade structure the surface of the water as abstract patches of light and dark colour. In his rapid, sketch-like execution of the picture using a loaded brush, Monet abandons all detailed object description and concentrates on the atmospheric interplay of light and shadow. The differences in the paintings of La Grenouillère by Monet and Renoir are revealing. While Renoir is concerned chiefly with shaping the human figure, Monet's characters – reduced to abstract dashes of paint – are embedded within their natural surroundings.

Although winter brought no improvement in Monet's financial situation, numerous snowscapes of Louveciennes and scenes from Bougival, such as *The Bridge at Bougival* (p. 44) and *Train in the Countryside* (p. 45) testify to a phase of creativity. All the greater, therefore, was the disappointment which followed the rejection of his works (*The Luncheon* and a version of *La Grenouillère* now lost) by the Salon of March 1870. The future looked threatening; Napoleon III's hostility towards the Germany unified by Bismarck seemed set to lead to war between Prussia and France. The dispute surrounding the succession to the Spanish throne provided the eventual excuse.

When Monet married Camille Doncieux in Paris on 28 June 1870 in the presence of Courbet, it was not least under the pressure of approaching war. Monet faced the possibility of conscription. To avoid call-up, he and his family moved to Trouville on the Normandy coast, where Boudin and his wife appeared soon afterwards. Boudin later recalled working with Monet on the beach at Trouville: 'I can still see you and poor Camille in the Hotel Tivoli. I've even still got a drawing which shows you on the beach. It contains three young women in white. Death has since snatched two of them – my poor Marie-Anne and your own wife . . . Little Jean is playing in the sand, and his papa is sitting with a sketchboard in his hand.' This period is preserved in a series of pictures painted *On the Beach at Trouville* (p. 47), whose bold and generous style of heavy, loaded brush-strokes recalls the work of Courbet.

On 19 July 1870 France declared war on Prussia. Bazille subsequently volunteered for the army; it was a decision which was to cost him his life. On 2 September that same year the French were defeated at Sédan and Napoleon III was taken into Prussian captivity. France proclaimed itself a republic under Adolphe Thiers. Since Le Havre was an important strategic stronghold, from October onwards the situation intensified here, too. As a result, Monet – like other artists before him – decided to emigrate to the English capital.

His numerous rejections from the Salon had forced Monet to realise that it was not the right place in which to introduce the new understanding of painting which had been manifesting itself in his work since the end of the sixties. Monet now gave up

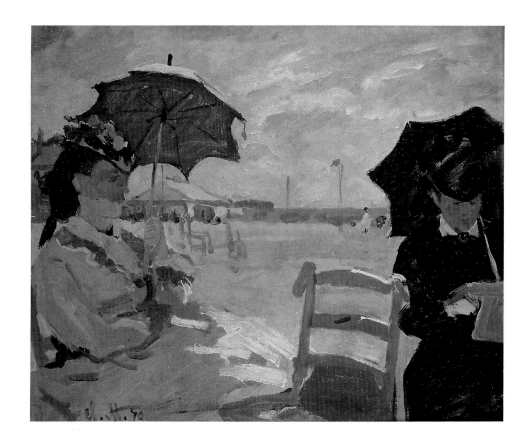

On the Beach at Trouville, 1870
Sur la plage à Trouville
Oil on canvas, 38 x 46 cm
Wildenstein I. 158
London, The National Gallery

painting the large, almost life-size portraits which – like *Camille* and *Madame Gaudibert* - were commissioned and conceived specifically for the Salon. When, years later, he returned to such subjects, as in *La Japonaise* (p. 86), his work lacked the characteristic power of his earlier figures.

Monet now devoted himself almost exclusively to the landscape painting which was to prove the major forum of the Impressionist innovations of the seventies. *Women in the Garden, On the Seine at Bennecourt* and *La Grenouillère* form the historical sites from which Monet set off along the individual paths which were to lead him beyond the work of Manet and Courbet to a new style of painting. It was a style which embraced their new understanding of reality, but started by necessity from work *en plein air.* It therefore opened up new areas and aspects of reality which combined both the novelties of the modern city and an interpretation of landscape as championed by the Barbizon school. The new approach to nature this latter had entailed, so different to conventional painting, had been inspired in particular by English and Dutch landscape painting. Monet's own stay in England and Holland in 1870/71, necessitated by the ravages of war, was thus significant at more than just a personal level.

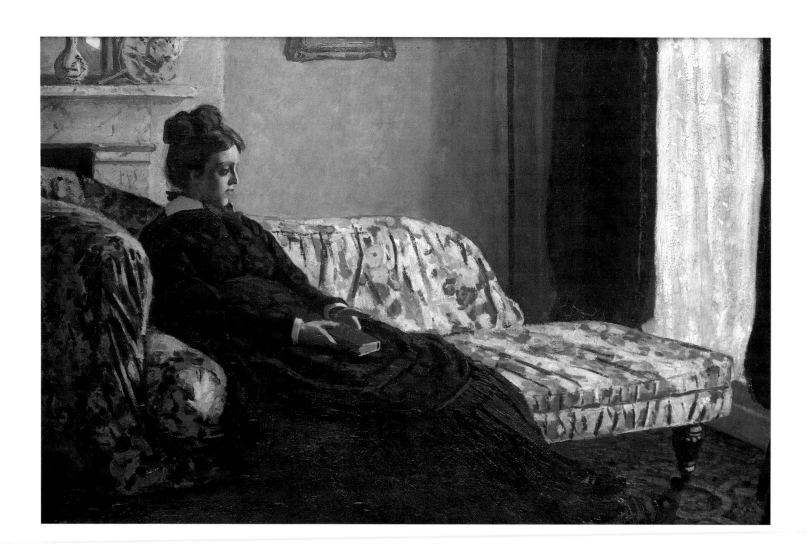

Interludes in England and Holland 1870/71

Madame Monet on the Sofa, 1871
Méditation, Madame Monet au canapé
Oil on canvas, 48 x 75 cm
Wildenstein I. 163
Paris, Musée d'Orsay

As Monet recalled: 'In 1870 we fled to London. We – Pissaro, Boudin and I – frequently went to a café where the French all used to meet. Daubigny would sometimes drop by. He realised we were all spiritual brothers and wanted to see our painting. He then got very excited, very enthusiastic, and assured Pissarro and myself of his support. "I'll send a dealer round to see you," he said . . . And indeed, it wasn't long before Durand appeared, having moved his gallery to London because of the War . . . Without Durand we would have starved like all Impressionists. We owe him everything. He was obstinate and dogged, and he risked everything more than once to support us.' This introduction to Paul Durand-Ruel was highly significant for not only Monet. Durand-Ruel was a committed and idealistic dealer who had previously specialized in the Barbizon painters in particular. He now took up the cause of the group around Monet, whom he held to be the leader of a new movement. Over the following years, his Parisian gallery, which from 1869 to 1924 was located at 16, Rue Lafitte on the corner of 11, Rue Le Peletier, became a central handling point of Impressionist art. The London branch which he opened in December 1870 showed pictures not only from the Barbizon school, but also by the younger Impressionists.

Monet, Camille and Jean initially settled at Piccadilly Circus in the centre of town, but moved to Kensington at the start of the following year. Here Camille, seated pensively on a sofa, was the model for an interior (p. 48) whose intimate mood recalls works by James Whistler, such as the *Portrait of the Artist's Mother* (1871; Paris, Musée d'Orsay). Monet was thoroughly acquainted with Whistler and his work. Although the city offered him a vast quantity of new motifs, the months in London were relatively unproductive, leaving just a few pictures of the Thames (p. 51), Green Park and Hyde Park. Monet was not to appreciate London's unique charms until later visits. The works from this first stay are, moreover, considerably less progressive than those of previous years. Since Monet's subjects differ from those of Pissarro from the same period, it can be assumed that the two did not work together. Of greater significance were their joint

visits to the London museums and their encounter with the English landscape painting of the late 18th and early 19th centuries, in which a new sensitivity towards nature and the influence of 17th-century Dutch painting had combined to inaugurate a modern style of landscape art. William Turner and John Constable were among the most important pioneers of this new view of nature. Constable's paintings of clouds (Victoria and Albert Museum) in particular revealed his interest in the fleeting moods of light. He was one of the first to give up the dark and earthy colouring and artificial composition which had long characterized conventional Salon painting of this theme. The light-flooded realism of landscapes such as his *Meadows near Salisbury* (1829/30; London, Victoria and Albert Museum), in which colour became the vehicle of light and mood, offer clear parallels with the art of Daubigny and Monet.

Equally profound was the impact of Turner's work in the National Gallery. Turner's fog landscapes in particular demonstrate a dematerialization of the object, a dissolution of form through coloured light, which recalls Monet's later series of *Rouen Cathedrals* (p. 172/173). For Turner, too, changes in a landscape at different times of day and under different weather conditions were of decisive interest. His intensive observations of nature make him a vital link in the development of Impressionist painting. Indeed, he may be called one of the first Impressionist painters, since the impression made by nature was his fundamental starting-point. Although Monet always protested against comparison with Turner, his pictures contradict him. As Pissarro recalled: 'We also visited the museums . . . We were chiefly struck by the landscape painters, who shared more in our aim with regards to

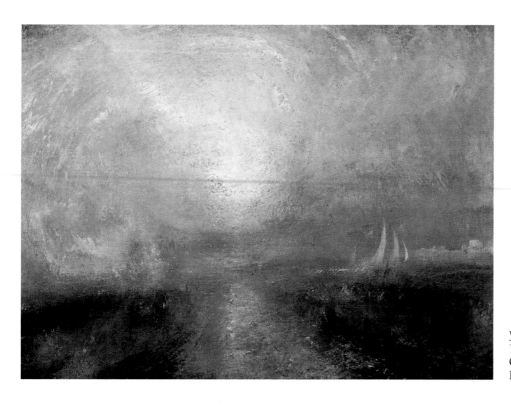

William Turner
Yacht Approaching the Coast, c.1838-1840
Oil on canvas, 102 x 142 cm
London, The Tate Gallery

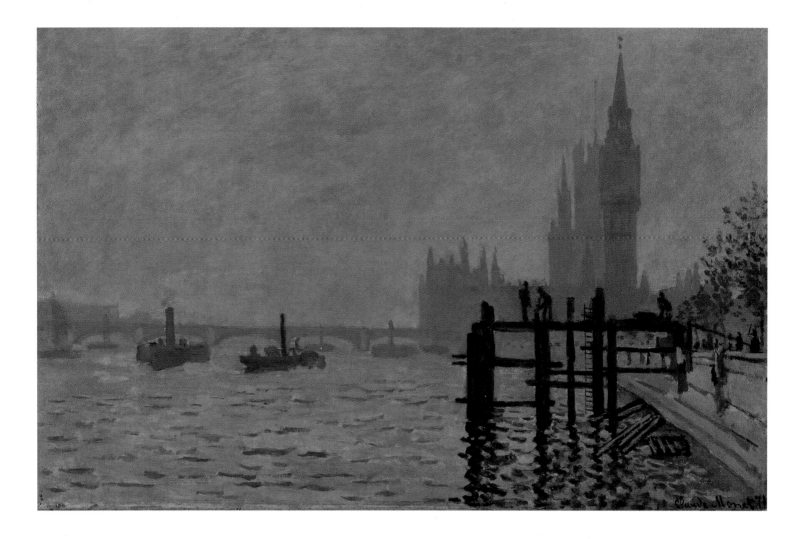

plein-air, light and fugitive effects.' Turner and Constable un-doubtedly contributed to the development of Impressionism, albeit only insofar as they accelerated a process already in motion and reinforced Monet and Pissarro in their conviction of being on the right path.

The few items of news which reached Monet from France were bad. His father had died on 17 January, shortly after marrying his mistress, Amande-Célestine Vatine, for the sake of their daughter Marie. German troops had furthermore occupied Paris in January. They had also billeted Pissarro's house in Louveciennes and destroyed a large number of its stock of paintings by Pissarro and Monet. For Pissarro this meant the almost total loss of some 15 years' work. The end of the war and the signing of the Versailles peace treaty were accompanied almost simultaneously by the setting up of the Paris Commune. Its bloody suppression by the republican government under Thiers in May 1871 was a heavy blow for emigrants, who had placed great hopes on the birth of a social and progressive movement. A second wave of refugees washed over England.

In the same month, Monet left London for Holland, where he settled with Camille and Jean in Zaandam in the north, halfway between Haarlem and Amsterdam. A small inheritance from the death of his father and the French conversation lessons which

The Thames and the Houses of Parliament, 1871
La Tamise et le parlement
Oil on canvas, 47 x 73 cm
Wildenstein I. 166
London, The National Gallery

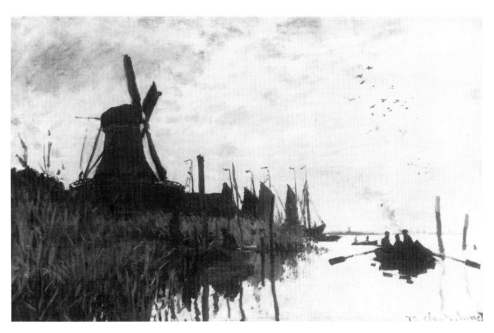

Camille gave to the wealthy daughters of this small, aspiring industrial town meant there were no immediate financial worries. Monet was thrilled by the Netherlands, by its rich colours and the new motifs he found in Zaandam. 'We crossed virtually all of Holland, and there is no doubt that what I saw of it was much more attractive than what people say. Zaandam is particularly charming, and there is enough here to last a painter a lifetime . . . Houses of every colour, mills by the dozen and enchanting boats.' In mainly small-format paintings of the harbour, dike, mills, boats and quays, Monet devoted himself to the water-dominated subjects which he so loved. In the rapid, sketchy and coarse style of these pictures, however, Monet's debt to Dutch landscape painting of the 17th century is less evident than in other of his waterscapes from Rouen and Argenteuil. These light and airy pictures, their skies fair or laden with stormy clouds, nevertheless indicate atmospheric observations such as found in Dutch artists.

Both pre-Impressionism and Impressionism are bound up with Holland in a variety of ways, via historical influences and through personal contacts between French and Dutch artists. French Romantics such as Delacroix had enthused about Dutch art. But it was the Dutch landscape painting of the 17th century, above all by Salomon van Ruysdael and Meindert Hobbema, which was to interest the pre-Impressionist movement. The painters attached

LEFT:
Mill at Zaandam, 1871
Moulin à Zaandam
Oil on canvas, 48 x 73.5 cm
Wildenstein I. 177
Private collection

RIGHT:
Mill at Zaandam, 1871
Moulin à Zaandam
Pencil drawing, 20 x 41 cm
Private collection

Jacob van Ruysdael
Wijk Mill near Duurstede, c. 1670
De Molen bij Wijk bij Duurstede
Oil on canvas, 83 x 101 cm
Amsterdam, Rijksmuseum

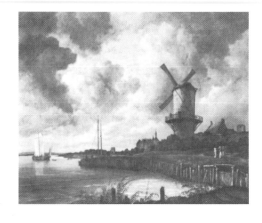

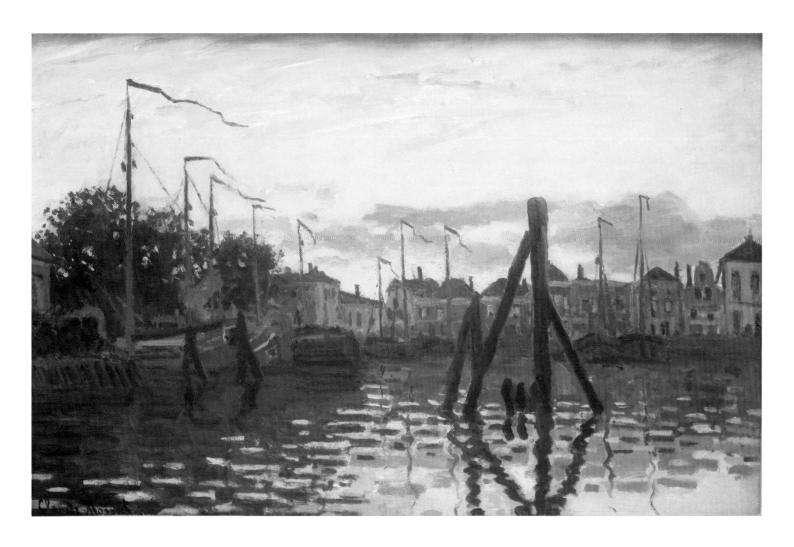

Zaandam Harbour, 1871
Le Port de Zaandam
Oil on canvas, 47 x 74 cm
Wildenstein I. 188
Private collection

to the Barbizon school, such as Corot, Troyon, Narcisse Diaz and Daubigny, copied their works in the Louvre. Monet in turn acknowledged a lifelong debt to the Barbizon school, and to Corot and Daubigny in particular.

As from 1830, Barbizon had attracted independent landscape artists who, following the example of the Dutch in the 17th century, had turned away from the school of classical Italian landscape painting. Such landscapes were composed in the studio according to rigid intellectual rules and frequently overlaid with allegorical, mythological and historical references. Academic opinion considered pure landscape painting a less noble form of art, since it proceeded from sensual impressions and the projected feelings of the artist. The Academy stood for painting as erudition, and thus the Salon was effectively dominated by history painting throughout the first half of the 19th century. The situation was little changed by the introduction in 1817 of a prize for the category of landscape painting, nor by the landscape theories of Pierre Henri Valenciennes and Jean-Baptiste Deperthes (*Theory of Landscape,* 1818), which appeared around 1820. These simply reinforced the existing classification of landscape painting within academic theory.

This theory viewed pure landscape painting as dangerous, since it gave excessive rein to the subjectivity and imagination of the

artist. The French Romantic painting of artists such as Delacroix had thus been condemned for such qualities as freedom, independence and imagination. In a subsequent backlash, pure and unadulterated nature became, for the Barbizon painters, a symbol of freedom from constraint, convention and loathsome authority. In employing the devices of Dutch landscape painting, they wanted to reproduce impressions of nature which were immediate and individual. In their subsequent explorations of atmospheric changes in nature, light and colour became vital elements of their painting. In order to achieve a realistic, faithful portrayal of nature, they worked extensively outdoors. Their ordinary motifs, such as the edges of forests, marshes, villages, windmills and watermills, boats, ports and river landscapes, both recall Dutch 17th-century painting and look ahead to later Impressionist landscapes. The influence of Dutch painting can be felt most clearly in Daubigny, in his preference for riverside and boat motifs. Daubigny, who made a large impact on Monet, also lived in Holland after the Franco-Prussian War.

Following his return from Holland, Monet settled briefly in Paris in the autumn of 1871 in lodgings not far from the Saint-Lazare railway station. His studio was just a short walk away. Boudin, who lived in the immediate neighbourhood, was a frequent and welcome guest at the Monet apartment. They must certainly have discussed the fate of Courbet, then sitting in Sainte-Pélagie prison. In April 1870 Courbet had been named Fine Arts Delegate by the Commune. It was during his office, on 16 May, that the Vendôme Column – a symbol of the hated monarchy – was demolished in Paris. Following the fall of the Commune, Courbet was arrested; in a subsequent trial he was sentenced to six months' imprisonment and a fine, since he was considered proven to have been responsible for the column's destruction. While most of his artist friends subsequently distanced themselves from him, Monet and Boudin visited him in prison in January 1872. It was the last time the two painters were to meet before Courbet's flight to Switzerland in 1873.

Monet brought back over twenty landscapes from Holland. Stylistically, their medium-sized format, fluid brushwork, free composition and integral approach place them halfway between the Seine studies at La Grenouillère and those from Argenteuil from the years between 1872 and 1878. When he saw them in Paris after Monet's return, Boudin was enthusiastic: 'He's brought some really beautiful studies back from Holland. I think he's got all the makings and is going to be the leader of our movement.' The next few years were to confirm the accuracy of Boudin's prediction.

Zaandam, 1871
Oil on canvas, 48 x 73 cm
Wildenstein I. 183
Paris, Musée d'Orsay

Houses on the Waterfront, Zaandam, 1871
Maisons au bord de la Zaan à Zaandam
Oil on canvas, 47.5 x 73.5 cm
Wildenstein IV. 185
Frankfurt, Städelsches Kunstinstitut

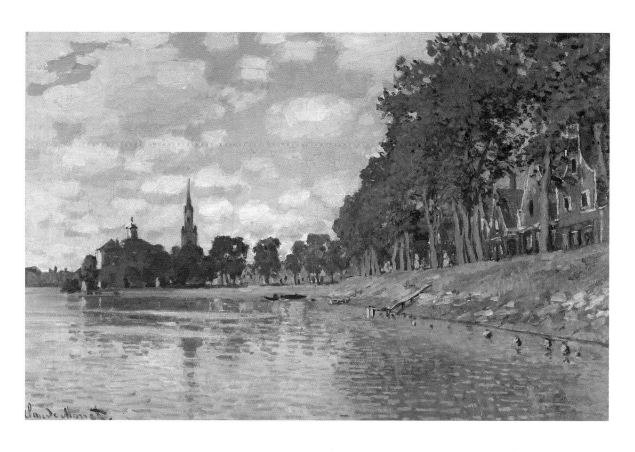

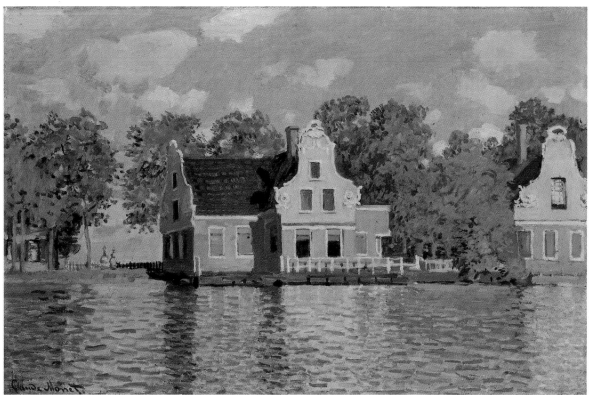

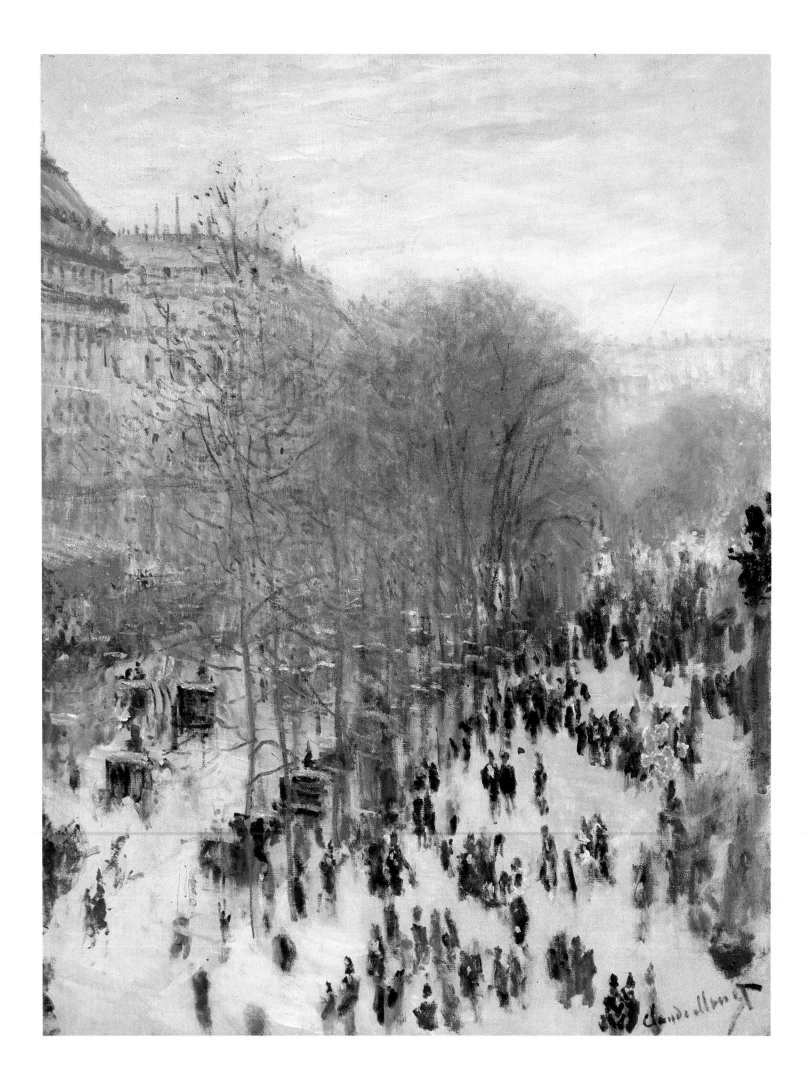

Argenteuil 1872-1878
The new movement is named

The years in Argenteuil represent not only the height of Impressionism, but also the middle phase of Monet's creative life. Although, during this period, he retained the landscape themes of the sixties, he now assigned greater significance to atmospheric effects, movement and visual phenomena. Whereas the nine previous years had seen him regularly moving from place to place, this was the first time he had worked for a longer period – six whole years – from a single base. He was away from Argenteuil only on short trips to Rouen, Paris, Amsterdam and the Normandy coast. Monet was extraordinarily productive during this period, painting more pictures than in the entire thirteen years before. The town and its surroundings offered him a rich supply of his favourite motifs: bridges, boats, town and nature, family scenes in the house and garden.

It may have been Manet's recommendation which led Monet to choose Argenteuil as his new home. Manet had good contacts there with the influential Aubry family, who agreed to rent Monet a house. This first home lay not far from the railway station at 2, Rue Pierre Gienne. It was in the garden of this house that Monet painted *Lilacs, Overcast Weather* (p. 59) during the spring of 1872. But Monet soon moved to another house in the neighbouring Rue Saint-Denis. Argenteuil lay on the right bank of the Seine just six miles from the Paris Saint-Lazare railway station. The completion of a rail link in the fifties had opened a new chapter in the lives of the 8000 inhabitants of this small provincial town. The trains leaving Paris every hour not only brought Argenteuil increasing numbers of pleasure-seekers, but also hastened industrial progress, leading to the building of several factories amidst this rural idyll.

The beginnings of industrialization and a nature not yet spoilt both find their expression in Monet's work. Indeed, the factory stacks tracing the advance of industry appear as positively welcome elements of landscape in, for example, *The Promenade at Argenteuil* (p. 63). In such works, Monet celebrates progress as a new religion in which man and industry work together for the good of mankind. His interest in the writings of French social

The Boulevard des Capucines, 1873
Le Boulevard des Capucines
Oil on canvas, 80 x 60 cm
Wildenstein I. 293
Kansas City (Mo.), The Nelson Atkins Museum of Art, Purchased with purchase funds from the Kenneth A. and Helen F. Spencer Foundation (F 72-35)

57

critics such as Claude Henri de Rouvroy and the Comte de Saint-Simon, for whom science and industry were the pillars of a new world, was no coincidence. Monet is not known to have been politically active, however. In his representations of industrial plants, trains, railway stations and modern steel bridges, he simply addressed the phenomena of modern life and thereby followed the trend towards realism which had characterized the work of both Monet and his brothers-in-arms since the sixties.

However, Monet frequently also withdrew to isolated spots on the right bank of the Seine, where the Petit Bras arm of the river embraced the small island of Marante, whose high poplars could be seen from all around. A very early rendition of this motif, painted at the beginning of spring 1872, is *The Petit Bras at Argenteuil* (p. 60). In March Monet set off for Rouen, where his brother Léon lived and where he wanted to take part in an exhibition. During his stay, he painted *The Ruisseau de Robec* (p. 61) in the factory quarter of Rouen, as well as views of the Seine with the Rouen skyline and its cathedral in the background. Monet subsequently restricted his range of motifs; from his return from Rouen until the end of 1872, he concentrated above all on the Seine near Argenteuil, as in *The Basin at Argenteuil* (p. 62), the *View of the Argenteuil Plain from the Sannois Hills* (p. 63), the *Regatta at Argenteuil* (p. 67) and *Festival at Argenteuil (p. 66)*. These pictures of Argenteuil and its surroundings differ considerably in terms of painting style, whereby their variability becomes their specific characteristic. Complex brushwork is applied on top of flat, unmodelled washes; quiet, matt colours are followed by pastel shades and animated impasto. In the View of the Argenteuil Plain, Monet provides a panoramic view out towards a far-off Argenteuil, a view also enjoyed by the two walkers who seem to melt into the surrounding vegetation as they disappear down the path. The equally-weighted clusters of trees to the left and right and the horizon starting from the centre of the picture give this expansive composition its balanced and harmonious tenor. Here, too, there is no brushwork differentiation of the objects portrayed; they are distinguishable by colour alone.

Monet's views of the town of Argenteuil, including the *Festival at Argenteuil* (p. 66), also capture a contemplative and unchanging side of rural life not yet affected by industrialization. Paris, on the other hand, had been dramatically reshaped under the prefecture of Georges Eugène Haussmann. Quarters whose twisting alleyways and winding streets had grown up over the centuries were, in the fifties, pulled down to make way for spacious boulevards and avenues. Although officially for the purpose of ensuring the State better control of epidemics, civil wars and barricades, these measures were above all intended to drive the traditional populace into the suburbs. The *quartiers* of Paris lost their individual identity. The doors were thrown well and truly open to economic speculation, and the inhuman face of Moloch's metro-

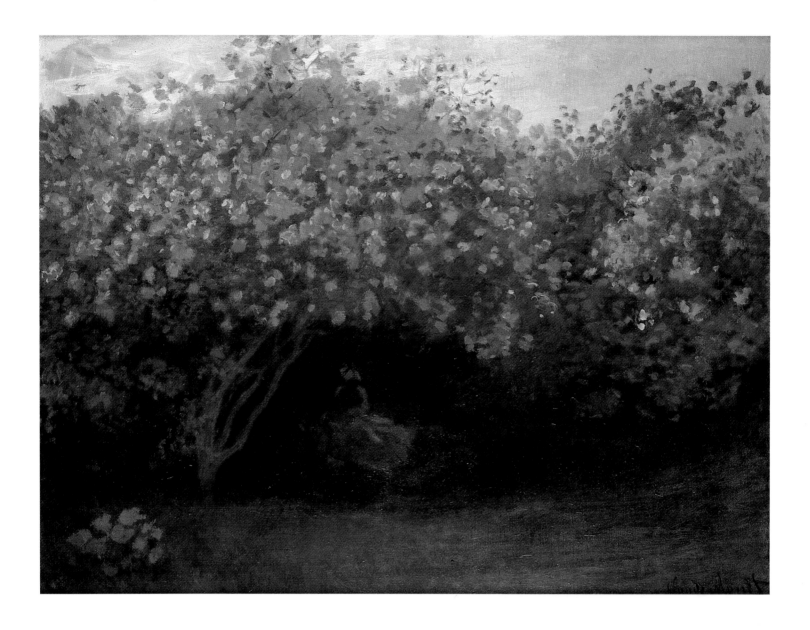

Lilacs, Overcast Weather, 1872
Les Lilas, temps gris
Oil on canvas, 50 x 65 cm
Wildenstein I. 203
Paris, Musée d'Orsay

polis was soon revealed. Luxurious department stores sprung up, such as the famous *Bon Marché* in 1876, together with malls, exhibition halls and panoramas – suitable settings for the city's beau monde. At the World's Fair of 1867 this capital-oriented culture reached its most glittering peak. The Empire was at the height of its power, and Paris confirmed its position as the centre of luxury and fashion. It was a world in which security and success were no longer guaranteed by tradition; profit and competition were the new driving forces.

As the backdrop to this animated and sparkling urban life, the boulevards and avenues became a favourite theme of Impressionist painting. But although this aspect of the city had a fascination for Monet, too, he maintained a certain distance. Monet remained a remote observer even in his views of the Argenteuil landscape; he never painted the hardships of rural life, for example. His tendency towards selectivity and even isolation can be recognized in more than just his paintings of unspoilt nature. In the *Festival at Argenteuil* (p. 66), the painter places a strip of empty space

59

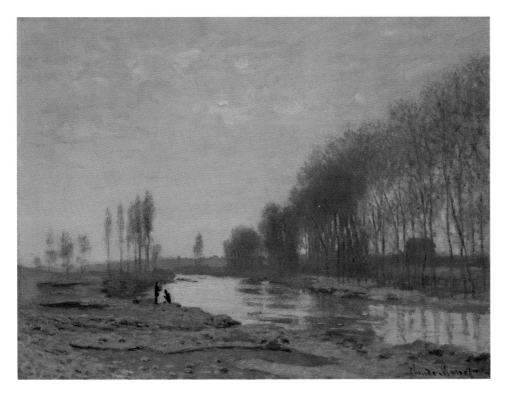

The Petit Bras at Argenteuil, 1872
Le Petit Bras d'Argenteuil
Oil on canvas, 53 x 73 cm
Wildenstein I. 196
London, The National Gallery

between himself and the dense crowd of merry-makers. The festive atmosphere of the scene is underlined in the rows of flags and festival buildings on the right and the flashing of white Sunday bonnets and black hats. The technique has in some places become so free that the sky zone is merely suggested through rapid strokes of the brush.

The view of *The Boulevard des Capucines* (p. 56) in Paris, which Monet painted from the studio of the photographer Nadar, places a similar distance between the observer and the observed. It corresponds to the view enjoyed by the top-hatted figures appearing on the right, looking down from a balcony in the Rue Danou. The schematic reproduction of the bustling boulevard, its comings and goings, the strolling pedestrians and passing carriages which – from our elevated viewpoint – appear simply as dashes of colour, is like an action photograph in which the outlines have blurred. Indeed, the new medium of photography was to have a powerful influence on the independent painters, in particular Degas. The painting seems to capture a vanishing moment. Today – our own senses being used to the constant change produced by movement –, Monet's interpretation appears highly true-to-life. The critic Louis Leroy, who saw the work in 1874 on the occasion of the first Impressionist exhibition, ridiculed precisely these qualities in a fictitious conversation: "'Now this really takes the biscuit! If this isn't an impression, then I don't know what is. Only be a good chap and tell me what all those little black dribbles are down there?" "Why, those are the passers-by." "Ah, so that's what I look like when I walk down the Boulevard des Capucines! Well I never! Are you trying to pull my leg? . . .but these blotches have been obtained in the same

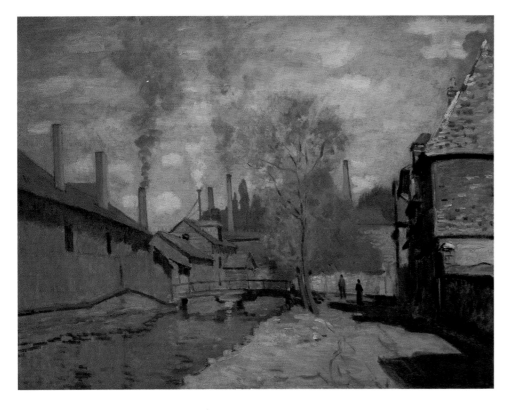

way as marbling – in splodges, any old way. It's outrageous, appalling! It's enough to give a man apoplexy."'

This was simply another echo of the accusation repeatedly levelled at Impressionist works by conservative critics, namely that they were unfinished, painted too quickly and – since they were based on the rules of the sketch – at best only preliminary studies. Since this work, like a sketch, gives first priority to the overall impression, Monet was able to extensively abandon the intellectual principle of perspective organization, whereby perception concentrates upon a specific point. Vision instead becomes expansive and comprehensive, objects both near and far are seen simultaneously, without spatial separation. Thus space in the *Boulevard* - despite the diagonal line of the trees – is shaped through the linking of objects by mood, the colour *enveloppe*, and perspective reduced to colour relationships. The muted palette and blue-violet mist miraculously express not only the atmosphere of a cool spring day, but also a spatial continuum, a sense of distance.

The rapid recording of something seen, which perforce neglects detail and contributes to formal dissolution, corresponds – in the open-air academic sketch just as much as in Impressionist painting – to the striving for truthfulness (*vérité*) vis-à-vis the direct experience of nature. In order to capture the light conditions of a fleeting moment (*effet*), it was necessary to paint fast. Artists in the academic tradition were not, however, content to stop at a style of painting based on visual experience and thus on colour alone. In their view, such painting decidedly lacked the expression which was demanded by the art of ideas and which was developed from preliminary drawings. According to a belief inherited from

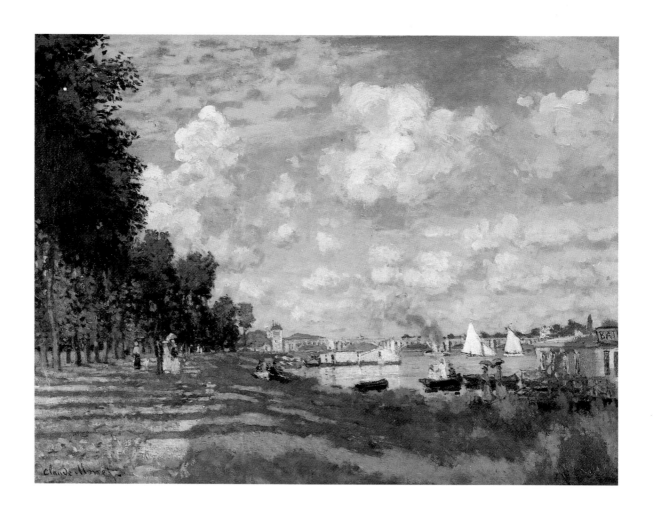

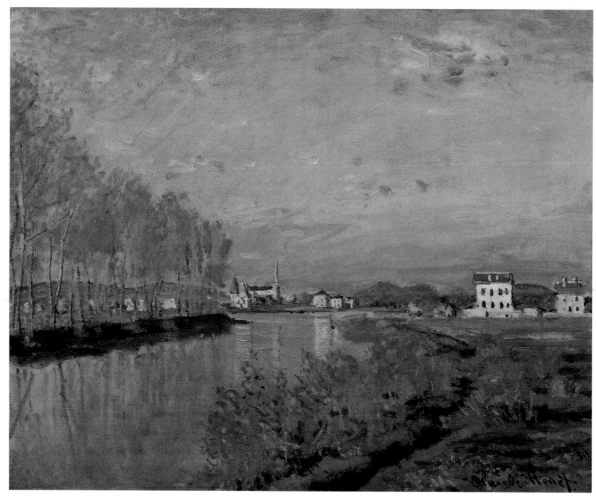

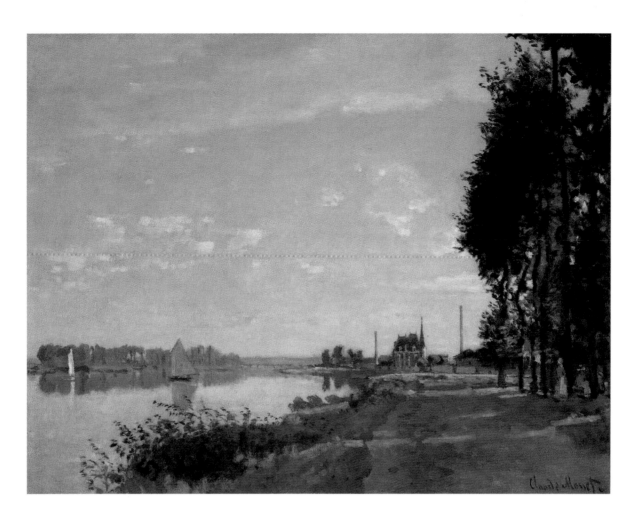

the academies of the Renaissance, painting had to be intellectual; this could surely only be guaranteed by starting from drawing, and not from sensual effects of colour.

This belief found its most resolute apologist at the beginning of the 19th century in the figure of the classical painter Jean Auguste Dominique Ingres. The artistic process was divided into the sketch, representing the first stage, followed by its development in the studio. Essential preconditions included the use of perspective, clear, linear forms and chiaroscuro, namely the modelling of colours with black and white. These were the criteria against which conservative opinion judged Impressionist painting. Criticism focussed not only upon its lack of formal finish, its two-dimensionality, but above all upon its rejection of traditional chiaroscuro in favour of pictorial structure on the basis of colour alone. The Impressionists no longer treated shadows as areas of darkness, but instead combined them with their complementaries in manifold modulations. Although it is not entirely accurate to say that the Impressionists, in particular Monet, abandoned earthy colours and black altogether, it is nevertheless their innovatory use of a light, bright palette which distinguishes their works at the height of the movement. These include the large numbers of boat and regatta paintings which were produced between 1873 and 1875 not only by Monet, but also by Sisley, Renoir and Gustave Caillebotte.

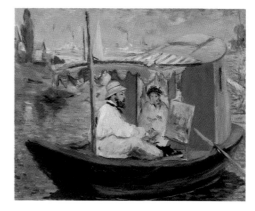

Edouard Manet
Monet Painting in His Boat, 1874
Monet peignant dans son Atelier
Oil on canvas, 82.5 x 100.5 cm
Munich, Neue Pinakothek

Boating, as a means of escaping an increasingly industrialized daily routine, had grown progressively more popular since the beginning of the 19th century. The idea that sporting activity brought refreshment and regeneration was also current, and attracted more and more Parisian city-dwellers, who founded regatta clubs and held competitions in Argenteuil from 1850 onwards. In the seventies, Argenteuil was synonymous with boating. Its contemporaneity and its dominance of Argenteuil life lent this aspect of *modernité* a peculiar fascination for Monet. Many of his motifs were captured directly from a boat which he had bought to work in. 'I painted my first Argenteuil boat scenes from my studio. From there I could see everything happening on the Seine up to about forty or fifty paces away. Then, one day, a good sale unexpectedly left me with enough money to buy a boat and to build on it a wooden cabin with just enough room to set up my easel. The hours I spent with Manet on that little boat were unforgettable. He painted my portrait there, and I painted both him and his wife.' This floating studio, whose inspiration had been Daubigny's 'Botin,' was preserved for posterity by Manet in his *The Rowing Boat* or *Monet with Camille in his Floating Studio* (p. 64).

It was from this boat, anchored not far from the shore of Petit-Gennevilliers near Argenteuil, that Monet painted the *Regatta at Argenteuil* (p. 67). It was purchased by the painter Caillebotte, who settled in the area in around 1880. The houses of

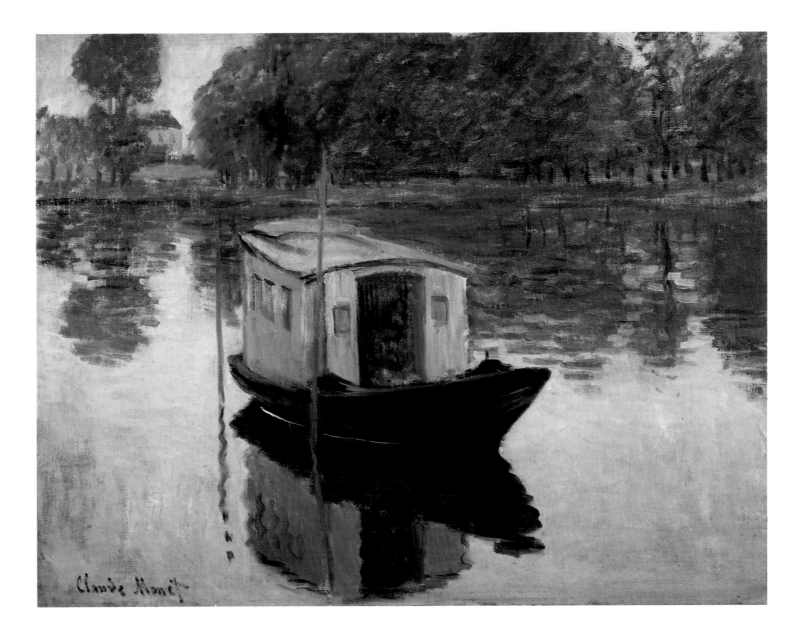

Petit-Gennevilliers are visible on the right. The Argenteuil road bridge can just be made out in the left-hand background. Before it, the sailing boats bobbing on the Seine cast their long, broken shadows across the water in the afternoon sunlight. As in *La Grenouillère* (p. 43), a sense of space is evoked via the different shapes and sizes of the reflections in the water. In both its technique and its combination of reality and reflection, the picture relates directly to its Bougival predecessors. With an extraordinary lightness of touch, the movement of the water and the play of the reflections are brought to life with crude, abstract brush-strokes. From the interplay of pure and broken, cool and warm colours the picture draws tremendous freshness and luminosity. It is one of the most brilliant Impressionist displays of the Argenteuil period.

1872 was a sucessful year for Monet in financial as well as creative terms. Durand-Ruel had purchased on a large scale and friends and collectors had rallied round. Monet's average monthly

The Studio-Boat, 1874
Le Bateau-atelier
Oil on canvas, 50 x 64 cm
Wildenstein I. 323
Otterlo (The Netherlands), State Museum
Kröller-Müller Collection

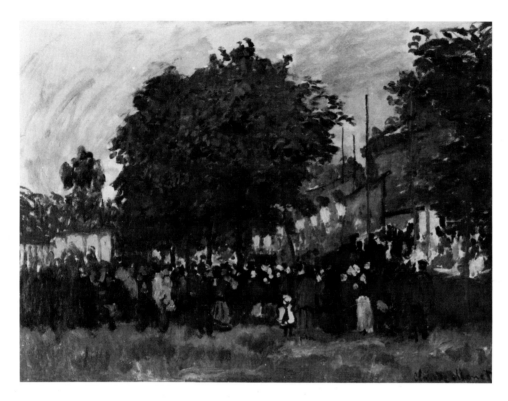

Festival at Argenteuil, 1872
La Fête d'Argenteuil
Oil on canvas, 60 x 81 cm
Wildenstein I. 241
USA, private collection

income rose to over 14,000 Francs, and thus lay considerably above that of a worker, who had to be content with 10,000 Francs at the most. Change in the Argenteuil household was not long in coming. Monet, who valued the comforts of middle-class life, now employed two domestics and a gardener. His pictures from the years between 1872 and 1875 widely reflect the harmonious and carefree atmosphere of the period. But Monet's new-found prosperity was built on unstable foundations. The bank crash of 1873 and the six years of economic crisis which followed left Durand-Ruel in dire financial straits. He was forced to call a temporary halt to all further purchases of Impressionist works in view of his overflowing stock rooms. It seemed sensible to establish new contacts, and Monet now made the acquaintance of art critic and collector Théodore Duret, who had been interested in the new style of independent art since 1870. He now became its vehement champion in his reviews and started deliberately collecting Impressionist works. His book, *The Impressionist Painters*, published in 1878, bears impressive witness to his expertise. In Duret, Monet found a friend who was ready to lend a hand in even the most difficult financial situations. Other Impressionist painters, such as Renoir and Pissarro, were equally grateful for Duret's help.

The profound happiness of these years in Argenteuil radiates

not only from sunlit river landscapes, but also from affectionate portraits of Camille (*Madame Monet in a Red Hood*; p. 68) and the family, as in *The Luncheon* (p. 68/69). *The Luncheon* is one of the few large-format paintings after 1870. The charm of this painting lies above all in the ordinariness and intimacy of the scene. In the garden of the Aubry's house in Argenteuil, Monet's young son Jean appears in the left-hand foreground and Camille in the background. The table which has not yet been cleared away, the hat hanging forgotten from the branches of the tree and the child entirely absorbed in play suggest that the meal has only just finished. The eye is drawn from the shady foreground to the sun-drenched gravel path and flower-beds, whereby the layering of planes creates an impression of depth. Monet's setting recalls the compositions and subjects of the *Intimisme* of Pierre Bonnard and Edouard Vuillard.

In *The Poppy Field at Argenteuil* (p. 70/71), an equally happy and untroubled mood is expressed in the blossoming abundance of a sunlit field of poppies. The figures meandering through this idyllic scene seem to melt into the nature around them, and the weight of the painting lies essentially in the warm, red, almost abstract dabs of paint which make up the poppies, and which stand out against the matt, complementary green of the ground with particular vitality. It is here once more evident that Monet's

Regatta at Argenteuil, 1872
Régates à Argenteuil
Oil on canvas, 48 x 75 cm
Wildenstein I. 233
Paris, Musée d'Orsay

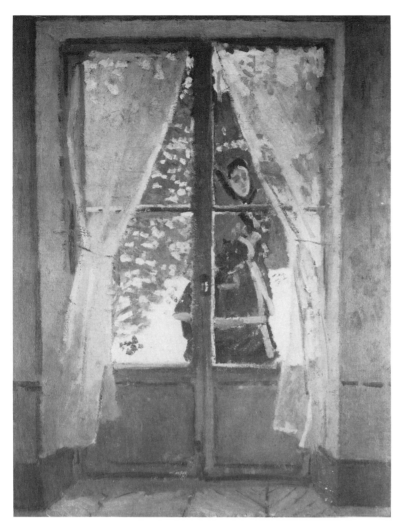

Madame Monet in a Red Hood, 1873
La Capeline rouge, Portrait de Madame
Monet
Oil on canvas, 100 x 80 cm
Wildenstein I. 257
Cleveland (Ohio), Cleveland Museum of
Art, Bequest of Leonard C. Hanna, Jr. 58.39

The Luncheon, 1873
Le Déjeuner
Oil on canvas, 160 x 201 cm
Wildenstein I. 285
Paris, Musée d'Orsay

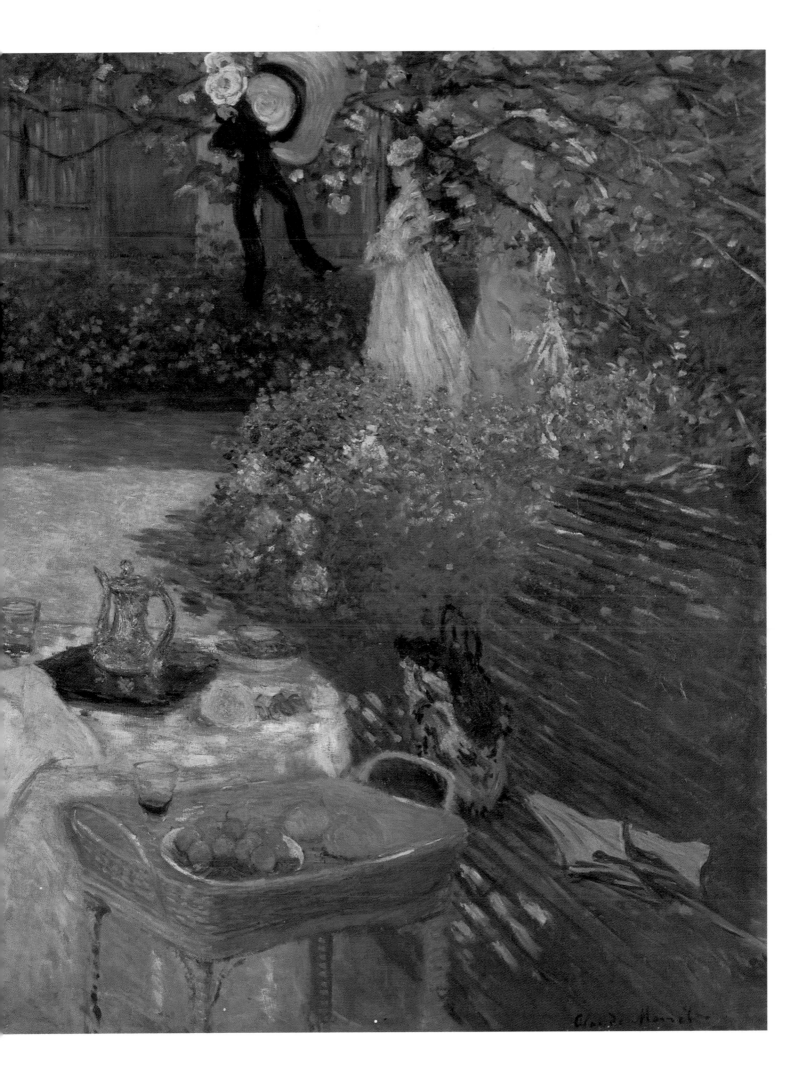

Claude Monet

The Poppy Field at Argenteuil, 1873
Les Coquelicots à Argenteuil
Oil on canvas, 50 x 65 cm
Wildenstein I. 274
Paris, Musée d'Orsay

understanding of the effects of colour arose from an intense observation of nature and was not, as often claimed, a systematic development of 19th-century colour theories. Monet had now disassociated himself from the Salon and in 1873, as in 1872, submitted no pictures. Manet was the only one of the independent painters to be accepted by the Jury that year. Although his *Le Bon Bock* (1873; Philadelphia, Philadelphia Museum of Art) was a great Salon success, his colleagues criticized its Old Master style. It was a clear demonstration of how far one had to bow to official taste to get accepted by the Salon. It was a compromise which Monet and his friends were no longer willing to accept.

The number of refusals was enormous, with the rejections extending to conventional painters as well as to the independent artists such as Renoir, Sisley, Pissarro, Jongkind and Daubigny. In order to silence the subsequent noisy protests, it was decided to hold another Salon des Refusés similar to that of 1863. This exhibition was held in a makeshift wooden shed behind the Palais de l'Industrie, and included such a quantity of mediocre works

Monet's Garden at Argenteuil (Dahlias), 1873
Le Jardin de Monet à Argenteuil (Les Dahlias)
Oil on canvas, 61 x 82 cm
Wildenstein I. 286
Private collection

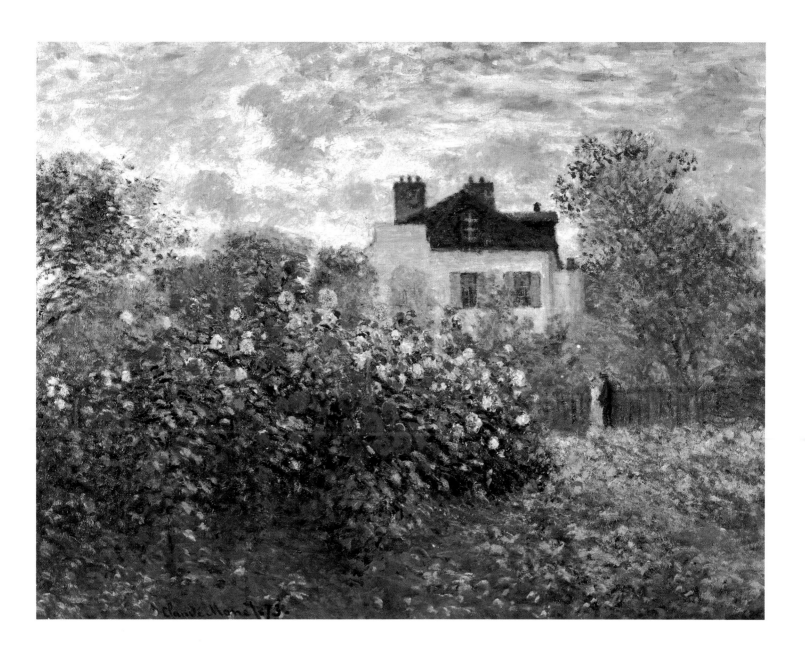

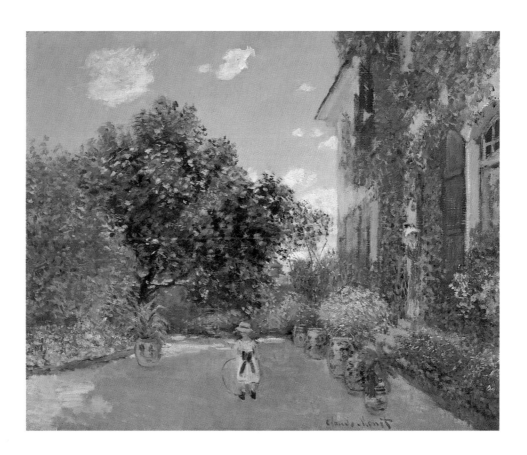

Monet's House at Argenteuil, 1873
La Maison de l'artiste à Argenteuil
Oil on canvas, 60.2 x 73.3 cm
Wildenstein I. 284
Chicago, The Art Institute of Chicago,
Mr. und Mrs. Martin A. Ryerson Collection, 1933.1153

that the criticism and judgement of the Salon Jury seemed in every way justified. The results of the show were correspondingly disappointing. This sparked off a new round of discussions among the group of independent painters around Monet on the possibility of organizing their own, independent exhibiting society. The idea was not new. It had been mooted by Bazille in 1867 and had been the regular subject of debate among the Batignolles group since 1870. Since the members of this group had meanwhile reached a certain artistic maturity, and since the poor economic situation meant Durand-Ruel was purchasing fewer works, it finally seemed time to take action. Moreover, it would be a chance to show the public more than just the Salon quota of two works per artist.

The birth of the society was accompanied by endless bickering. Monet wanted to include just a few members who would offer an initial definition of aims. Degas, on the other hand, insisted upon involving a large number of artists to avoid a small group of radicals alienating the public. The first collective exhibition was also to be opened *before* the Salon to ensure it would not be mistaken for another Salon des Refusés. Manet, not wishing to jeopardize his success in the Salon, refused to participate. Courbet was already in exile in Switzerland and Jongkind was too deeply wrapped up in personal problems to take part. The 'Société anonyme coopérative d'artistes peintres, sculpteurs, graveurs' ('Anonymous co-operative artists' society of painters, sculptors and engravers') was founded on 23 December 1873. Monet spent the winter months and the period up to the first exhibition in, among other places, Le Havre and Amsterdam.

Still Life with Melon, 1872
Nature morte au melon
Oil on canvas, 53 x 73 cm
Wildenstein I. 245
Lisbon, Fundação Calouste Gulbenkian
Museum

By 15 April 1874, everything was ready. Works by a total of thirty independent artists filled the eight rooms of the photographer Nadar on the Boulevard des Capucines. In addition to many, today unfairly forgotten artists, the exhibitors included Monet, Boudin, Cézanne, Degas, Pissarro, Renoir, Sisley, Gautier, Berthe Morisot and Félix Bracquemond. The exhibition lasted for a month, until 15 May. Its catalogue was designed by Edmond Renoir, journalist brother of the painter. Monet showed nine pictures; in addition to three pastels and a view of the port of Le Havre, he exhibited *The Poppy Field at Argenteuil* (p. 70/71), *The Boulevard des Capucines* (p. 56) and *Impression, Sunrise* (p. 77). The 3500 visitors who attended were, like the conservative press, vociferous in their ridicule and mockery. Enthusiastic voices were heard chiefly among the artists' circle of friends.

A review by writer-cum-landscape painter Louis Leroy has since become particularly famous. Writing in the satirical magazine *Charivari* on 25 April 1874, he composed a fictitious conversation between two visitors under the heading 'Exhibition of Impressionists': 'My goodness, what a tiring day that was when I braved the first exhibition on the Boulevard des Capucines . . .in the company of the landscape painter Joseph Vincent. He went along without the slightest inkling of trouble. He was expecting to find good and bad painting, and probably more bad than good, but certainly not such violations of art, the Old Masters and form. Huh, form and Old Masters indeed! They've had their day, my dear chap. We've made sure of that! . . .It was left up to Monet to deal him the final blow. "Ah, there he is," he muttered in front of picture no. 98. "Unmistakeable, the darling of papa

Vincent! But what is it? Have a look in the catalogue." "Impression, Sunrise," said I. "Impression, I knew it; after all, I'm impressed, so it must be an impression . . .What freedom! What ease of craftsmanship! Wallpaper in its original state is more finished than this seascape!"' The title of Monet's painting in Renoir's catalogue was soon to give the group its name. Later – after the Impressionist style had won general recognition – Leroy was to boast that it was he who had first christened the movement.

Impression, Sunrise (p. 77) was painted from a hotel window during Monet's stay in Le Havre in 1873. Out of a blue-grey and orange-coloured mist, the skeletal outlines of the docking facilities emerge in the background. The light of the rising sun, an orange ball on the horizon, is reflected in the water and magically transforms the austere harbour setting into a unique, ephemeral ap-

Jean Monet on His Mechanical Horse, 1872
Jean Monet sur son cheval mécanique
Oil on canvas, 59 x 73 cm
Wildenstein I. 238
USA, private collection

parition. The watchers of this natural drama are shadowy figures in dark boats, silhouetted against the background. The painting is kept entirely two-dimensional; spatial depth is suggested solely by the diagonal row of small boats which draw the eye to the centre of the picture. The treatment of objects, reduced to just a few strokes of the brush, is extraordinarily free. In view of the subject – a rapidly-changing natural spectacle and the mood it invokes –, details appear out of place. It is a question of overall impression. At some points the wash is so thin as to reveal the canvas beneath; impasto is used only for the reflection of the orange sunlight.

In comparison to the *Regatta at Argenteuil* (p. 67), there is nothing actually revolutionary about this picture. It reveals relatively little of the new interpretation of light and open air which was to make the new movement so famous and is thus somewhat untypical of the Argenteuil period. The work is tonally very restricted and looks back both to the tradition of Turner and the watercolours of Jongkind. It nevertheless features the reflections in water which numbered among Monet's favourite Argenteuil themes.

In comparison with the subjects – often far removed from reality – treated by conventional painting, the works in the exhibition were criticized for the ordinariness, not to say banality of their themes. Above all, however, it was the technique of these relatively small-format pictures which attracted attention. They were considered sketchy in their execution. Criticism was repeatedly aimed at their planarity and abstractive, free treatment of objects, more at their rejection of chiaroscuro modelling than at their often unusually stong and bright colouring. As we have seen, the work of the Impressionists was thought to display the properties of the sketch, merely the first step towards the finished

Boats: Regatta at Argenteuil, 1874
Les Barques, régates à Argenteuil
Oil on canvas, 60 x 100 cm
Wildenstein I. 339
Paris, Musée d'Orsay

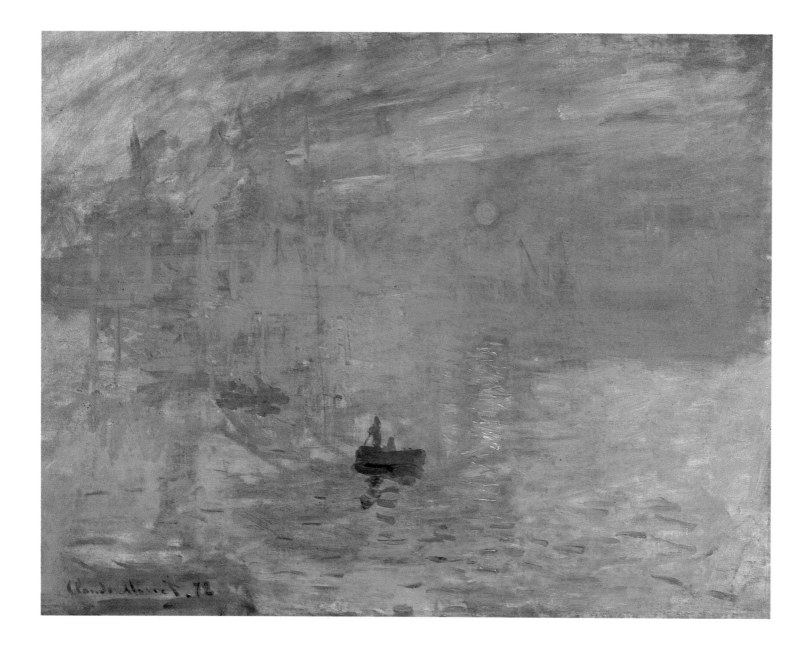

painting. In these works, the sketching process remained visible, with even the canvas ground appearing in places, while the brush was applied in rough combinations which merely suggested their subject. As a result, the surface of the picture distracted the interest of the viewer away from the actual subject. Colour dominated, and chiaroscuro modelling in the traditional sense was no more.

The palette employed in these pictures was bright and clear, and since bright light was associated with natural outdoor light, a 'school of bright and clear colours' was the inevitable consequence. Brightness and clarity were hereby achieved through pure, powerful colour contrasts and a light, hue-in-hue style of painting, with colours divided and applied separately in dots, dashes and dabs. It was only logical that light-coloured grounds should be preferred, although these were not – as frequently claimed – universally white. These paintings also lacked emphatic outlines. Open contours and related chromatic values were used

Impression, Sunrise, 1873
Impression, soleil levant
Oil on canvas, 48 x 63 cm
Wildenstein I. 263
Paris, Musée Marmottan

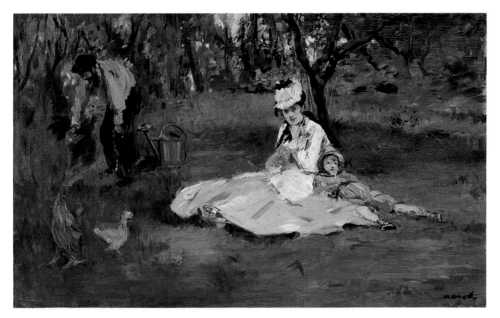

Edouard Manet
The Monet Family in Their Garden, 1874
La Famille Monet au Jardin
Oil on canvas, 61 x 99.7 cm
New York, Metropolitan Museum of Art,
Bequest of Joan Whiney Payson, 1975
(1976.201.14)

for figure and ground. Form was now invoked through the interplay of colour, as seen in the pictures from Argenteuil. In consequence, the sensual nature of objects grew while their compositional significance diminished. Space was suggested rather than created through illusionistic means of linear perspective. Experiments were made with the abbreviation of objects in the background and the use of high horizons.

This definition of Impressionist style is essentially valid for a group of artists briefly sharing the same philosophy between 1873 and 1875. During this period Renoir, Sisley, Caillebotte and Manet all came to Argenteuil and for a while worked before the same motif. Argenteuil correspondingly marks the height of Impressionism. But the aims of the individuals within this group were to prove too various, for while Monet, Sisley and Pissarro had devoted themselves to landscape painting, Degas and Renoir were particularly interested – albeit each from an entirely different angle – in the human figure. At least two groups can be identified within the new movement: the colourists and landscape artists such as Monet, and the circle around Degas. When the Salon opened fifteen days later, however, it declared war on the movement as a whole.

The financial outcome of the first Impressionist exhibition was discouraging; in December of the same year, members learned they each owed the Society an outstanding 184 Francs. It was unwelcome news to Monet, whose 1874 income had already fallen, due to poor sales, to a level well below that of the previous year. All the more vigorous, then, were his efforts to attract new collectors. These included both the well-known opera singer Jean-Baptiste Faure and the wealthy businessman Ernest Hoschedé. Hoschedé was a cloth dealer who had made his fortune by marrying lady-of-means Alice Raingo and who owned profitable department stores in Paris. In January 1874, more for speculative

Camille Monet with a Child in the Garden, 1875
Camille Monet et un enfant au jardin
Oil on canvas, 55 x 66 cm
Wildenstein I. 382
Boston, private collection

than financial reasons, he anonymously sold 13 of his pictures by independent painters at the Hôtel Drouot auction rooms. In the hope of repeating the success of this sale, he went on to build up a considerable collection of Impressionist works over the next few years.

The summer months of 1874 number among the least troubled and most creative phases of the Argenteuil period. Renoir was a guest of the Monets and, as earlier in Bougival, the two artists worked in front of the same motif. Renoir thereby assimilated something of Monet's style in the greater fragmentation of his brush-strokes. A comparison of Monet's *Boaters at Argenteuil* (1874; private collection) and Renoir's *Seine at Argenteuil* (1874; Portland, Art Museum) makes this particularly clear. The pair were joined by Manet, who was spending the summer at his family home in Petit-Gennevilliers, not far from Argenteuil. This period saw the production of Manet's most Impressionist works – summery scenes flooded with light in lively colours. Monet's floating studio (p. 64) was just one of his many boat subjects. Confronted by this picture at the Salon of 1875, the otherwise well-meaning art critic Zola accused Manet of a formlessness similar to that characterizing Monet's work.

The carefree holiday mood is also captured in the identical views of Monet's garden in Argenteuil addressed by all three artists. Monet later owned Renoir's *Camille Monet and Jean in the Garden at Argenteuil* (1874; Washington, National Gallery of Art) and recalled the hours they spent working side by side: 'The exquisite picture by Renoir which is now in my possession shows my first wife. It was painted in our garden in Argenteuil. One day, excited by the colours and the light, Manet started an open-air study of figures under trees. While he was working, Renoir came along. He, too, was captivated by the mood of the moment. He asked me for palette, brush and canvas, sat down next to Manet and started painting. The latter watched him out of the corner of his eye and now and again went over to have a closer look at his canvas. Then he grimaced, tiptoed over to me and whispered: "The lad has no talent! Since you're his friend, tell him he might as well give up."' This remark was perhaps not purely ironic and indicates Manet's reservations towards the Impressionist movement.

In the summer of 1874, in addition to boat and regatta paintings, Monet returned to the bridge paintings which he had first treated in 1873 and which form their own group within his Argenteuil works. Argenteuil had two bridges crossing the Seine: an old wooden bridge on stone piers for pedestrians and road traffic (*The Seine Bridge at Argenteuil*, p. 82) and *The Railway Bridge, Argenteuil* (p. 83) built of concrete and steel. Steel was then still a very novel building material and stood for modern, contemporary architecture. Bridges were a traditional symbol of the link between man and nature and had fascinated Monet earlier in London and

Holland. But the railway bridge, as a symbol of the technical achievements of the age, had a particular aesthetic which appealed both to Monet and other of his Impressionist colleagues.

Monet exploited the clear architectural shapes of these bridges to introduce geometric structure into his pictures. *The Seine Bridge at Argenteuil* (p. 82), which shows the road bridge as painted from Monet's floating studio, displays an almost classical clarity in its pictorial composition. In this cropped view of the bridge, two piers demarcate the right- and left-hand edges of the picture. These verticals find their compositional counterweights in the masts of the boats bobbing in the foreground, whose diagonal positioning creates an impression of depth despite an absolutely two-dimensional water surface. The central arch of the bridge is echoed in the curving silhouette of the hill on the far side of the river. This and the high horizon ensure a spatial continuum of foreground, middle distance and background, despite Monet's rejection of traditional perspective design.

The accusation levelled at Monet's work by formalist-idealists from the world of abstract art, namely that it is 'determined by chance', that it is purely 'eye' and thus perforce neglects the rational element, is here clearly shown to be invalid. It is an accusation based upon the 19th-century belief that perception and 'pure' seeing were two separate things, a distinction which has since been refuted by modern perceptual psychology. There is no perception independent of experience values, no 'pure' seeing. Numerous pencil drawings from Monet's sketchbooks, today in the collection of the Musée Marmottan in Paris, reveal the pictorial logic behind Monet's selection and rejection of motifs. The execution of *The Seine Bridge at Argenteuil* is itself extremely sketch-like, and only makes descriptive use of more detailed and dense brushwork in those areas where the movements of water and light reflections are to be brought alive.

This is equally clear in *The Railway Bridge, Argenteuil* (p. 83). *The Seine Bridge at Argenteuil* (p. 82) recalls Japanese woodcuts of similar themes both in its cropping and overlapping, as seen in the boats in the left-hand foreground, and in the graphic dominance of the bridge architecture. Here, too, bridge structures are employed to introduce space into absolutely two-dimensional compositions.

The break with traditional ways of seeing which they discovered in the colourful Japanese prints (Ukiyo-e) of Ando Hiroshige, Katsushika Hokusai, Kitagawa Utamaro and others encouraged the Impressionist artists in their own experiments. The Japanese prints employed bright colours often far removed from reality, and sought to layer colour planes in order to create a new type of space. The independent artists enthused about their two-dimensionality and renunciation of modelling, their bold views and cropped compositions, their everyday themes and the concept of executing a series of the same motif, innovations which this art

The Road Bridge, Argenteuil, 1874
Le Pont routier, Argenteuil
Oil on canvas, 60 x 79.7 cm
Wildenstein I. 312
Washington (D.C.), National Gallery of Art, Mr. and Mrs. Paul Mellon Collection

The Bridge at Argenteuil, 1874
Le Pont d'Argenteuil
Oil on canvas, 60 x 80 cm
Wildenstein I. 311
Paris, Musée d'Orsay

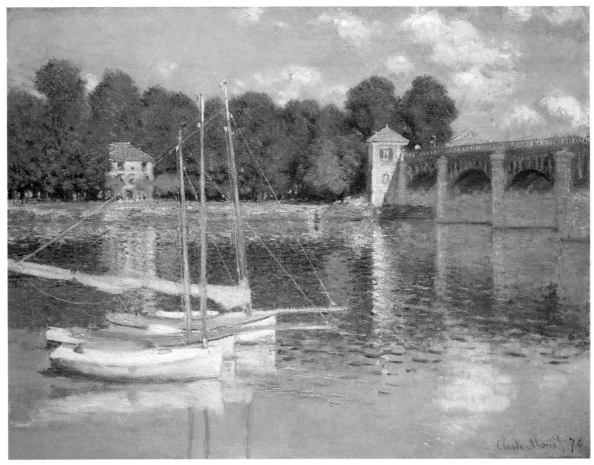

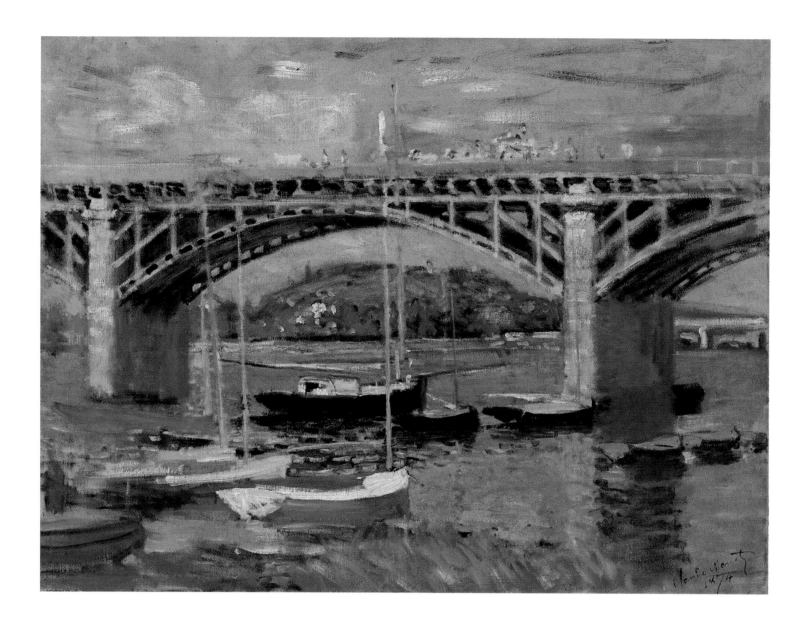

The Seine Bridge at Argenteuil, 1874
Le Pont d'Argenteuil
Oil on canvas, 60 x 81.3 cm
Wildenstein I. 313
Munich, Neue Pinakothek

brought alive and which was so close to their own intentions. The Japanese woodcut is thus directly related to the development of the Impressionists' new style of painting.

It was not until the 1850's, when Japan finally opened its borders to international trade, that Europe began to enjoy wider exposure to Japanese culture. 'La Porte chinoise,' which sold Japanese prints and handicrafts, opened in 1862 in the Rue de Rivoli in Paris. Frequent visitors included both avant-garde painters such as Monet, Manet, Degas, Whistler and Fantin-Latour and literary figures such as Baudelaire, Zola and the brothers Edmond and Jules de Goncourt, who not only pursued Japanese themes in their novels, but also furthered the understanding of oriental culture through their monographs on Japanese artists. The World's Fair of 1867 offered a further opportunity to learn about Japan. Artists began collecting Japanese woodcuts and, in a mood of decorative exoticism, surrounded themselves with kimonos, fans, ceramics and screens with Japanese motifs. Leaving aside for a moment his artistic debt to Japanese art, Monet's confrontation with Japan was to result in the construction of a Japanese garden

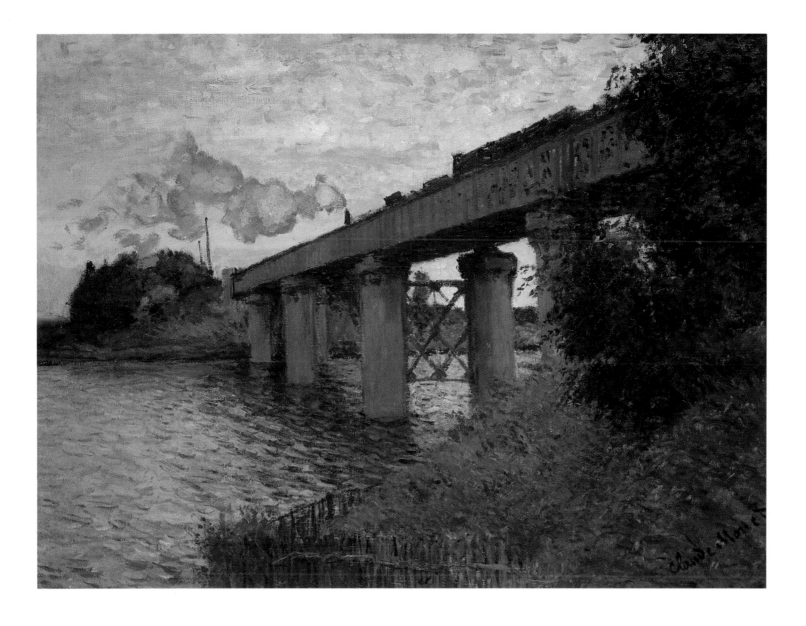

in Giverny as well as in the comprehensive collection of Japanese colour prints which can be admired in Giverny today.

With not uncharacteristic exaggeration, Monet claimed to have seen and bought his first Japanese prints in 1856, when he was 16 years old. Here, as elsewhere, events are backdated to fit the picture the artist wishes to create. Monet is unlikely to have discovered and acquired such woodcuts before 1862, however, and probably only did so in 1871 in Zaandam. Here he had the opportunity to purchase a whole packet of such prints at an extremely cheap price from a porcelain dealer who – clearly ignorant of their value – was using them to wrap china.

In *La Japonaise* (p. 86), Monet makes direct reference to the Japonism of the day. The composition bears eloquent witness to his love of Japanese objects and arrangements. Although figural themes played an ever-decreasing role in his work over the seventies, they survived in individual paintings executed above all with exhibitions in mind. In a clear departure from the natural subjects that Monet usually chose, everything here appears artificial and contrived. A boldly-patterned carpet covers the floor,

The Railway Bridge, Argenteuil, 1873
Le Pont du chemin de fer, Argenteuil
Oil on canvas, 54 x 71 cm
Wildenstein I. 319
Paris, Musée d'Orsay

Snow at Argenteuil, 1874
Neige à Argenteuil
Oil on canvas, 54.6 x 73.8 cm
Wildenstein I. 348
Boston, Museum of Fine Arts, Bequest of
Anna Perkins Rogers
Courtesy, Museum of Fine Arts, Boston

ABOVE RIGHT:
*The Boulevard de Pontoise at Argenteuil,
Snow*, 1875
Le Boulevard de Pontoise à Argenteuil.
Neige
Oil on canvas, 60 x 81 cm
Wildenstein I. 359
Basle, Öffentliche Kunstsammlung Basel,
Kunstmuseum

BELOW RIGHT:
The Train in the Snow, 1875
Le Train dans la neige. La Locomotive
Oil on canvas, 59 x 78 cm
Wildenstein I. 356
Paris, Musée Marmottan

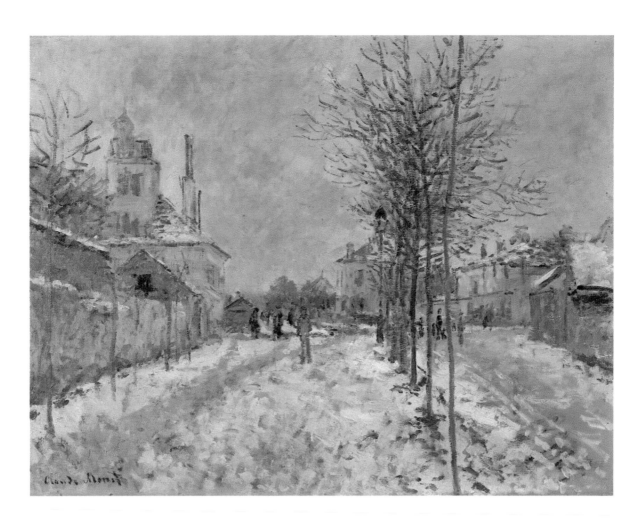

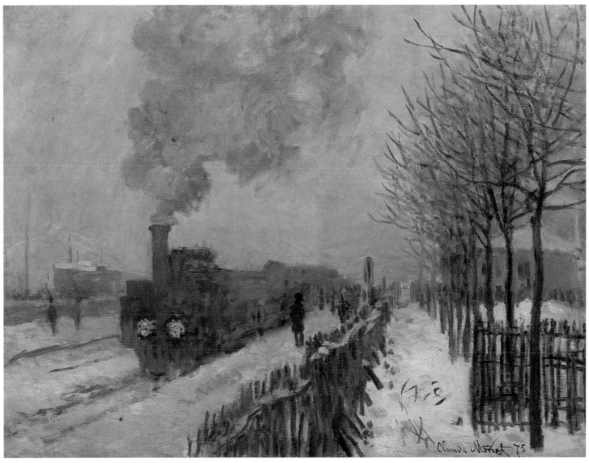

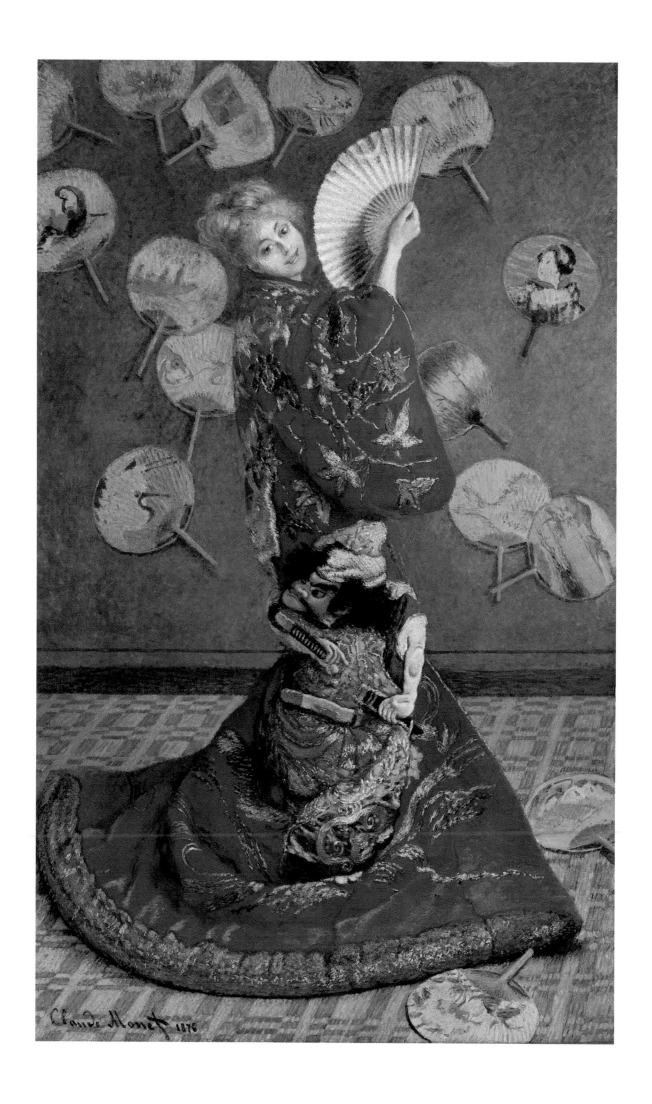

The Chrysanthemums, 1878
Les Chrysanthèmes
Oil on canvas, 54 x 65 cm
Wildenstein I. 492
Paris, Musée d'Orsay

La Japonaise, 1875
Oil on canvas, 231 x 142 cm
Wildenstein I. 387
Boston, Museum of Fine Arts, Purchase
Fund 1951
Courtesy, Museum of Fine Arts, Boston

while the fans decorating the rear wall appear to float in mid-air. Equally theatrical is the pose adopted by Camille, who is wearing a blond wig and a heavily-embroidered, richly-coloured robe whose Japanese motifs appear to stand out with almost three-dimensional plasticity. Here Monet not only borrows from the figure painting of Manet, Renoir and Whistler, but also refers back to *The Woman in the Green Dress* (p. 22), the painting which had been such a Salon success. Monet subsequently distanced himself from this work for its concessions to the public taste of its time; it nevertheless proved a great success in the second Impressionist exhibition of 1876 and was sold for 2000 Francs.

Financial pressures resulting from the first Impressionist exhibition forced Monet, Renoir, Sisley and Morisot to auction a large number of paintings in the Hôtel Drouot in March 1875. Despite a favourable reception by influential critics such as Philippe Burty, the sale was a disaster. The prices obtained were ridiculously low and many of the public simply laughed or even protested as the works were brought out. The voices of the few serious collectors such as Henri Rouart and Georges Charpentier were thereby drowned. Charpentier's encounter with Impressionist art nevertheless proved significant for the later history of the movement. At the auction he acquired a painting by Renoir, who subsequently introduced him to Monet, Pissarro and Sisley. He now not only collected their works but also, as publisher of the magazine *La Vie Moderne* which he founded in 1879, helped support and promote their art. Edmond Renoir later became director of the gallery which the magazine also owned, and which

The Tuileries, 1876
Les Tuileries
Oil on canvas, 54 x 73 cm
Wildenstein I. 401
Paris, Musée Marmottan

housed the earliest one-man Impressionist exhibitions. Monet's
financial situation grew steadily worse. In desperation, he ap-
proached friends and collectors for money; Manet in particular
helped him by buying his paintings. A meeting with Victor Choc-
quet, arranged by Cézanne, brought a further glimmer of hope.
Chocquet was an official in the Customs Service who was inter-
ested in art and had attended the auction in the Hôtel Drouot.
In February 1876, accompanied by Cézanne, he visited Monet in
his new home in the Rue Saint-Denis in Argenteuil, where he
purchased two works. Following his death in 1879, Chocquet
bequeathed his wife a sizeable collection of Impressionist works.
He corresponded with Cézanne and Renoir as well as entertaining
them in his Rue de Rivoli apartment. It was from here, in 1876,
that Monet painted *The Tuileries* (p. 88).

It is not difficult to imagine the high hopes that Monet must
have pinned on the second Impressionist exhibition, held at
Durand-Ruel's gallery in April 1876. Although many of the more
conservative participants from the first show had now withdrawn,
the number of exhibitors was still 19. Monet showed 18 works,
half of them loans. This time even the literary press took notice
of the exhibition of 'Intransigeants,' as they called themselves.
The Impressionists were described as a new school working in
the direction of light and truth, who had made fashionable a
remarkably bright spectrum of colours. And even though they
frequently contented themselves with studies and summary
sketches, they were identified as pioneers of a new style of
painting.

Despite selling *La Japonaise* (p. 86) through the exhibition,

The Tuileries (sketch), 1876
Les Tuileries (esquisse)
Oil on canvas, 50 x 75 cm
Wildenstein I. 403
Paris, Musée d'Orsay

Monet's financial worries were still pressing. Among the few collectors still willing to purchase his works in 1876 was the doctor and art lover Georges de Bellio. When it was a question of raising money for the family or of painting materials, he often proved the last hope. As Renoir later recalled: 'Whenever any of us desperately needed 200 Francs, we went to the Café Riche at lunchtime. There we would be sure to find Monsieur de Bellio, who would buy the pictures we took along without even looking at them.' Caillebotte, whom Renoir had invited to participate in the second Impressionist exhibition and who lived not far from Monet in neighbouring Gennevilliers, was also wealthy enough to prop up his less fortunate colleagues, in particular Monet, through occasional purchases. Caillebotte's own painting was less independent and oriented itself towards the realism of Duranty.

Now famous dates in the Impressionist diary were the free dinners on the first Wednesday of the month, given by Eugène Murer and attended by Monet, Renoir, Sisley and for a while Cézanne, as well as by collectors and admirers of Impressionist art. Murer was a pâtissier, restaurateur, author and self-taught painter. He had been interested in Impressionism since the early seventies and used all the means available to him to support its artists. It was in this context that he organized, among other things, a lottery whose first prize was a picture by Renoir. The eventual winner, a simple servant-girl from the local neighbourhood, chose a cake instead. There could hardly be a better illustration of the general estimation in which Impressionist works were held.

Gladioli, c.1876
Les Glaïeuls
Oil on canvas, 60 x 81 cm
Wildenstein IV. 414
Detroit, The Detroit Institute of Arts, pur-
chased by the City of Detroit 21.71

The Turkeys, 1876
Les Dindons
Oil on canvas, 174.5 x 172.5 cm
Wildenstein I. 416
Paris, Musée d'Orsay

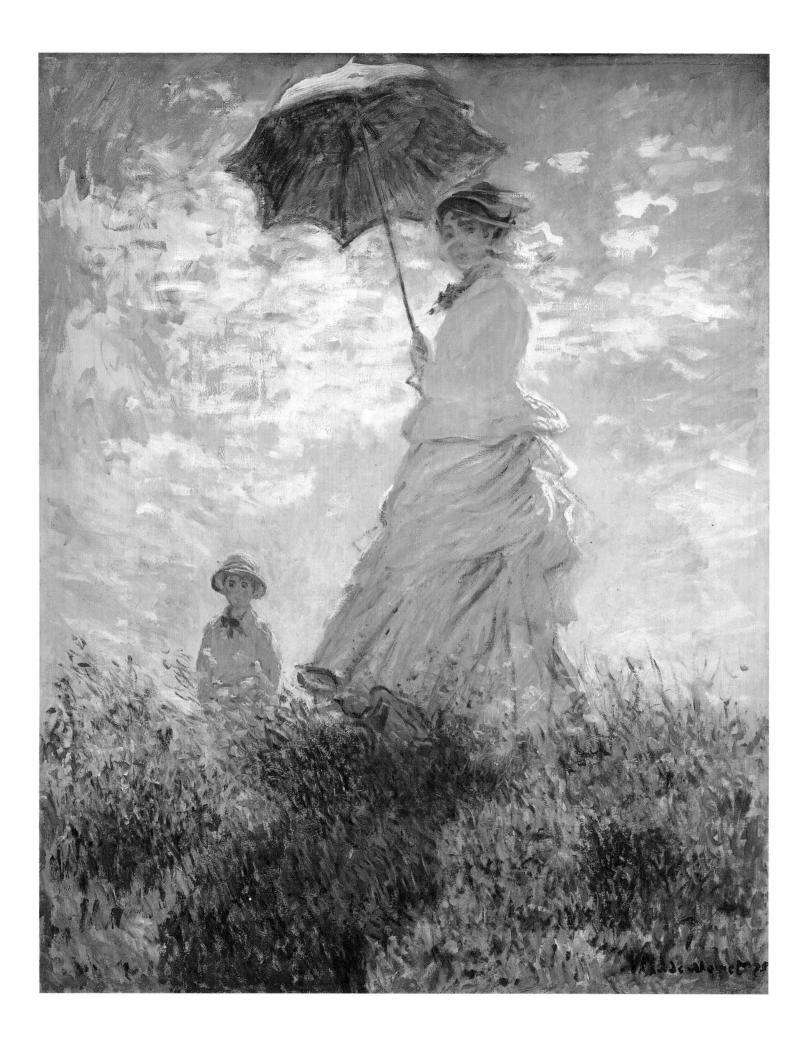

In autumn 1876 Monet was invited to join Hoschedé and his wife Alice at their Montgeron estate, the Château de Rottenbourg, where Monet was given his own studio in the park. Manet and his wife had already spent the summer here. Monet was commissioned to paint four decorative panels for the château interior, taking motifs from the local surroundings – *The Turkeys* (ill., p. 91), *Corner of the Garden at Montgeron* (Leningrad, Eremitage), *The Pond at Montgeron* (Leningrad, Eremitage) and *The Hunt* (France, private collection). While Camille and Jean remained behind in Argenteuil and Hoschedé pursued his – now troubled – business in Paris, Monet spent the autumn with Alice and her six children in Rottenbourg. It is sometimes assumed that the affair between Alice and Monet began here, but it was not until much later that she officially became his mistress and wife. The two couples developed a close friendship which went far beyond

Detail from illustration opposite

Woman with a Parasol – Madame Monet and Her Son, 1875
La Promenade. La Femme à l'ombrelle
Oil on canvas, 100 x 81 cm
Wildenstein I. 381
Washington (D.C.), National Gallery of Art, Mr. and Mrs. Paul Mellon Collection

The Gare Saint-Lazare, 1877
La Gare Saint-Lazare
Oil on canvas, 75 x 100 cm
Wildenstein I. 438
Paris, Musée d'Orsay

their dinners together in Paris in the winter of 1876/77. Such dinners and invitations not only enabled Monet to better survive hard times, but also led him to spend more time in Paris, where he kept a studio even after moving to Argenteuil.

Argenteuil could no longer offer him any truly new motifs. In the capital, on the other hand, he found a new and fascinating subject in the carriages and steam-engines of the Gare Saint-Lazare. Monet knew the station as the terminus both for Argenteuil and for westbound trains to Le Havre. In January 1877 he rented accommodation in the nearby Rue de Moncey. Renoir later recounted to his son Jean how one day Monet had announced his audacious plan to paint the station. Monet wanted to capture the play of sunlight on the almost impenetrable clouds of steam produced as the trains pulled out. He therefore decided to have the Rouen train delayed half an hour on the grounds that the light would be better then that at its scheduled time of departure. An unshakeably self-confident Monet paid a call on the director of the railway company and 'got everything he wanted. Trains were stopped, platforms cordoned off and the engines fully stoked so that they could belch out as much steam as Monet wanted.'

Trains and stations were outstanding symbols of the modernity which the Impressionists claimed as their own. In his *Railway* (Washington, National Gallery of Art) Manet had made a pictorial subject of these wonders of industrialization in as early as 1854. The Impressionist painters wrested from these scenes of smoke and steel their own poetry, whereby Monet's emphasis lay above all on the appearance of the industrial construction under different lighting. The human figure was thereby assigned a schematic

The Gare Saint-Lazare: the Normandy Train, 1877
La Gare Saint-Lazare. Le train de Normandie
Oil on canvas, 59.6 x 80.2 cm
Wildenstein I. 440
Chicago, The Art Institute of Chicago, Mr.und Mrs. Martin A. Ryerson Collection, 1933.1158

background role. The constantly-changing effects of smoke and steam in a railway context had already inspired Turner to paint his famous *Rain, Steam and Speed* (1844; London, National Gallery).

In the second half of the 19th century the railway – with its previously unknown speed – had brought with it an entirely new form of perception. Objects viewed while rapidly traversing the landscape appeared to melt, and nature itself to be in motion. This experience produced fear and insecurity among contemporary travellers. The scenes which unfolded from a fast-moving train were now mere panoramas and 'rapid sequences . . . It [the train] only shows you the essence of a landscape . . . Do not ask it to give you details, but simply the whole,' was the typical reaction of one passenger, Jules Claretie, in 1865. The train, offering fast and comfortable access in place of long journeys by carriage and cart, brought a different concept of distance; real geographical distance shrank in the mind and could no longer be directly experienced. The industrial innovation to which our own perception has long been accustomed, and whose implications of boundlessness and the rapid accessibility of even the remotest locations are today commonly accepted, thus led to a revision of the space/time concept. The rejection of conventional space by Impressionist painting was now seen to match these new developments; it, too, replaced three-dimensional perspective depth with an open, planar linking of objects which incorporated the moment of motion. By making the reflection of reality their basis, Impressionist works could thus claim to be the last word in modernity, the definitive expression of their times.

In *The Gare Saint-Lazare* (p. 94), the rigid glass-and-steel frame of the hall is filled with light and dark clouds of steam, some conjoined with almost corporeal solidity, others disintegrating into vaporous wisps. In the background, the Pont de l'Europe viaduct and neighbouring houses emerge from the blue-grey mist as if freed of solid architectural form. Within this all-blurring, all-permeating atmosphere, the girders of the vaulted hall and the suggested presence of the tracks offer orientation and stability. An important role is here given to the atmospheric cloak which envelops all parts of reality and the picture and robs them of their distinguishing, distinctive features, rendering them anonymously equal. The scenes of steam, fog, rain and snow which for a while numbered among Monet's favourite themes offered him ideal opportunities to explore such effects. While human figures in these pictures are reduced to mere silhouettes, the vibrant black colossus of the engine advances puffing and panting into the station. But what may perhaps appear an apotheosis of technology is in essence an exploration of atmospheric changes in exactly the same terms as Monet's motifs from nature. The Saint-Lazare railway station thus shows not only the modern Parisian metropolis, but also its vitality, rhythm and atmosphere.

The total of twelve surviving paintings of the Gare Saint-Lazare can be subdivided by location. One group shows a view of a train pulling into the station itself, as in *The Gare Saint-Lazare* (p. 94) and *The Gare Saint-Lazare: the Normandy Train* (p. 95); another group shows the area outside the station, as in *The Pont de l'Europe* (p. 97). The numerous preparatory drawings which accompany these paintings indicate, however, that Monet was unable to complete his work directly in front of the motif as originally planned – no doubt because of the volume of traffic. This was one of the reasons for his renting a studio nearby.

The Gare Saint-Lazare pictures are forerunners of Monet's later serial painting, in which he painted the same motif from an almost identical angle under different lights and at changing times of day. They refine the method of expressing immediacy developed in *The Quai du Louvre* (p. 34) and *The Boulevard des Capucines* (p. 56), where Monet had also worked simultaneously on two views of the same motif under different lighting conditions. The series suggested in the Gare Saint-Lazare paintings came to dominate Monet's work from the eighties onwards, and was to take him beyond even the Impressionist way of seeing.

Degas had already employed the series as a means of better rendering the phenomena of nature and thus reality itself. For the Impressionist painters and (from 1867 onwards) for Degas' *Dancers,* inspiration for serial painting was provided by contemporary photography, such as the pictures taken by Desideri showing dancers in a variety of poses. Their familiarity with Japanese woodcuts, such as Hokusai's *One Hundred Views of Mount Fuji,* played a similarly important role. The concept of the series thus

Unloading Coal, 1875
Les Déchargeurs de Charbon
Oil on canvas, 55 x 66 cm
Wildenstein I. 364
Private collection

does not mean schematic reproduction with systematic variation. Serial painting offered an opportunity to capture an impression of the fleetingness of a given moment as well as the permanence and characteristic features of a landscape.

At the third Impressionist exhibition, opened in the Rue Le Peletier on 4 April 1877 under the title 'Exhibition of Impressionists,' Monet showed seven of his Gare Saint-Lazare paintings as a self-contained unit. The short-lived journal 'L'Impressioniste' was published to coincide with the exhibition, and was specially devoted to the 18 painters on display. The magazine was produced by Georges Rivière, a close friend of Renoir, whose reaction to Monet's 30 exhibits, and in particular his Gare Saint-Lazare paintings, was one of rapturous praise. The exhibition was nevertheless a financial failure for Monet, and in the course of the autumn and winter his economic situation grew increasingly desperate. Hoschedé's own approaching bankruptcy meant that

The Pont de l'Europe, 1877
Le Pont de l'Europe, Gare Saint-Lazare
Oil on canvas, 64 x 81 cm
Wildenstein I. 442
Paris, Musée Marmottan

he was no longer in a position to support the artist as generously as before. In June 1878 the Hoschedé collection was put up for compulsory auction. This was a catastophe for the Impressionists since it caused prices for their works to plummet.

Monet – when he found a buyer at all – was forced to sell his works at a knock-down price, as revealed by a fresh round of begging letters to Caillebotte and Chocquet. The situation was not helped by Monet's lifestyle in Argenteuil; for a while he was employing two domestic helps and a gardener, although these were still claiming outstanding wages many years later. Nor was Monet at any stage willing to give up his worldly pleasures. Tobacco and wine always had to be available in plentiful quantities. Another worry which weighed heavily upon him, however, was the impaired state of Camille's health. It is thus not surprising that only four pictures survive from the nine months following his return from Paris after completing the Gare Saint-Lazare paintings. In addition to the money worries underlying this artistically lean period, Monet may have found Argenteuil's motifs less motivating than those of Paris. Was Monet becoming aware of the impossibility of harmoniously combining growing industrialization and unspoilt nature, and did Argenteuil thus become an irredeemable myth? Paintings such as *Unloading Coal* (p. 96) are just as revealing as his noticeable retreat into the garden at Argenteuil (*Camille Monet with a Child in the Garden*; p. 79), into the Parisian parks (*Parisians Enjoying the Parc Monceau*; p. 98) and into the remote surroundings of the Petit Bras arm of the Seine.

By October 1877 Monet had already moved back to Paris, where he took a spacious apartment at 26, Rue d'Edinbourgh near Parc Monceau, not far from the Pont de l'Europe. Monet's second son, Michel, was born here on 17 March 1878. Camille was never to recover from his birth, her health deteriorating from this point on. In addition to pictures of parks (*Parisians Enjoying the Parc Monceau*) and views of the excursion island of La Grande Jatte, Monet returned to Parisian street scenes such as the two almost identical versions of *The Rue Saint-Denis on 30 June 1878* (p. 101). The World's Fair which opened on 1 May in Paris was one of the great events of 1878, and was the reason why the Impressionists did not hold a group exhibition that year. However, useful publicity for the group was provided by the book *The Impressionist Painters* published by Duret, in which he introduced and analysed the aims and characteristics of Monet, Pissarro, Renoir, Sisley and Morisot.

In the last few days of June, the festivities taking place in conjunction with the World's Fair reached their peak. On the occasion of the public holiday on 30 June, festive processions turned the streets of Paris into a surging sea of colourful flags. The decorations and general tumult inspired Monet to paint two pictures (p. 101). As he later recalled: 'I loved flags. On 30 June,

Parisians Enjoying the Parc Monceau, 1878
Le Parc Monceau
Oil on canvas, 73 x 54 cm
Wildenstein I. 466
New York, Metropolitan Museum of Art,
Mr. and Mrs. Henry Ittleson, Jr., Fund,
1959 (59.142)

the first national holiday, I walked down the Rue Montorgueil with my painting equipment. The street was decked out with flags and swarming with people. I spotted a balcony, climbed the stairs and asked permission to paint from it. This was granted . . . Yes, those were good times, though life was not always easy.' Monet's picture miraculously succeeds in conveying the bustling activity on the street. The eye is drawn with dynamic force into the imagined depth of the street. The dense throng of swelling crowds, the fluttering flags, the interplay of light and shadow in the street and on the façades of the houses are rendered in flickering, dissipated brush-strokes which deprive forms of their original identity and weave all into an animated tissue of colour. The painting represents an outstanding example of the spontaneous, rapid fixation of the overall impression which characterized Impressionist painting during the Argenteuil period.

Duret was right to call Monet the most Impressionist of all the Impressionists, 'for he has succeeded in fixing on the canvas those fleeting appearances which painters before him have either neglected or believed impossible to reproduce with the brush. He has recorded in all their truth the thousand nuances assumed by the waters of the ocean and rivers, the play of light in the clouds, the changing colouring of flowers and the transparent reflections of foiliage under a burning sun. Since he paints landscapes not only in their unchanging and permanent state, but also from fleeting and chance atmospheric points of view, Monet renders an astonishingly lively and moving impression of the subject he has chosen. His paintings give real impressions. His snow scenes makes us shiver, while his sunshine warms.' The years in Argenteuil played a vital role in the development and refinement of this painting.

Monet had missed nature and the countryside during his months in Paris, and his decision to move to Vétheuil was thus prompted by more than simply financial considerations alone.

The Rue Saint-Denis on 30 June 1878,
1878
La Rue Saint-Denis, fête du 30 juin 1878
Oil on canvas, 76 x 52 cm
Wildenstein I. 470
Rouen, Musée des Beaux-Arts

Vétheuil 1878-1881
'A difficult time with a dark future'

In September 1878 Monet set up camp in Vétheuil, an enchanting spot on the banks of the Seine. This town, with some 6000 inhabitants, the majority farmers, lay about 30 miles west of Paris. It was more rural than Argenteuil, and there were no factories, no railway and thus no town/country conflict. The magnificent surrounding countryside, the old houses grouped around the 13th-century church in the town centre and the Vétheuil castle offered Monet a fruitful supply of motifs.

Monet found accommodation for the family, which now included eight members of the Hoschedé household, in a house in the Rue des Mantes. It had a garden going down to the Seine where Monet could moor his floating studio. Room had to be found for twelve people – not including the maid, cook and governess. The finances of both families were poor, and the situation was only a little improved by sales of Monet's paintings in October. Staff wages could no longer be paid. Ernest Hoschedé soon moved back to Paris, leaving his family behind in Vétheuil.

Camille's illness was the cause of growing concern, and a more comfortable environment for both families seemed necessary. It was decided to move again, this time to the northwest of Vétheuil on the road leading to La Roche-Guyon, in a house which Monet included in *The Road to La Roche-Guyon* (1880; Tokyo, National Museum of Western Art). From the garden there were steps down to the Seine where Monet now anchored his boat. He captured this setting in *Monet's Garden at Vétheuil* (p. 102).

Vétheuil lay at the top of a lengthy, meandering section of the Seine. It was linked by ferry to Lavacourt on the other side of the river. The river contained several small islands at this point; the largest upstream was Moisson, and the largest downstream Saint Martin. To the west of Vétheuil, high chalk cliffs sloped steeply down to the river, while the Lavacourt side of the Seine was composed of broad, flat countryside and the forest of Moisson. These surroundings, and the neighbouring villages up and downstream which Monet now explored with his boat, offered him a wide range of new motifs. In autumn 1878 he worked mainly downstream or overlooking the Seine near Vétheuil and Lavacourt,

Monet's Garden at Vétheuil, 1881
Le Jardin de Monet à Vétheuil
Oil on canvas, 150 x 120 cm
Wildenstein I. 685
Washington (D.C.), National Gallery of Art, Ailsa Mellon Bruce Collection

Poppy Field near Vétheuil, 1879
Champ de coquelicots près de Vétheuil
Oil on canvas, 70 x 90 cm
Wildenstein I. 536
Zurich, Stiftung Sammlung E.G. Bührle

as in the *Towpath at Lavacourt* (private collection). In comparison to his Argenteuil works, these views appear relatively classical and in places recall the landscapes of Daubigny.

The following winter of 1878/79 was unusually cold and long. As such it anticipated the extremely cold Vétheuil winters to come. It nevertheless inspired Monet to paint numerous snowscapes and wintry scenes in the immediate vicinity, such as *The Road to Vétheuil, Winter* (p. 106), in which Monet's own house can be seen on the left. These pictures, together with *Lavacourt, Sun and Snow* (London, National Gallery) and *The Church at Vétheuil, Snow* (p. 107), possess a power which recalls the days of Saint-Siméon. They are often empty of people and bury the whole of nature under broad sheets of white; their depressed and melancholy atmosphere reflects the difficult situation in which Monet was then living. He identified and sought in nature correspondences with his own inner state. Monet thereby shared the Romantic notion of a merging of the self and nature in landscape painting.

Monet painted a number of panoramic views of Vétheuil in winter from either his studio boat, one of the small islands in the Seine or the opposite bank of the river, as in *The Church at Vétheuil, Snow* (p. 107). Here, the snow-covered houses of Vétheuil are grouped around the small church. The composition is determined by the horizontal line of the river, which finds its harmonizing counterweight in the verticals of the church tower and the trees. The architectural forms are solid and specific and not yet dematerialized by the light. In the foreground, which plays

Path in the Ile Saint-Martin, Vétheuil, 1880
Sentier dans les coquelicots,
Ile Saint-Martin
Oil on canvas, 80 x 60 cm
Wildenstein I. 592
New York, Metropolitan Museum of Art,
Bequest of Julia Wildenstein Emmons,
1956 (56.135.1.)

a particularly important role, Monet employs a technique already fully developed in Argenteuil. The movement of the water is recreated in multiple, broken brush-strokes, forming a powerful contrast to the flatter areas of wash. This was to become a characteristic feature of the works of this period.

Snow scenes were popular with other Impressionist landscape painters apart from Monet, since they offered a particular opportunity to explore reflections of light, incorporated into the painting as detailed flecks of paint. In this picture, too, the white of the snow is overlaid with blue reflections. The palette is both extremely muted and restricted. The only lively dash of colour is the blue waistcoat of the human figure shown only faintly emerging from the background.

The long-awaited spring of 1879 brought new stimulus, and blossoming trees offered appropriate motifs. Hopes were also attached to the fourth Impressionist exhibition, which opened at 28, Avenue de l'Opéra on 10 April 1879 under the title 'Exhibition of Independent Artists.' Although 15 artists took part in the show, Morisot, Sisley and Renoir were missing. Renoir was exhibiting in the Salon, which in 1879 revealed – from the young painters' point of view – an interesting trend towards the replacement of academic, mythological and historical themes by naturalism and subjects from modern life, as championed by the Impressionists.

Thanks to its accessible location, the Impressionist exhibition attracted a large number of visitors and took a profit for the first time, so that it was possible to pay back 439 Francs to each member. Monet was represented by 29 works, mainly landscapes

The Road to Vétheuil, Winter, 1879
La Rue à Vétheuil, l'hiver
Oil on canvas, 52 x 71 cm
Wildenstein I. 510
Göteborg, Göteborgs Konstmuseum

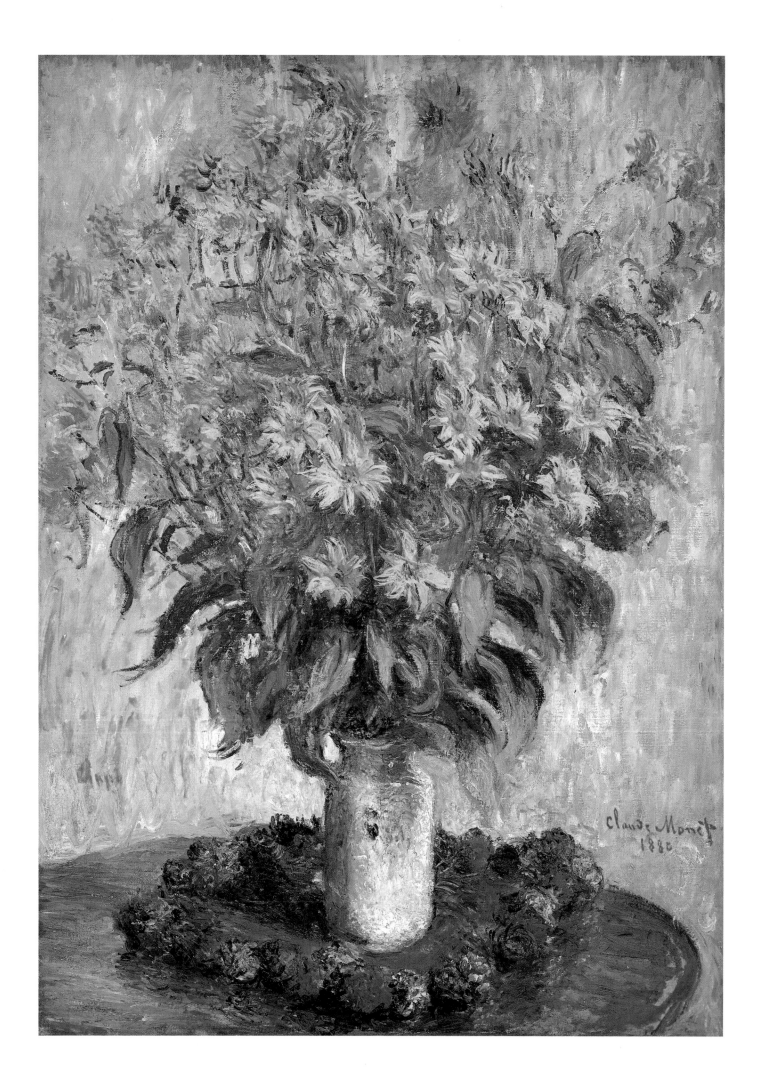

to that which can be observed in the 1879/80 Breakup of the Ice paintings (p. 115) and later in the Etretat paintings of 1886 (p. 131).

Monet's material difficulties were exacerbated by an extremely hard winter – one of the coldest Vétheuil had ever experienced, with temperatures falling as low as minus 25 degrees. The Seine itself froze over and could be crossed on foot. Even such extreme weather conditions as these seldom stopped Monet from working, as he later recalled: 'I painted in January 1879 on the ice, for example. The Seine had frozen over, and I set myself up on the river, trying hard to keep my easel and my camping stool steady. From time to time, someone would bring me a hot-water bottle. But not for my feet! It was not me that suffered from the cold, but my numb fingers, which threatened to drop the brush.' Monet pursued nature like a hunter and fighter. He exposed himself to increasingly extreme situations, such as the coastal bluffs of Etretat, where he was once overtaken at his easel by a large wave which soaked him to the skin and sent his canvas flying. Indeed, some of his seascapes include real grains of sand blown up by the wind and trapped between layers of paint. In Bordighera, Italy, he was later to give himself heatstroke working under the blazing sun. As from the eighties, Monet increasingly sought motifs which challenged him from every aspect, such as steep, barely accessible cliffs, rocks and bays, and views painted in the freezing cold, pouring rain and dazzling sunshine.

The frost and the thaw which set in on 4 and 5 January 1880 in Vétheuil inspired a number of masterly pictures. His letters from this period reveal that these often gloomy winter landscapes,

Basket of Fruit (Apples and Grapes), 1879
Corbeille de fruits (pommes et raisins)
Oil on canvas, 68 x 90 cm
Wildenstein I. 545
New York, The Metropolitan
Museum of Art

devoid of people, helped him find his way back to painting after the death of his wife. One such landscape is Monet's *Hoar-Frost* (p. 109), which shows a side arm of the Seine downstream of Vétheuil; two other, very similar versions also exist. The water has frozen over, and the rowing boat in the right-hand foreground has been trapped in the ice. Poplars seal the composition in the background. The shrubs and grasses are covered with ice crystals. Everything is motionless and rigid.

The thaw at the beginning of January not only led to Monet's garden being flooded, but also induced a massive breakup of the ice on the Seine. Monet produced a series of Breakup of the Ice paintings (p. 115), whose significance is increased by their relationship to Monet's later Giverny Water Lilies. The foreground is occupied entirely by the surface of the water, on which individual ice floes, suggested by just a few strokes of the brush, appear to float in weightless suspension. Horizontal and diagonal boundaries

Pears and Grapes, 1880
Poires et Raisins
Oil on canvas, 65 x 81 cm
Wildenstein I. 631
Hamburg, Hamburger Kunsthalle

113

are set by the vertical trunks of the poplars reflected in the water. These natural borders are alone responsible for the creation of pictorial space and depth. Brushwork approximates; the subject of the picture is more invoked than described. In their earthy palette and avoidance of strong contrasts, as well as in their unusual subject and its new interpretation, these works mark an emphatic break with the Impressionist phase of Argenteuil.

In another new departure, Monet resolved in spring 1880 to exhibit at the Salon. He may have been encouraged in this by Renoir's success in the 1879 Salon. But Monet's decision signalled a crisis in Impressionist painting and his break with the Impressionist group, since he simultaneously refused to exhibit in the fifth Impressionist exhibition. He submitted two works to the Salon, of which the rather more conventional summer landscape of Lavancourt, executed on the basis of careful preliminary studies, was accepted, while the dramatic, less agreeable Breakup of the Ice painting was rejected. Although Monet's landscape was hung very badly – i.e. very high up – in the Salon, it appears – if the reviews of the exhibition are to be believed – to have outshone its neighbours.

Monet's decision not to exhibit with the group had other, disagreeable consequences. In January 1880, the *Gaulois* carried an anonymous, malicious report which rebuked Monet – in conjunction with his unfaithfulness to the Impressionists – for his 'strange' relationship with the Hoschedés, and in particular Alice. Degas attacked him personally and Pissarro allowed their relations to cool. Monet subsequently wrote to Duret: 'I am suddenly being treated as a deserter by the whole band, but I believe it was in my own interest to make the decision I did, since I'm more or less sure to do some business, particularly with Petit, once I've broken into the Salon.' In the event Monet was not to be disappointed; gallery-owner Georges Petit, a competitor of Durand-Ruel, subsequently purchased three of Monet's paintings. One of the consequences of this in-fighting was Monet's decision to take part neither in the Salon nor the Impressionist exhibition in the following year.

There were a number of other painters in the group apart from Monet who, around 1880, started to display a more critical attitude towards their own work. For Renoir, for example, the lack of definition and the formal dissolution of Impressionism posed a danger which he sought to counter in the eighties through a provisional return to strong lines and solid forms. Meanwhile, in about 1884, Pissarro came into contact with the neo-Impressionism developing around Georges Seurat. In his subsequent work up to about 1888, he turned away from the 'disorder' of Impressionist brushwork to the systematic divisionism of Pointillism. Following scientific investigations based in part upon the colour theories of Eugène Chevreul, Pointillism used dots of pure colour in close juxtaposition whose optical mixture was

believed to achieve a more powerful luminosity. In addition to Renoir and Monet, Sisley and Cézanne had also chosen to exhibit at the Salon that year, effectively leaving only Pissarro to represent the original direction of Impressionism, with Degas and his circle representing the other side. Degas had even approved the title of the fifth Impressionist exhibition – 'Exhibition of Independent Painters.'

During this period, Monet was also subject to increasing criticism regarding the elaboration (*réalisation*) and finishing (*fini*) of his works, and was the constant prey to doubts about the value of his painting and the method of its execution. But Monet's repeated insistence that he was and remained a *plein-air* painter served only to perpetuate a myth which in no way corresponded to reality, namely, that he had also long been a studio artist. The works which he had submitted to the Salon were themselves painted in the studio. On top of all this came his permanent money worries and his unclear relationship with Alice.

On the occasion of his first one-man show, held in June 1880 in the galleries of the magazine *La Vie Moderne*, Monet was interviewed by Emile Taboureux; in the course of the conversation,

Breakup of the Ice near Vétheuil, 1880
La Débâcle près de Vétheuil
Oil on canvas, 65 x 93 cm
Wildenstein I. 572
Paris, Musée d'Orsay

115

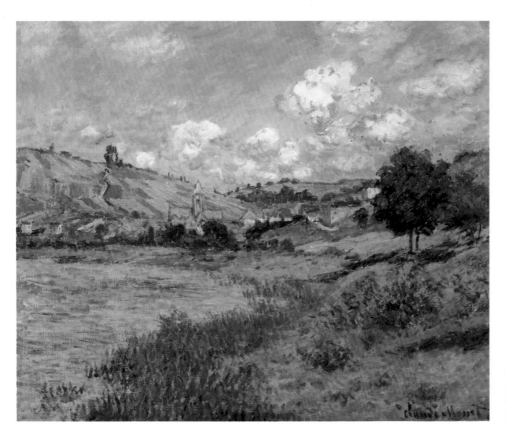

Landscape, Vétheuil, 1879
Paysage, Vétheuil
Oil on canvas, 60 x 73 cm
Wildenstein I. 526
Paris, Musée d'Orsay

Monet fuelled a number of contemporary prejudices against Impressionism and at the same time announced his resignation from the group. 'I am and always will be an Impressionist . . .but I now see my comrades-in-arms, men and women, only rarely. The small set has today become a banal school opening its doors to the first dauber who comes along.' This dig was intended not only for Jean-François Raffaeli, whom Degas had introduced into the group, but also Paul Gauguin, who was exhibiting with the Impressionists for the second time and of whom Monet had a very low opinion.

In his one-man exhibition, Monet was able to show the Breakup of the Ice painting which had been refused by the Salon as well as 17 other works, chiefly views of Vétheuil, whereby a number of individual motifs were treated several times as a means of studying the same landscape at different times of day and year and under different weather conditions. The exhibition aroused great interest among the younger generation, including Paul Signac, who subsequently rose to prominence as a neo-Impressionist. Monet now had to adjust to a new role as heroic father figure for a new generation of independent painters. In the press, too, the show was well reviewed. Monet was gradually becoming respectable. He found new collectors and admirers for his art, including the banker Charles Ephrussi, later owner of the 'Gazette des Beaux-Arts,' an art magazine which dedicated numerous articles

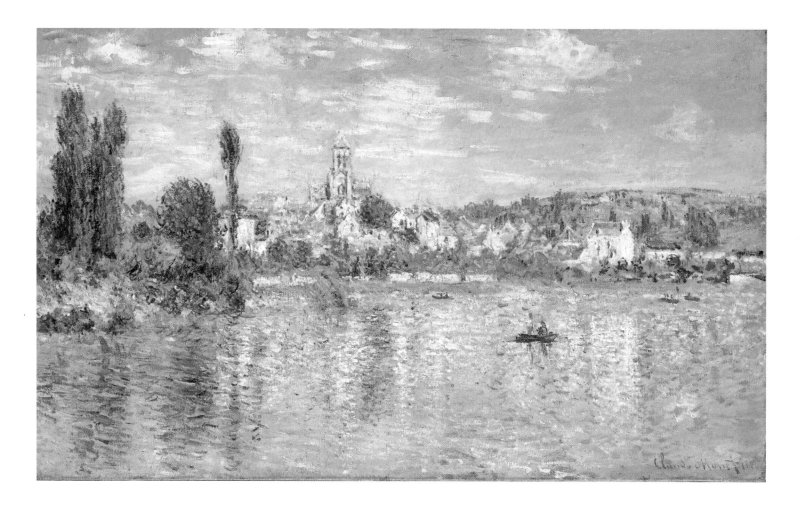

to the Impressionist movement from 1880 onwards. This glittering personality was the inspiration behind the patron of the Impressionist artist Elstir in Marcel Proust's 'In Remembrance of Things Past.' Monet's Vétheuil neighbours, the Coqueret family, also commissioned numerous portraits from him, even though the human figure was playing an increasingly minor role in his work. Paintings such as *Woman Seated under the Willows* (p. 119), in which Alice's silhouette can be recognized, are seldom to be found. Apart from the fact that Alice was exceedingly jealous of any female model, Monet had always focussed chiefly upon landscape painting.

In September 1880, an invitation to Rouen from Monet's brother, Léon, afforded a pleasant break. Léon, a great admirer of Claude's work, took him off to his country cottage in Petit-Dalles, a small resort on the Normandy coast near Fécamp. Imposing chalk cliffs numbered among the local tourist attractions and offered Monet a dramatic pictorial setting which matched his inner mood. Although he produced only four pictures during this stay, the many marine motifs which he painted on the Normandy coast over the following few years had their origins here. Following Monet's return to Vétheuil, an extreme thaw in the winter of 1880/81 prompted a series of *Flood* paintings. These show a Seine which has swollen and burst its banks, inundating the surrounding countryside and leaving large numbers of trees under water.

Vétheuil in Summer, 1880
Vétheuil en été
Oil on canvas, 60 x 99.7 cm
Wildenstein I. 605
New York, Metropolitan Museum of Art, Bequest of William Church Osborn, 1951 (51.30.3)

PAGE 118:
Woman Seated under the Willows, 1880
Femme assise sous les saules
Oil on canvas, 81 x 60 cm
Wildenstein I. 613
Washington (D.C.), National Gallery of Art, Chester Dale Collection

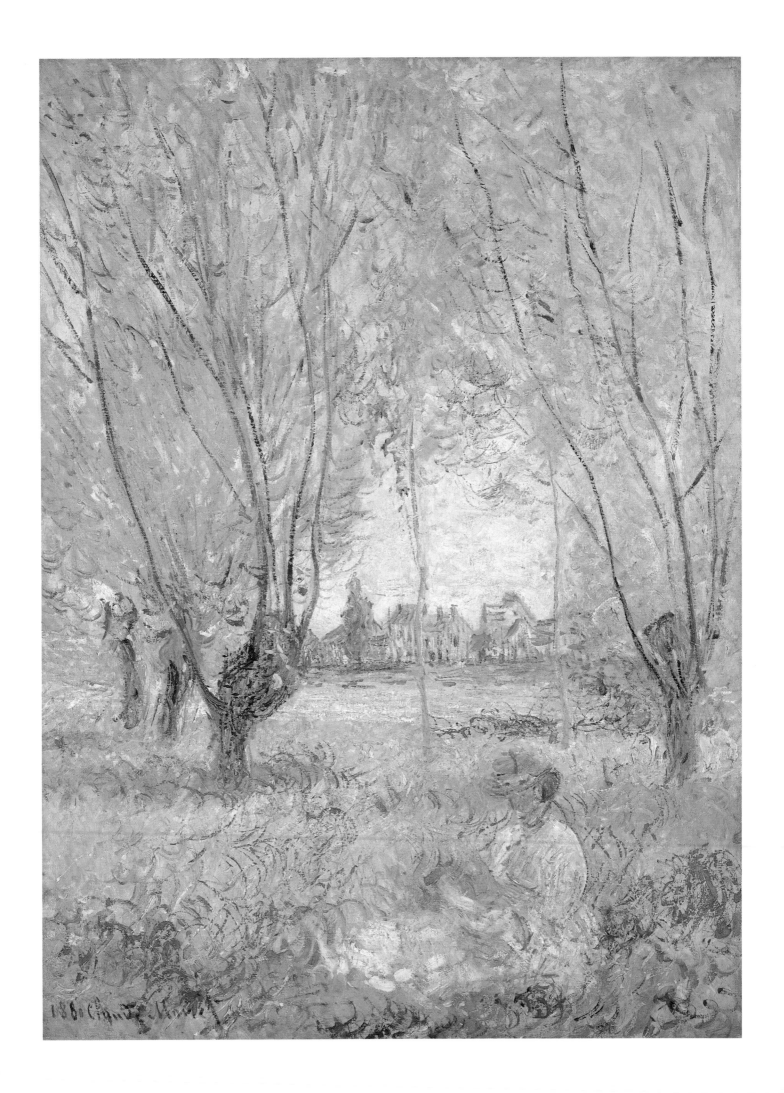

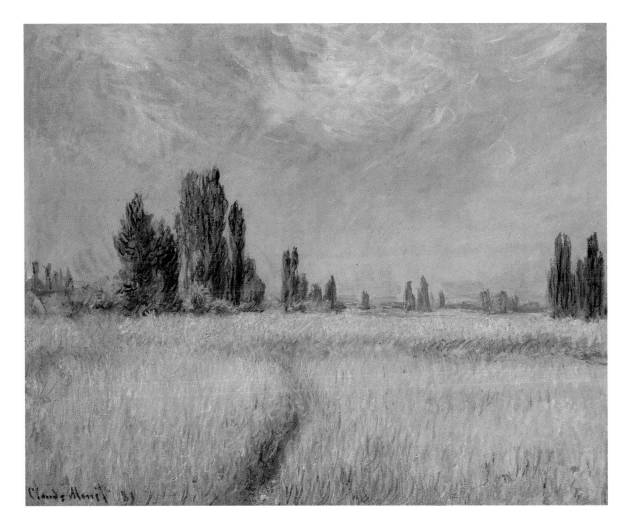

Wheat Field, 1881
Champ de blé
Oil on canvas, 65 x 81 cm
Wildenstein I. 676
Cleveland (Ohio), The Cleveland Museum of Art,
Gift of Mrs. Henry White Cannon, 47.197.

1881 started hopefully. Durand-Ruel's business had sufficiently recovered for him to conclude a contract with Monet at the beginning of the year; this committed him to purchasing a large number of Monet's pictures at regular intervals. Artist and dealer remained in lively written contact from now on. Their correspondence, since published, provides illuminating insights into Monet's working even today. Durand-Ruel's solid support confirmed Monet in his decision to give up the Salon once and for all. The prospect of a regular monthly income had a calming influence on his frame of mind, which in turn led to better-finished pictures and more courageous experimentation in the search for new motifs. His refusal to take part in the sixth Impressionist exhibition was due not least to the unpleasantness of the year before.

The great success of his marine paintings convinced Monet to return to Fécamp on the Normandy coast towards the end of winter. The fruits of this stay are paintings such as *The Coast at Fécamp* (p. 120), which is closed to the left by a wall of limestone, while the view to the right opens out to the billowing, foaming sea. The unusually expressive brushwork matches the motif.

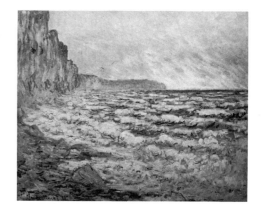

The Coast at Fécamp, 1881
Fécamp, bord de la mer
Oil on canvas, 67 x 80 cm
Wildenstein I. 652
USA, private collection

By the time Monet left the coast to return to Vétheuil in spring, he had decided it was time to break camp. There were a number of reasons to move, including not only the long-overdue rent and the expiry of the lease in the coming autumn, but also the hostility of the local village population towards Monet's 'strange,' disconcertingly unconventional domestic arrangements. In May, therefore, Monet asked Zola to reconnoitre the small village of Poissy, just a few miles from where the writer was living. It was not until December that the move finally took place. Alice had decided to follow Monet to Poissy. While the illness and death of Camille had justified, however tenuously, her previous presence within the Monet household, Alice's present decision caused general consternation. Ernest Hoschedé, who had been living in Paris for a considerable while, was surely stunned, since he had long been pressing Alice to rejoin him in the capital. Monet's situation was now exceedingly ambiguous and he sought in future to avoid personal meetings with Ernest. The extent to which he was already attached to Alice was to become increasingly clear in his letters over the coming years.

Monet concluded the bleak period of Vétheuil with *Monet's Garden at Vétheuil* (p. 102), painted in summer 1881. For this work, which Monet subsequently antedated to 1880, there exist three similar, smaller versions showing the same view of the central path and steps in Monet's garden and the house and road in the background. In comparison to the years before, these pictures are characterized by a remarkable luminosity and cheerfulness which look forward to the Giverny period. As in his Argenteuil works, Monet intensifies the effect of colour by em-

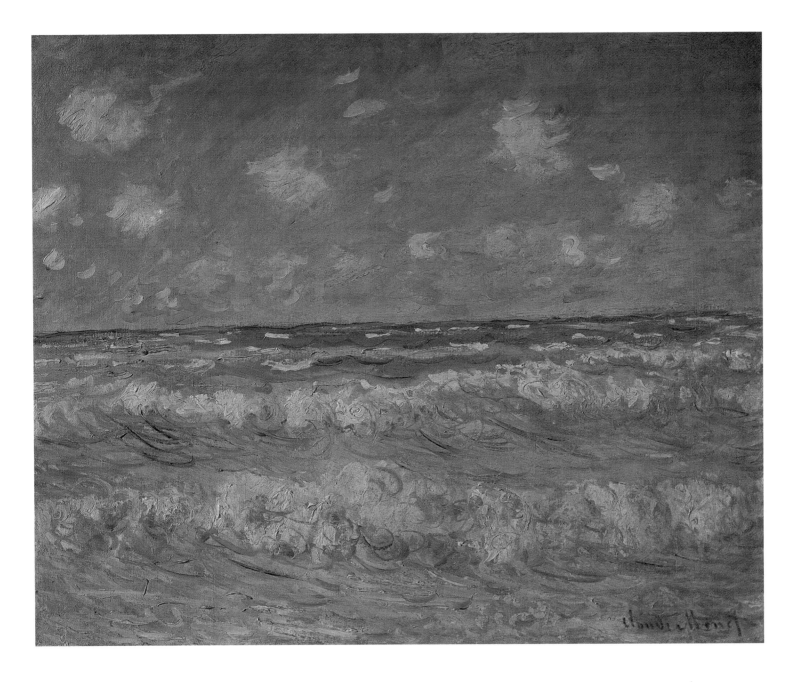

ploying separate strokes of complementary hues. Exquisitely col-
ourful shadows thereby soften the strongly vertical and horizontal
compositional layout. The figures of the young Jean-Pierre Ho-
schedé and Michel Monet merge into the exuberantly flowering
surroundings as if part of nature itself. Monet had always been
fascinated by gardens in bloom, and in the last 25 years of his
life the garden at Giverny was to become his favourite motif.

Rough Sea, 1881
Mer agitée
Oil on canvas, 60 x 74 cm
Wildenstein I. 663
Ottawa, National Gallery of Canada

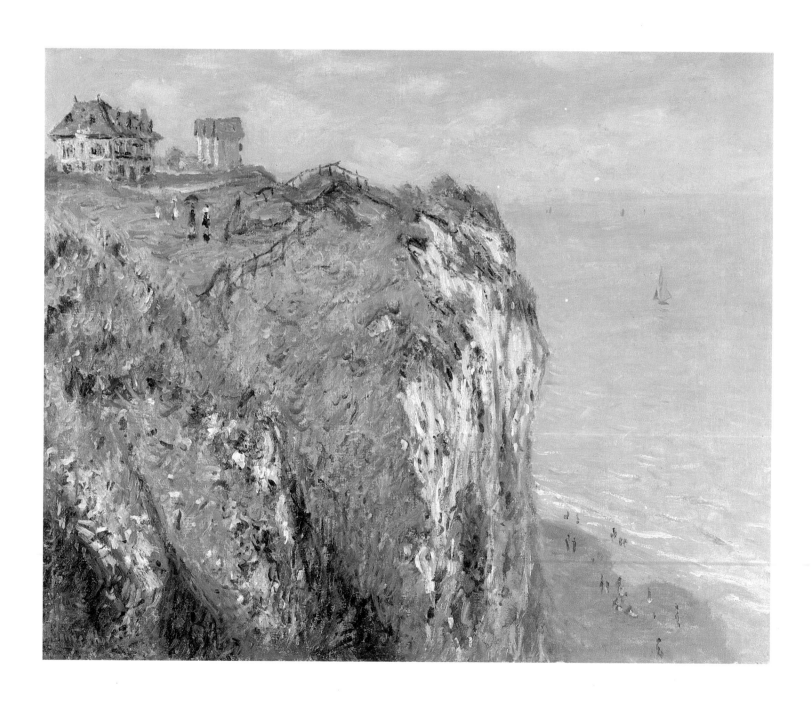

Poissy 1881-1883
'New start and new hope'

Poissy, a small town with some 6000 inhabitants, lay upriver on the right bank of the Seine about 12 miles northwest of Paris. Industrial expansion had not yet spread as far as this little settlement. Although, in their Villa Saint-Louis with its picturesque view of the Seine, the Hoschedé and Monet families were housed far more comfortably than previously in Vétheuil, it was never to feel like home. More important, the town had little appeal for Monet, and only a handful of works were painted here; next to still lifes and portraits, only one picture takes the town as its motif, the *Lime Trees in Poissy* (1882; private collection).

Monet therefore set off for the Normandy coast as early as February 1882, where he began by renting accommodation in Dieppe. With the financial support of Durand-Ruel, he soon moved to Pourville, a small fishing village some three miles to the west, near Varengeville. Monet remained here almost without interruption until the beginning of October. He entered an unusually productive phase and worked like a 'madman' on dramatic views of the sea (p. 122) painted both at the bottom and on top of the local chalk cliffs, as well as on the nearby *Coastguard's Cottage at Varengeville* (p. 126). His preference lay with asymmetrical compositions, as in the Coastguard's Cottages in particular, in which the confrontation of the triangular planes of rock, sea and sky plays a decisive role in creating spatial depth. The magnified surface structures appear set in rhythmical motion. Here, too, Monet approached his topography by painting the same motif several times under different atmospheric conditions. The concept of the series, which Monet was to fully develop in the nineties, is thus becoming increasingly significant.

While Monet was staying on the Normandy coast, lively debates were taking place within the Impressionist group regarding the seventh Impressionist exhibition. Pissarro, who had taken over its organization together with Caillebotte, succeeded in persuading Monet to participate, even though the behaviour of Degas and other members of the group in 1880 still rankled in Monet's memory. There were many disagreements. Degas and Renoir

Fishermen at Poissy, 1882
Pêcheurs à Poissy
Pencil drawing, 25 x 34 cm
Cambridge, Mass., Fogg Art Museum,
Harvard University

Cliffs at Dieppe, 1882
La Falaise à Dieppe
Oil on canvas, 65 x 81 cm
Wildenstein II. 759
Zurich, Kunsthaus Zürich

On the Coast at Trouville, 1881
Sur la côte à Trouville
Oil on canvas, 59.7 x 81 cm
Wildenstein I. 687
Boston, Museum of Fine Arts, John Pickering Lyman Collection, Gift of Theodora Lyman
Courtesy, Museum of Fine Arts, Boston

refused to exhibit with the 'dictator' Gauguin, while Morisot would only take part if Monet did. Monet himself demanded the participation of Renoir and Caillebotte. After endless quarrelling, with Durand-Ruel acting as referee, the exhibition of 'Independents' finally opened on 1 March 1882 at 125, Rue Saint-Honoré. Only nine artists were on show, Degas and Cézanne being absent.

It was an unfortunate choice of location, since the same building housed a mediocre panorama depicting a battle from the Franco-Prussian War. Panoramas such as these were among the most important media of the times. They were usually housed in specially-built rotundas as circular paintings of predominantly historical and landscape subjects. They could be viewed from a raised podium at the centre of the room. They were intended to induce in the viewer the illusion of looking at real – rather than painted – nature. These panoramas only lost their attraction at the turn of the century with the birth of film and thus of motion pictures. For Monet, strongly represented with 35 works, this was to be his last Impressionist exhibition. Durand-Ruel had selected seascapes, landscapes and still lifes; at Monet's request, these were given vague titles which could be changed if necessary. The works were given a friendly reception by the press, and Manet, too, praised the outstanding winter and river landscapes from the Vétheuil period.

Monet returned to Poissy briefly in May, since the children had successively all fallen ill. Unhappy with the situation in Poissy, he rented the Villa Juliette in Pourville for himself, Alice and the children from June to October. Family life proved relaxing.

Blanche Hoschedé took her first painting lessons and, in a period of intense activity, Monet captured the sunny atmosphere in the *Cliff Walk at Pourville* (p. 127). In his views of *The Church at Varengeville, Sunset* (p. 125), he uses the high cliffs as the pretext for an expressive use of colour in which the rock formations are captured in a passionate sweep of the brush. These peaceful times were interrupted by bouts of depression, in which Monet doubted the value of his work and his own artistic talent and destroyed many of his pictures. The situation was helped neither by a spell of rain and overcast skies nor by Alice, who was bored. A trip to Rouen with the children brought Monet only short-term distraction. With their departure from Pourville in October, the summer ended on a decidedly depressed note. Life in Poissy turned out to be even more difficult. Alice, not used to living in permanent financial straits, did not spare her reproaches, and her husband was only allowed to appear in Poissy when Monet was absent.

The Church at Varengeville, Sunset, 1882
Eglise de Varengeville, soleil couchant
Oil on canvas, 65 x 81 cm
Wildenstein II. 726
Private collection

Monet used the autumn to rework the pictures he had brought back from the Normandy coast and which the poor weather had prevented him from finishing on site. He also resumed still-life painting. Monet's ideas of leaving Poissy were reinforced by the flooding of the house in December. But he was nevertheless able to look back upon a fruitful year; his sales to Durand-Ruel were continuing apace and his seascapes in particular were proving very successful. This was one more reason to flee Poissy and its unhappy atmosphere and head for the coast of Normandy. In January 1883 his travels took him to Le Havre, and from there to Etretat, famous for its impressive coastal scenery. Etretat, with its bathing coves walled by steep chalk cliffs towering up out of the sea, had long been popular among artists, including Boudin and Corot. Monet was familiar with the works that Courbet, too, had painted here (p. 129). Guy de Maupassant, a naturalist writer who, like Monet, had grown up on the Normandy coast and who stayed with him in Etretat in 1885, included this craggy setting of perpendicular, plunging cliffs more than once in his novels. In *Miss Harriet* (1883), the picture by the painter Léon Cheval recalls Monet's work in Etretat: 'The entire right-hand side of my canvas depicted a rock, an enormous, knurled rock covered with brown, yellow and red seaweed, the sun pouring over it like oil. Without one seeing the heavenly body hidden behind me, the light fell upon the stone and gilded it with fire . . . On the left the sea, not the blue sea, the sea of slate, but the sea of jade, greenish, milky and at the same time hard beneath the dark sky.'

Coastguard's Cottage at Varengeville, 1882
Cabane du Douanier à Varengeville
Oil on canvas, 60 x 81 cm
Wildenstein II. 743
Philadelphia, Philadelphia Museum of Art,
William L. Elkins Collection

In *The Manneporte, Etretat* (p. 133), a giant stone arch similarly thrusts itself into the picture with threatening proximity, albeit here from the left. Monet could only have obtained this particular angle from a highly inaccessible beach. His limited number of compositional elements and his cropped and asymmetrical positioning of the arch recall Japanese prints by Hokusai.

These pictures reveal the artist's tendency to restrict himself to essentials, to provide no more than an overall impression. Sea and rock, which on the left side of the painting appear to lie within virtually the same foreground plane, are distinguished solely by brush-structure and colouring. While the shapeless, open sea is shown in ceaseless motion by the innumerable swirling strokes of blue, green and broken white, the horizontal structures of the blue-grey rock, with its powerful contours, recall natural rock layers. This polarity of hard, moulded stone and moving, shapeless sea is resolved through the dramatic interplay of bright

Cliff Walk at Pourville, 1882
La Promenade sur la falaise, Pourville
Oil on canvas, 66.5 x 82.3 cm
Wildenstein II. 758
Chicago, The Art Institute of Chicago, Mr. und Mrs. Lewis Larned Coburn Memorial Collection, 1933.443

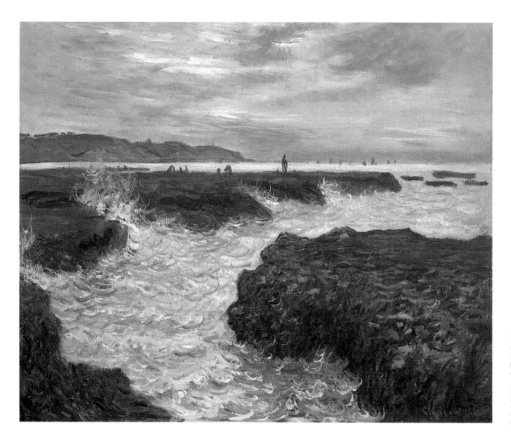

The Rocks at Pourville, Low Tide, 1882
Les Rochers à Marée Basse, Pourville
Oil on canvas, 62.9 x 76.8 cm
Wildenstein II. 767
Rochester, Memorial Art Gallery of the
University of Rochester, Gift of Mrs.
James Sibley Watson

light and deep shadow. For while the interior of the rock arch is
illuminated by a soft, pink light which somewhat lessens the
monumentality of the stone, shaded areas give the surging waters
a hardness and solidity. The elements cautiously approximate
each other. Illusionistic illustration, the observation of nature
under various atmospheric conditions and a pictorial organization
determined more and more by colour here play equally important
roles.

Recalling a holiday spent with Monet in Etretat in an article
of 1886, Maupassant compared the painter's approach to that of
a hunter circling closer and closer to his prey. It is a comparison
applicable not least to Monet's series painting. Monet's tendency
to approach monumental objects more and more closely led to
the paintings of solely the façade of Rouen cathedral, and reached
its peak in the highly-magnified views of water surfaces to which
the Giverny Water Lilies are restricted. 'I often followed Monet
on his search for new impressions,' wrote Maupassant. 'He was
not so much a painter as a hunter. He was followed by a swarm
of children, carrying five or six canvases representing the same
subject at different times of the day and with different effects.
He took them up and put them aside again in turn, according to
the changes in the light. Face to face with his subject, he lay in
wait for the sun and shadows, capturing a ray of light or scuttling
cloud with a few strokes of the brush . . . Once I saw him seize
a glittering shower of light on the white cliffs and fix it in a flood
of yellow tone which strangely rendered the fugitive effect of

Gustave Courbet
Cliffs at Etretat after the Storm, 1869
La Falaise d'Etretat après l'orage
Oil on canvas, 133 x 162 cm
Paris, Musée d'Orsay

that intangible, dazzling brilliance. On another occasion he took a torrential cloudburst over the sea and dashed it onto the canvas – and succeeded in creating there in paint the very same rain.'

Monet was drawn back to the dramatic setting of Etretat every year until 1885. He painted the fishing boats on the deserted winter beach (p. 131) and the rock formations of Porte d'Aval, Porte d'Amont and La Manneporte, in which he contrasted the white and green foam of the waves with the blue and grey of the rocks. Only a small number of the Etretat pictures were finished on the spot. To Alice, who was getting worried about his long absence, Monet wrote that he would be bringing home vast quantities of material with which he would do great things at home. Monet was thereby returning to the method he had used earlier for the Salon and which looked forward to his later works in Giverny, in which studies made in the open air were deliberately finished in the studio.

Monet kept these marine paintings in his studio for a long time; Durand-Ruel was forced to ask for them more than once for the one-man exhibition he was planning for February 1883. In the end they were not included. The show opened on 28 February in Durand-Ruel's gallery on the Boulevard de la Madeleine. The 56 exhibits offered a comprehensive retrospective of Monet's oeuvre. Monet was extremely unsatisfied with the presentation of his works, however, not least due to the gallery's poor lighting. Press and collectors had also been inadequately notified, and thus Monet was convinced this 'fatal exhibition'

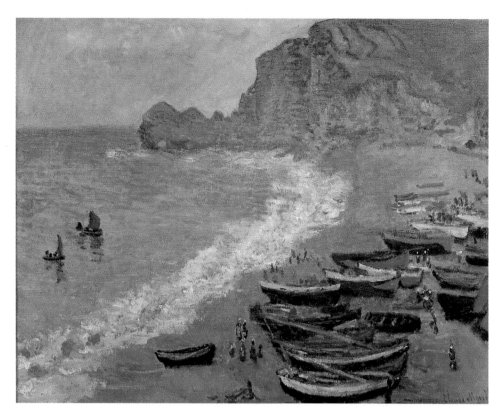

Beach at Etretat, 1883
Plage d'Etretat
Oil on canvas, 66 x 81 cm
Wildenstein II. 828
Paris, Musée d'Orsay

would prove no less than a catastrophe, a setback rather than a boost to his career. But Monet now found an admiring critic in Gustave Geffroy, a novelist and journalist who subsequently took up the cause of Impressionist art and the naturalist aesthetic with enthusiasm. The two did not meet in person until 1886 during a stay in Brittany. It was to be the start of a lifelong friendship. Among other things, Geffroy published the first comprehensive monograph on Monet (1924), in which the history of Impressionism is brought vividly to life.

In April 1883 material difficulties forced Monet to leave his home in Poissy. He started anxiously looking for a new home in the same area and not too far from Paris, which he visited monthly. Monthly, too, were the Impressionist dinners at the Café Riche, which offered out-of-town painters an opportunity to keep in touch with sympathetic writers, painters and art lovers. These gatherings, which continued until about 1894, were attended by Pissarro, Renoir, Caillebotte, Sisley, Guillaumin, Charpentier, Bellio, Hoschedé, Rivière and Cézanne as well as by Monet himself.

The Hoschedé-Monet family found their new home in Giverny. This small village with then just 279 inhabitants lay just over a mile from Vernon on the right bank of the Seine, halfway between Paris and Rouen, in the heart of idyllic countryside. Immediately after the move, made possible by the generous financial assistance of Durand-Ruel, Monet learned of the death of Manet, to whom he paid his last respects in Paris, together with Zola and Antonin Proust. Gustave, Manet's brother and ever a generous friend to Monet, died just one year later. Thus Monet lost two of his oldest

Cliffs at Etretat, c. 1885
La Falaise d'Etretat
Pastell, 21 x 37 cm
Paris, Musée Marmottan

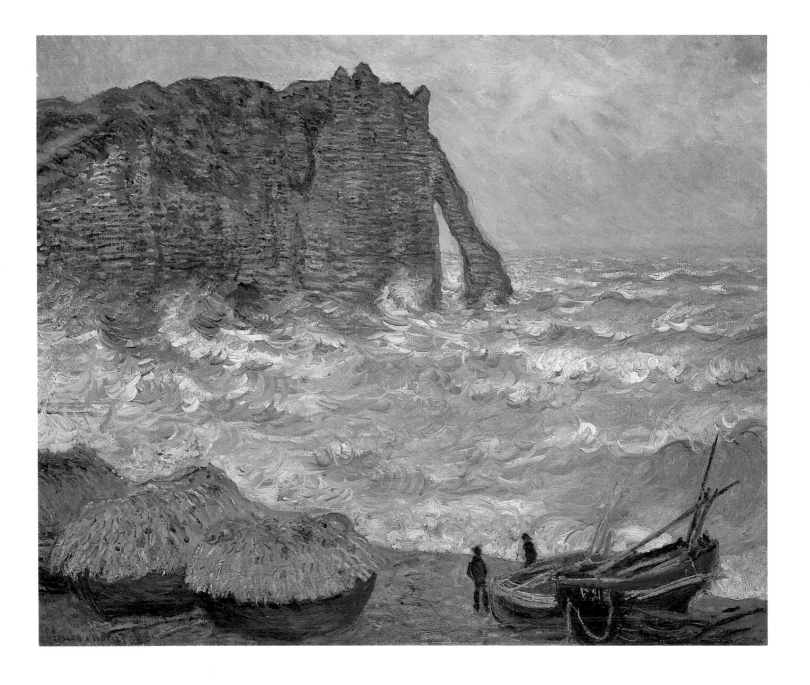

and truest friends within a short space of time. This, too, marked the new phase in the life of the 43-year-old Monet, which began with the move to Giverny. Here he not only spent the entire second half of his life, but created masterpieces which earned him the fame still surrounding him today.

Rough Sea, Etretat, 1883
Etretat, mer agitée
Oil on canvas, 81 x 100 cm
Wildenstein II. 821
Lyon, Musée des Beaux-Arts

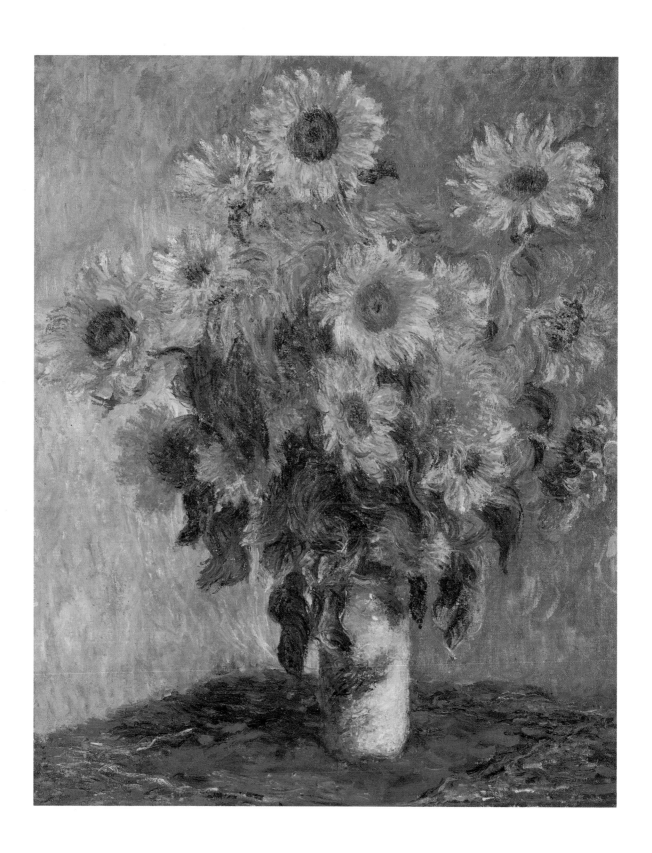

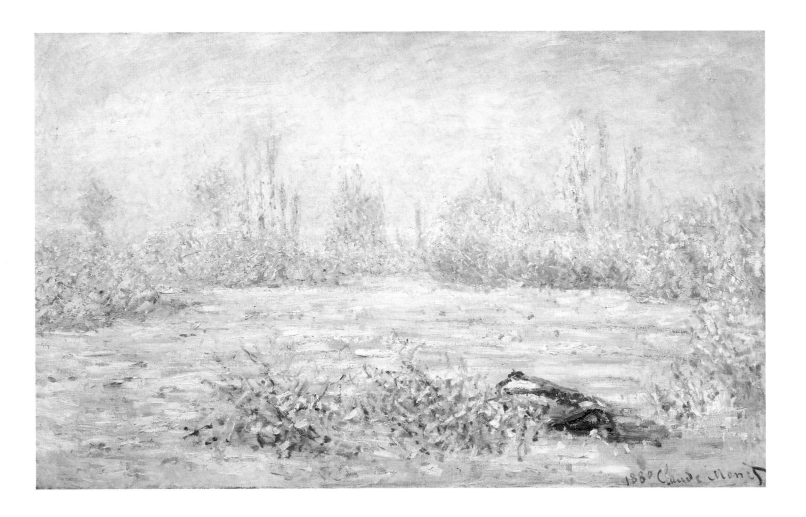

threw himself into work in the winter of 1879/80 as a means of temporarily forgetting the emptiness left by Camille's death. Here, too, his choice and treatment of motifs reflect his inner state. Forced to remain indoors by a prolonged period of rainy weather, he turned to a succession of still lifes composed of fruits, flowers and dead pheasants.

In comparison to landscapes, still lifes are rare among Monet's works – unless the deserted snowscapes and Breakup of the Ice paintings from 1879/80 are also assigned, in a wider sense, to this genre. In the following year, however, Monet painted several arrangements of fruit (p. 112/113) and – in particular – flowers, including the *Sunflowers* (p. 110/111) whose freedom and unrestraint made a deep impression on Vincent van Gogh. Monet had always loved flowers, as revealed in his devotion to gardening in Argenteuil and later Giverny. But the sunflower paintings of 1880 differ from his earlier, considerably more realistic reproductions of flowers and instead look forward to the later works of van Gogh. In place of detailed, true-to-life illustrations, these flowers now become the embodiment of light and sun set luminously against a blue-violet background. The artist exploits the intensifying effects of the complementary contrasts of yellow-violet and blue-orange. In the same way, the red of the table-cloth stands out from the green impasto of the leaves. The rapid, expressive handling of the paint reveals an emotional involvement similar

Hoar-Frost, 1880
Le Givre
Oil on canvas, 61 x 100 cm
Wildenstein I. 555
Paris, Musée d'Orsay

PAGE 110:
Sunflowers, 1880
Bouquet de soleils
Oil on canvas, 101 x 81.3 cm
Wildenstein I. 628
New York, The Metropolitan Museum of Art, Bequest of Mrs. H.O. Havemeyer, 1929. H.O. Havemeyer Collection (29.100.107)

PAGE 111:
Jerusalem Artichokes, 1880
Fleurs de Topinambours
Oil on canvas, 99.6 x 73 cm
Wildenstein I. 629
Washington (D.C.), National Gallery of Art, Chester Dale Collection

taken up with the care of his family, had hardly a thought to spare for painting. He described the desperate nature of his situation to Duret in January 1879: 'I am sitting here literally without a sou. I am therefore compelled to beg for my continued existence. I have no money to buy canvas or paints.' They were short of everything – food, heating, clothing. The same was true of the Hoschedé family. Even Alice, daughter of a wealthy family and used to assured circumstances, was forced to give piano lessons to contribute to the joint housekeeeping.

Among the few pictures to arise during the summer of 1879 was the *Poppy Field near Vétheuil* (p. 104), which shows the high trees of the island of Moisson in the background. Also from this period are the views of *Vétheuil, seen from Lavacourt* (p. 117) which, simple in expression, are seen horizontally and often frontally from across the river. Their differentiation lies solely in the ceaseless variation of foliage, light and weather conditions, whereby they are restricted less in formal terms than in expression. The latter part of summer was overshadowed by the death of Camille at the age of only 32. She died on 5 September after a prolonged illness. Inner compulsion led Monet, as he later explained, to preserve the dear face of the departed in *Camille on her Deathbed* (p. 108). 'I caught myself watching her tragic temples, almost mechanically searching for the sequence of changing shades which death was imposing upon her rigid face. Blue, yellow, grey, whatever. Such was the state I was in . . . But even before the idea had occurred to me to record those beloved features, my organism was already reacting to the sensation of colour, and my reflexes compelled me to take unconscious action in spite of myself'. Thus Monet described the feeling of being the slave to his own visions.

Seen through a veil of muted and broken hues, Camille's pallid face seems to be dissolving within an aethereal vacuum. The entire picture is permeated by the violet colours of rigor mortis. The fast and hasty brush-strokes suggest that Monet was in a hurry to finish the picture. In Zola's novel *The Masterpiece,* published in 1886, the character Claude Lantier is a fictitious Impressionist artist who – similarly driven by a painter's reflexes – paints a loved one, his young son, on his deathbed. This struck a very personal chord in Monet, as revealed in a letter he wrote to Zola shortly after the book's publication.

Monet remained in Vétheuil with the eight children and Alice, who now took over the role of mother to his two sons. For the local village population, these domestic arrangements were not unambiguous. And indeed, Alice produced all sorts of reasons not to return to her husband Ernest in Paris, who was busy looking for buyers for Monet's paintings. Their debts had meanwhile grown considerably; unpaid bills were constantly landing on the doorstep, followed on more than one occasion by the bailiff himself. But despite all these trials and tribulations, Monet

Camille Monet on Her Deathbed, 1879
Camille Monet sur son lit de mort
Oil on canvas, 90 x 68 cm
Wildenstein I. 543
Paris, Musée d'Orsay

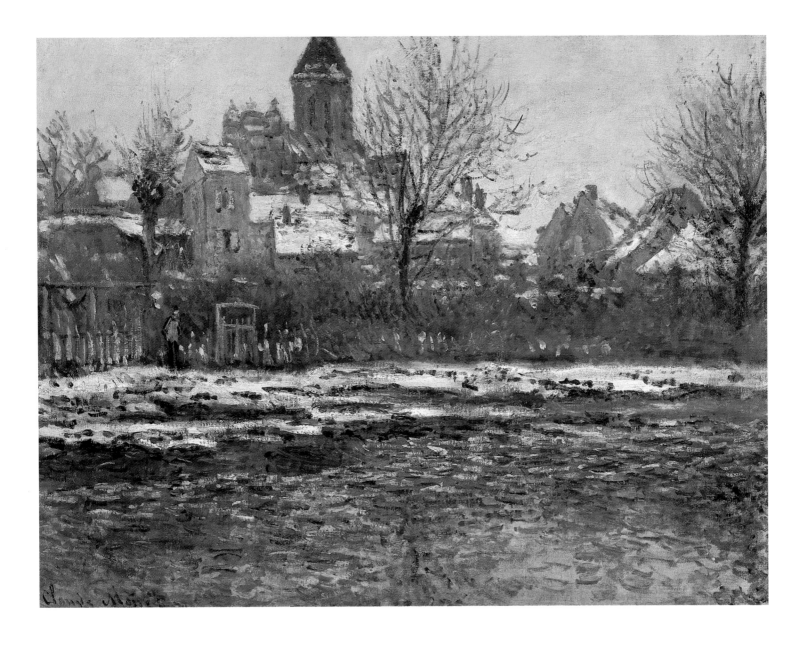

from Vétheuil and the surrounding countryside. The press trotted out the usual criticism – that the paintings were too quickly painted and too little finished. 'Monet sends thirty landscapes that look as if they were all painted in one afternoon,' wrote the conservative 'Figaro' shortly after the opening. Monet, burdened by financial worries, was indeed having to sell as much as he could, whereby he placed often very hastily painted works prematurely into the hands of gallery owners and dealers. The number of voices arguing for the significance of Impressionist art were nevertheless increasing. Monet, whose morale was exceedingly low, made no public appearance at the exhibition. He was kept informed of how the show was running by Caillebotte, who had agreed to assume responsibility for his works and their presentation.

The situation in Vétheuil was critical; Monet's financial crises were compounded by the suffering of the dying Camille and the bedridden condition of their child. Monet, his energies entirely

The Church at Vétheuil, Snow, 1879
L'Eglise de Vétheuil, neige
Oil on canvas, 53 x 71 cm
Wildenstein I. 506
Paris, Musée d'Orsay

107

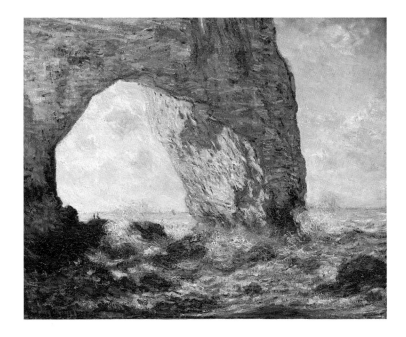

The Manneporte, Etretat, 1883
La Manneporte
Oil on canvas, 65.4 x 81.3 cm
Wildenstein II. 832
New York, Metropolitan Museum of Art,
Bequest of William Church Osborn, 1951.
(51.30.5)

LEFT:
Detail in orginal size

Giverny 1883-1926
'The legend has begun'

The pink house with the green shutters in Giverny, in which Monet lived until his death, provided ample room for a family of ten, and Monet was able to make a studio out of the barn in the west part of the house. The property included a large orchard, walled in the tradition of Norman farmsteads. A wide path ran straight through the garden from the house to a portal, behind which lay the tracks of the Gisors-Vernon railway line. These were followed by a meadow containing willows and a marsh and crossed by the Ru river, a small side arm of the Epte, which in turn flowed into the Seine towards Vernon.

Here, on the banks of the Seine, Monet built a shed in which to keep his boats, and from here he set off on numerous painting trips upstream towards Port-Villez and Jeufosse and downstream towards Vernon. In the course of the following years, Monet transformed the garden into a rustling sea of flowers which provided a rich source of artistic inspiration in good as well as bad weather. His love of gardening, which had its roots in the period at Argenteuil, grew increasingly stronger over the years. Although Monet was enchanted with Giverny, a landscape in which he at last found peace and whose willows and waters became his favourite subjects, building and conversion work on the new house kept him away from painting for quite some time. It was not until the summer of 1883 that he turned to the surrounding countryside in his views of Port-Villez. Durand-Ruel had to wait until October for the first pictures from Giverny. In the meantime, he organized what proved a not particularly successful exhibition of Impressionist painting in London, with the aim of introducing Monet's work to a foreign public and attracting new buyers.

In August Durand-Ruel commissioned Monet to design some decorative door panels for the dining room of his private Paris apartment. They were to employ the fresh colours of the Impressionist pictures in whose immediate vicinity they were to be mounted. Monet chose floral motifs of fruits and flowers. Such botanical interiors were then very modern, and call to mind in particular the Art Nouveau interiors of the nineties which matched

The Manneporte near Etretat, 1886
La Manneporte près d'Etretat
Oil on canvas, 81 x 65 cm
Wildenstein II. 1052
New York, Metropolitan Museum of Art,
Bequest of Lizzie P. Bliss, 1931. (31.67.11)

135

Menton, Seen from Cap Martin, 1884
Menton vu du Cap Martin
Oil on canvas, 65.5 x 81 cm
Wildenstein II. 897
Boston, Museum of Fine Arts, Julia Edwards Collection, Bequest of Robert J. Edwards and Gift of Hannah Mary Edwards and Grace M. Edwards in memory of her mother
Courtesy, Museum of Fine Arts, Boston

contemporary demands for the integration of art and the living environment.

The interior decoration of a room using large-scale motifs was not new to Monet. He had already been commissioned to execute four such pictures for the Hoschedé residence back in 1876 (p. 91). Monet accepted no more such commissions after the mid-eighties, not least because his paintings were now selling regularly. The decorations for Durand-Ruel kept Monet busy for quite a while. It seems that he was finding painting far from easy at the time; he complained to Durand-Ruel that he was having more and more difficulty in achieving what he had previously managed so effortlessly. He sought new sources of inspiration and, in December 1883, set off south with Renoir. The trip took the two men from Marseilles, via Saint-Raphaël and Monte Carlo, to Bordighera on the Italian Riviera and, on the way home, to Cézanne in L'Estaque. Hardly had Monet returned to Paris to see a retrospective of Manet's work than he decided to go back to Bordighera, the most beautiful of the places they had visited, to paint a series of entirely new works.

This time, however, he wanted to travel without Renoir, since he 'always worked better alone and solely on the basis of his impressions,' as Monet himself characteristically explained. He rented accommodation first in Bordighera and later in Menton, where he was granted permission to paint in Monsieur Moreno's garden, which contained the most magnificent palms on the whole coast and where he painted *Palm Trees at Bordighera*

(p. 138). During this second stay, from mid-January to mid-April 1884, he not only sent Alice – concerned about his long absence – written protestations of love, but also described the hard work he was putting in. Orange, lemon and olive trees were proving reluctant sources of inspiration. He was working flat out, taking as many as six sittings for some studies, but everything was so new that he found it hard to lay things aside.

Monet executed some fifty works, his enthusiasm fired by the landscape and its moods and the challenge of an entirely new palette. 'There may be some outcry among the enemies of blue and pink, because it is precisely this brilliance, this magical light, that I am trying to render, and those who have never seen this country, or haven't looked at it properly, will no doubt be up in arms about its improbability, although I am well below the true tone. Everything here is breast-of-pigeon and flame-of-punch; it's magnificent. The landscape is more beautiful every day and I am

Bordighera, 1884
Oil on canvas, 64.8 x 81.3 cm
Wildenstein II. 854
Chicago, The Art Institute of Chicago,
Potter Palmer Collection, 1922.426

Palm Trees at Bordighera, 1884
Palmiers à Bordighera
Oil on canvas, 64.8 x 81.3 cm
Wildenstein II. 877
New York, The Metropolitan Museum of
Art, Bequest of Miss Adelaide Milton de
Groot (1876-1967) 1967 (67.187.87)

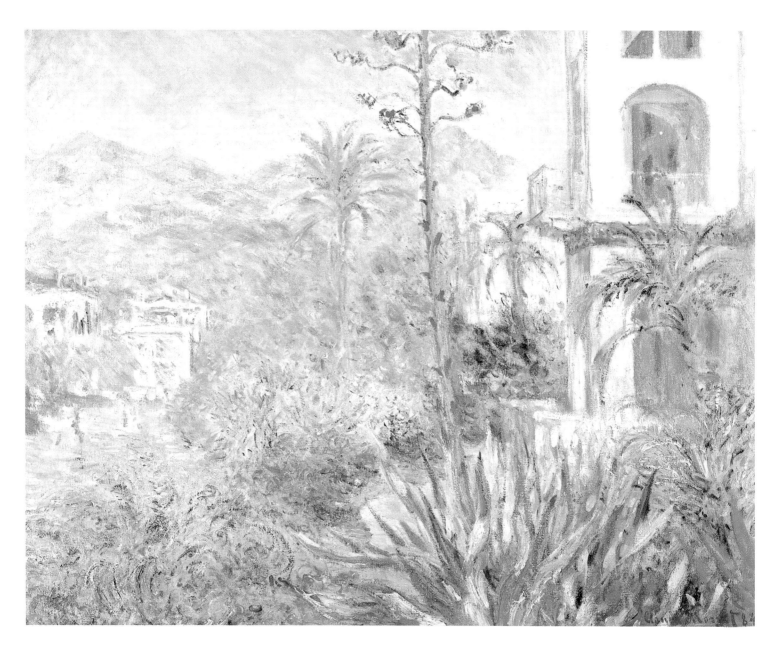

Villas at Bordighera, 1884
Les Villas à Bordighera
Oil on canvas, 115 x 130 cm
Wildenstein II. 857
Santa Barbara (Cal.), The Santa Barbara
Museum of Art

enchanted with the country,' wrote Monet to Durand-Ruel. And indeed, he painted here a succession of pictures characterized by a powerful and luminous palette, whose expressiveness goes far beyond reality and thereby recalls the work of both van Gogh and the Fauves. The emphasis upon arabesque shapes of vegetation created in dynamic brush-strokes corresponds to this new expressivity. These pictures clearly indicate that the impression received by the artist in front of the motif is an essential factor in the creation of the picture, and that Monet is leaving his Argenteuil days behind him. In mid-April, heavily laden with new pictures and impressions, Monet began his journey home – not without difficulties at the Italian customs, who proved unwilling to let his works cross the border without hindrance.

Durand-Ruel, who was now expanding towards America since business in France was bad, was only able to buy a small proportion of the new works. Monet felt it necessary to resume contacts with other dealers, such as Petit and Adolphe Portier. Monet's shrewd tactics and his skill at playing one dealer off against another later led Durand-Ruel to accuse him of ingratitude. But it was no more than commercial acumen applied to painting. Art dealers such as Portier visited the artist at home in Giverny in order to buy from him direct. Portier was also prepared to barter for his purchases with works by Monet's Impressionist colleagues. It was partly to him that Monet owed his exclusive collection of Impressionist paintings. He owned twelve Cézannes, nine Renoirs, four Manets, three Pissarros and five Morisots as well as works by Sisley, Degas, Fantin-Latour, Daubigny, Corot, Delacroix, Jongkind, Boudin and younger painters such as Signac, Vuillard and Albert Marquet. Monet's financial situation undoubtedly improved considerably during this period, so much so that Gauguin was soon telling his wife that Monet earned about a hundred thousand Francs a year.

In August 1884 Monet once more set off with the children for Etretat and the Normandy coast. Here he met the singer Jean-Baptiste Faure and his wife, who owned a villa in Etretat, which they were to place at Monet's disposal the following year. Bad weather and the permanent presence of the children meant it was not a fruitful stay. Back in Giverny, Monet devoted himself throughout the autumn and winter to various views of the surrounding countryside. In the spring of 1885 he showed ten landscapes in the fourth International Exhibition of Painting in Petit's gallery. Monet returned to Etretat in September 1885 upon Faure's invitation and remained there until the beginning of December. Important seascapes such as *The Manneporte near Etretat* (p. 134) and *Boats in Winter Quarters, Etretat* (p. 141), a picture whose expressivity deeply impressed van Gogh, were the fruits of this stay.

Monet's work was greatly admired amongst the young independent artists, a fact which Theo van Gogh – then branch

manager of the Goupil gallery in Paris – frequently remarked to his brother Vincent. Monet felt himself under increasing pressure to continue to be successful and this – in conjunction with his own perfectionist standards – sent him into bouts of crippling depression and self-doubt, although also distinguishing his art. His supporters included the Morisot-Manets (the painter Berthe Morisot had married Eugène Manet, brother of Edouard, in 1884), whose admiration for his talent knew no bounds. Their regular dinners in Paris, which Monet attended during his trips to town, offered younger artists and others the chance to meet the now increasingly famous painter in person.

Monet's new contacts included not only the novelist Maupassant, whom he had already met in Etretat and who visited him in Giverny in autumn, but also the author Octave Mirbeau. Like Monet, he was a guest at the dinners at the Café Riche, took part

Boats in Winter Quarters, Etretat, 1885
Bateaux sur la plage à Etretat
Oil on canvas, 65.5 x 81.3 cm
Wildenstein II. 1024
Chicago, The Art Institute of Chicago, Charles H. and Mary F.S. Worcester Collection, 1947.95

George Seurat
Sunday Afternoon on the Island of La Grande Jatte, 1884-86
La Grande Jatte
Oil on canvas, 207.6 x 308 cm
Chicago, The Art Institute of Chicago,
Helen Birch Bartlett Memorial Collec
tion, 1926.224

Self-Portrait with Beret, 1886
Autoportrait de Claude Monet,
coiffé d'un béret
Oil on canvas, 56 x 46 cm
Wildenstein II. 1078
Private collection

in the meetings of Les Bons Cosaques and was invited to Banlieu gatherings, whose chairman was Edmond de Goncourt. Both loved sailing and took a joint sailing trip down the Normandy coast in 1895. More important, however, they shared an enduring passion for gardening and rare flowers, in which they were joined by Caillebotte, a welcome guest in Giverny. Mirbeau soon become one of Monet's favourite authors, while Mirbeau in turn felt a particular affinity towards Monet's art. The similarity in their attitudes to nature is revealed in a letter from Mirbeau to Monet written on the occasion of a planned meeting: 'We shall, as you say, only talk about gardening, since art and literature are mere vanities. The earth alone is important, and I love it as one loves a woman.' For Monet, too, the withdrawal into nature brought him longed-for security, escape and healing, as was increasingly confirmed by his painting.

The following year, 1886, proved a watershed not only for Monet, but for the art of the 19th century as a whole. It was the year of the eighth and last Impressionist exhibition in which Monet, despite Pissarro's entreaties, did not take part. He harboured absolutely no sympathies for the new tendencies it manifested in the neo-Impressionist works of Seurat, Signac and Pissarro. Neo-Impressionism emerged just at a point when Monet's own style was at last finding acceptance and must have appeared to him as competition. The neo-Impressionists sought to elevate the Impressionist principle of colour division, the juxtapositioning of pure colours, to a strict, schematic method of working. They thereby drew upon recent scientific findings in the fields of colour theory and optics. These included Chevreul's theory of the simultaneous contrast of colours (1839 and 1869), the scientific

treatises by Hermann von Helmholtz and the Gestalt theories of Charles Blanc (1867). They saw their art as an exact, objective and scientifically-based form of Impressionism which was intended to replace the arbitrary, subjective and Romantic image of earlier Impressionism. They sought to give landscape a definitiveness and impression of permanence as argued by Cézanne. But contrary to their desire to render the chromatic appearance of reality with greater accuracy, the schematism of neo-Impressionist works made them more subjective and artificial than the Impressionism they wanted to overcome. The dogmatic rigidity and 'deathly monotony' of its method had already led Pissarro to abandon it for a freer style of painting by 1888. Neo-Impressionism was launched at the 1884 Salon des Indépendents in the form of Seurat's *Bathing at Asnières* (1883/84; London, National Gallery); by the eighth and last Impressionist show, which included Seurat's most famous work, *Sunday Afternoon on the Island of La Grande Jatte* (p. 143), it had become the dominant trend.

Woman with a Parasol, 1886
Femme à l'ombrelle
Pencil drawing, 53 x 41 cm
Private collection

1886 was also the year in which van Gogh came to Paris and, following his encounter with Impressionist works, developed his luminous and powerful palette. Gauguin had now moved to Pont-Aven in Brittany, where he formed the Pont-Aven School together with Emile Bernard in 1888. Their 'Synthetist' painting greatly influenced a new style of Symbolist art, which owed its inspiration to the Symbolist literature which had been appearing since 1880. Important authors included Stéphane Mallarmé and Joris-Karl Huysmans, whose novel *Against Nature* (1884) became a manifesto of the Symbolist art of living. Their aims were defined in the short-lived journal *Le Symboliste* (started in 1885) and the *Manifeste du Symbolisme* by Jean Moréas (1886). This new art rejected the naturalistic illustration of banal reality and sought instead to suggest the mysterious and invisible relationships between objects in this world. Landscapes were thereby understood as vehicles of mood and elementary forces, a point which relates Symbolism to Romanticism.

Monet displayed an increasing affinity with such ideas from 1880 onwards, and his late works in particular reflect the thinking of Mallarmé. Such affinities are also suggested by Monet's participation, probably on the urging of Octave Maus, in the 1886 exhibition of 'Les Vingt,' an exhibiting society founded in 1884 which made significant contributions to European Symbolism. The Impressionist exhibition organized by Durand-Ruel in New York in the spring of 1886 also helped publicize Monet's work abroad. It included 48 of his pictures and was to prove highly successful for the artist.

In his novel *The Masterpiece*, which appeared in 1886, Zola revealed himself to be less approving of the work of Monet and his Impressionist colleagues. The book was a judgement upon the painting of Impressionism. Its publication permanently ruined

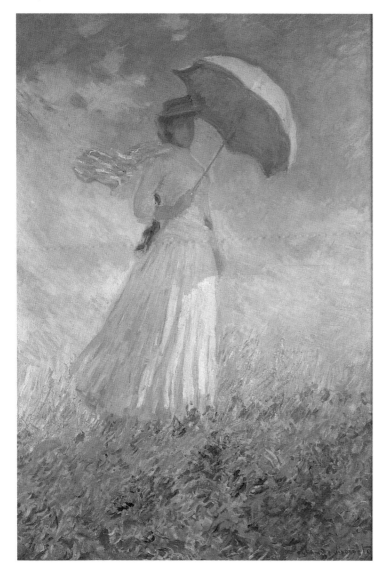
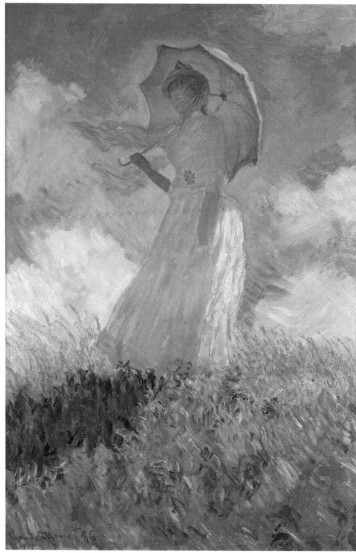

the friendship between Zola and the painter Cézanne, who took the book's main character, artist Claude Lantier, to be himself. Monet and Pissarro were equally outraged, and feared the book might damage them in the eyes of the public. As Monet wrote to Pissarro: 'Have you read Zola's book? I'm very afraid it will do us a lot of harm.' The figure of Lantier was in fact based upon a number of the various Impressionist painters Zola knew personally.

After a short painting trip to Holland in the spring of 1886, Monet – accompanied by Blanche Hoschedé – spent the summer painting the countryside around Giverny. Among other works from this period, he produced two large-format *Open-air Figure Studies* (p. 145) on the Ile des Orties, a small island near the point where the Epte flows into the Seine. As Camille had done earlier, so now Suzanne Hoschedé posed as his model. She is seen standing on a slope with a parasol, silhouetted against the open sky.

These magnificent compositions, painted with forceful strokes

Open-Air Study: Woman Turned to the Right, 1886
Essai de figure en plein air, vers la droite
Oil on canvas, 131 x 88 cm
Wildenstein II. 1076
Paris, Musée d'Orsay

Open-Air Study: Woman Turned to the Left, 1886
Essai de figure en plein air, vers la gauche
Oil on canvas, 131 x 88 cm
Wildenstein II. 1077
Paris, Musée d'Orsay

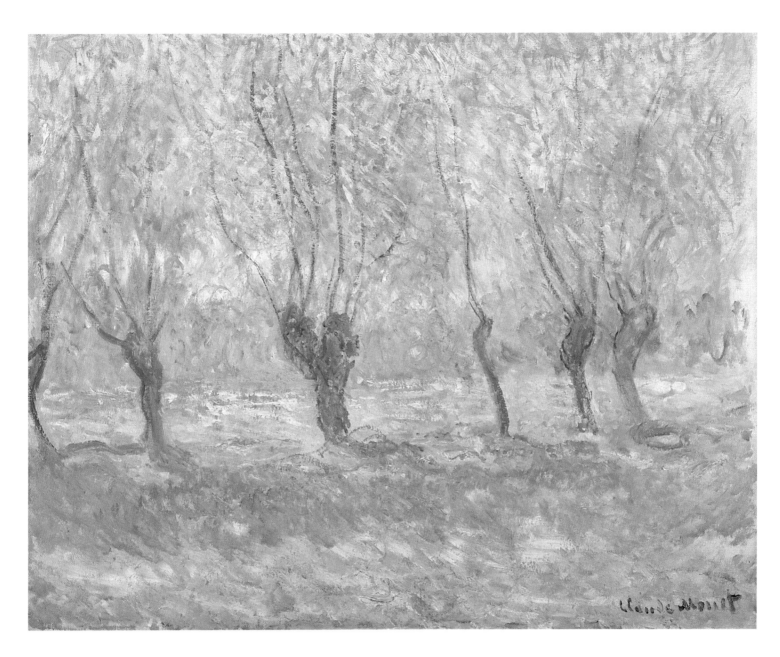

Willows at Giverny, 1886
Les Saules, Giverny
Oil on canvas, 74 x 93 cm
Wildenstein II. 1059
Göteborg, Göteborgs Konstmuseum

RIGHT ABOVE:
Spring, 1886
Le Printemps
Oil on canvas, 65 x 81 cm
Wildenstein II. 1066
Cambridge (Mass.), Fitzwilliam Museum

Field of Yellow Iris near Giverny, 1887
Champ d'iris jaunes à Giverny
Oil on canvas, 45 x 100 cm
Wildenstein III. 1137
Paris, Musée Marmottan

of the brush, nevertheless lack the power of expression which characterized the portraits of Camille. They were Monet's last attempts at large-scale, full-figure representations. As part of his constant search for pictorial subjects, Monet discovered entirely new motifs in the wild, sombre rock landscapes of Belle-Ile during his stay in Brittany from September to December 1886. He wrote to Durand-Ruel: 'The sea is inimitably beautiful and accompanied by fantastic rocks. Moreover, the place is called "The Wild Sea"I'm fascinated by this sinister region, above all because it takes me beyond my normal limits; I must admit I am having to really punish myself in order to render this gloomy and fearful atmosphere.'

He had come at a good time. There were no tourists and hardly any bathers, and Monet, who always sought solitude, was thus alone with nature and the local fisherman. For Monet, it was a plunge into the unknown, a battle in which – under the most difficult of conditions – he had to triumph on canvas. Gustave Geffroy, who here made Monet's acquaintance and who was permitted to accompany him on his painting excursions, remembered how gusts of wind would tear both brush and palette from Monet's hands as he worked on *Belle-Ile Rocks* (p. 148) in the wind and rain, and how his easel had to be anchored with ropes and stones. Both men were staying in a simple inn in Kervilhaouen, where they met in person for the first time; Monet had known Geffroy previously only through correspondence. Geffroy was at that time a journalist for Georges Clemenceau's journal 'La Justice'

Storm, Belle-Ile Coast, 1886
Tempête, Côte de Belle-Ile
Oil on canvas, 65 x 81.5 cm
Wildenstein II. 1116
Paris, Musée d'Orsay

and was thus largely responsible for the later friendship between Monet and Clemenceau.

In the pictures painted in Brittany, the pounding of the waves against the rocks forms the occasion of colour contrasts and gradations, while the extensive rejection of naturalistic reproduction assigns the pictures a symbolic dimension. Rocks and needles are set dramatically against the sea while the line of the horizon is reduced to a minimum, producing a pictorial surface occupied almost entirely by water and rocks. The palette is both muted and unnaturally intense, determined by powerful contrasts. While in *The Wild Sea* (p. 149) the drama derives from the stormy waves of the sea, the tension in *Belle-Ile Rocks* (Reims, Musée de Beaux-Arts) lies in the lighting, with its juxtaposition of large areas of shadow and sunlight and a palette which is intensified to the point of unreality. In these pictures, landscape becomes

The Wild Sea, 1886
La Côte sauvage
Oil on canvas, 65 x 81 cm
Wildenstein II. 1100
Paris, Musée d'Orsay

149

Antibes, Afternoon Effect, 1888
Antibes, effet d'après-midi
Oil on canvas, 65 x 81 cm
Wildenstein III. 1158
Boston, Museum of Fine Arts
Courtesy, Museum of Fine Arts, Boston

the vehicle of primeval forces and emotional tensions which vent themselves in raw and abstract brushwork. As earlier in his unusual views of the cliffs at Dieppe and the monumental rock formations of Etretat, Monet here concentrates entirely upon the dramatic nature of his setting. Elemental opposites and extreme weather and lighting conditions had preoccupied him since the Breakup of the Ice paintings in Vétheuil, and marked his departure from the Impressionist style of the Argenteuil period.

The views of Belle-Ile were among the 15 works which Monet showed at the sixth International Exhibition of Painting held by Petit in May 1887. The critics were divided in the face of these unusual paintings. Some accused Monet of roughness, brutality and lack of artistic pleasantness, while others, such as Mirbeau, were full of praise. Monet had reason to be satisfied with the results of the exhibition, since almost all his pictures found buyers.

The powerfully emotional nature of the works from Belle-Ile found its counterweight in the sweetness of the pictures which Monet painted at the beginning of 1888 in Antibes on the Côte d'Azur, where he stayed from February to May in the Château de la Pinède. He was enraptured by the southern landscape and its lighting. 'There is nothing but blue, pink and gold,' he wrote to Geffroy; 'I plug away, give myself a devil of a time, and worry about what I'm doing. It is so beautiful here, so clear, so luminous! You swim in blue air, it's frightful.' He clearly found it very difficult to match his palette to the local conditions, to the blues and pinks permeating the atmosphere. He faced the same problem

View of the Esterel Mountains, 1888
Montagnes de l'Esterel
Oil on canvas, 65 x 92 cm
Wildenstein III. 1192
London, Courtauld Institute Galleries

as earlier in Bordighera, namely how to convey in painting the absolute intensity of the light. In *Antibes, Afternoon Effect* (p. 150) for example, he sought to render this remarkable luminosity by placing warm accents within a series of pale shades of blue; these blue-pink contrasts are strengthened through Monet's use of carefully-coordinated sequences of colour underlaying his southern blue. Paints are also mixed with more white than before, and shadows lightened. Monet made masterly use of coordinated colour sequences to create atmospheric moods in his later series of Cathedrals and Grain Stacks. This detailed elaboration and finishing inevitably had to take place in the studio. Monet's personal experimentation thus led him to the maxim which Cézanne was not to formulate until many years later: 'I wanted to copy nature, but I couldn't. I nevertheless felt a sense of achievement when I discovered that sunlight cannot be reproduced, but has to be represented by something else . . .by colour.'

Like *Antibes, Afternoon Effect* (p. 150), the *View of the Esterel Mountains* (p. 151), a chain of crouching hills strung out opposite the bay of Juan-les-Pins near Antibes, is essentially horizontal in its construction of layered colour planes. Colour harmony is determined by approximated rows of blue-orange and red-green and thereby embraces the three primaries of red, yellow and blue. The line of the tree in the foreground coils across the picture like a *Jugendstil* arabesque. It creates rhythm and at the same time a sense of near and far space. In June Monet showed ten of his Antibes landscapes in the Boussod-Valadon gallery, whose director, Theo van Gogh, was one of his regular buyers. This

caused further disagreement with Durand-Ruel, with whom Monet subsequently terminated his contract. These new works were sold primarily to the American public, and Mirbeau was not alone in deploring their irreparable loss. His enthusiasm was not shared by everyone, however. Pissarro, Degas, and Félix Fénéon, mouthpiece of the neo-Impressionist movement, criticized Monet's latest creations as superficially decorative, although even they had to admire his virtuouso hand.

Apart from a short trip to London, Monet spent the summer of 1887 in Giverny. Here he painted a number of highly poetic, less sales-oriented summer landscapes, such as the *Field of Yellow Iris near Giverny* (p. 147). He executed several versions of dreamy paintings showing his later step-daughters Suzanne, Marthe, Germaine and Blanche Hoschedé in a rowing-boat on the Epte in summery surroundings. *In the Rowing-Boat* (p. 155) contains, from left to right, Germaine, the youngest, then the pretty young Suzanne, then Blanche, the eldest. Monet wanted to reproduce the water and grass swaying below its surface, although as he himself commented, 'it is wonderful to look at; but trying to render it is enough to send you mad.' The blue-green of the water and vegetation is harmoniously complemented by the flattering pinks of the figures. The charm of young girls in a happy summer atmosphere and the tranquil and unspoilt nature around them recall Proust's novel, *Within a Budding Grove* (1918), and its reference to the impermanence of youth: 'The faces of these girls . . .were for the most part blurred with this misty effulgence of a dawn from which their actual features had not yet emerged . . .hence we feel, in the company of young girls, the refreshing sense that is afforded us by the spectacle of forms undergoing an incessant process of change, a play of unstable forces which recalls that perpetual re-creation of the primordial elements of nature which . . .moves the soul so profoundly.'

The reflection of the tender pinks of the girls' figures throughout the nature around them reveals just how far these paintings illustrate the Romantic notion of nature as a female being. Symbolic art, too, saw feminized landscape as housing the mysterious sources of life, a belief formulated in *The White Water Lily* (1885) a poem by Mallarmé which anticipates Monet's own Water Lilies. The concept of a dynamic unity of being, of man and nature, led to the development of corresponding symbols, motifs and themes in turn-of-the-century painting, in particular in the art of Symbolism and *Jugendstil*. A role was thereby taken not only by water and water reflections, in which objects are both combined and dissolved, but also by the water lily, a flower which only blossoms on swampy ground and thus seemed particularly linked to the sources of undivided life. Both the *Rowing-Boats* and Monet's later *Water Lilies* thus appear closely related to a female mythos prevalent in art around the turn of the century.

The dramatic and gloomy rock landscapes of Etretat and Belle-Ile

and the sweet, luminous and more decorative paintings from
Bordighera and Antibes also reflect the distinction in Monet's
work between masculine and feminine landscape in the Romantic
sense, a distinction influencing the choice and treatment of his
subjects. They reveal at the same time the contradictory ten-
dencies within the artist which were to find their solution in the
later water lily landscapes.

Serious and dramatic moods are also taken up in the Creuse
landscapes painted in the spring of 1889. In February 1889 Monet,
accompanied by Geffroy, was the guest of writer and musician
Maurice Rollinat at his home in Fresselines in the Creuse valley,
a relatively unspoilt and sparsely populated area between Orléans
and Limoges. Monet was enchanted. He explored the countryside
with Rollinat during the day and in the evening listened to his
host's musical compositions, based both on texts by Baudelaire
and on Rollinat's own poems. In March, therefore, on the occasion

Poppy Field in a Hollow near Giverny,
1885
Champ de coquelicots, environs de
Giverny
Oil on canvas, 65.2 x 81.2 cm
Wildenstein II. 1000
Boston, Museum of Fine Arts, Juliana Che-
ney Edwards Collection
Courtesy, Museum of Fine Arts, Boston

153

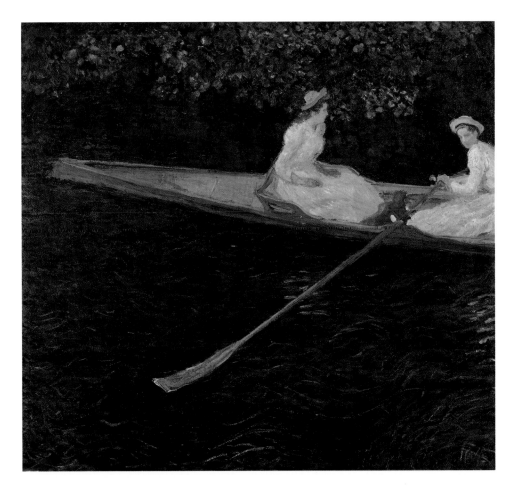

LEFT:
The Rowing-Boat, 1887
La Barque
Oil on canvas, 146 x 133 cm
Wildenstein III. 1154
Paris, Musée Marmottan

RIGHT:
Boating on the Epte, 1890
En Canot sur l'Epte
Oil on canvas, 133 x 145 cm
Wildenstein III. 1250
São Paulo, Collection of the Museu de
Arte de São Paulo

BELOW:
In the Rowing-Boat, 1887
En Norvégienne
Oil on canvas, 98 x 131 cm
Wildenstein III. 1151
Paris, Musée d'Orsay

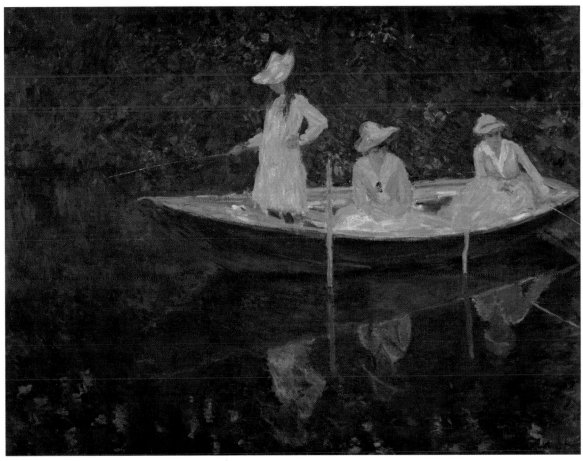

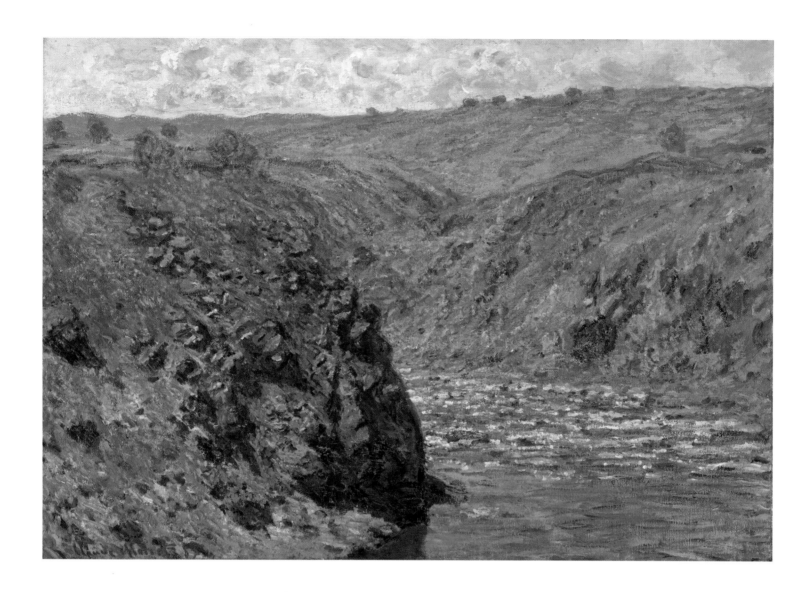

Ravine at La Creuse, Sun Effect, 1889
Les Eaux semblantes, Creuse, effet de
soleil
Oil on canvas, 65 x 92.4 cm
Wildenstein III. 1219
Boston, Museum of Fine Arts, Juliana Che-
ney Edwards Collection, Bequest of Robert
J. Edwards in memory of his mother, 1925
Courtesy, Museum of Fine Arts, Boston

of a further exhibition of his works at the Bousson-Valadon gallery, he decided to spend another three months in Fresselines. But bad weather sent him into despair, and he suffered phases of deep depression and self-tormenting doubt. 'I am utterly miserable, almost discouraged and so tired that I am almost ill . . . I have never been so unlucky with the weather! Not so much as three fine days in a row, so that I am obliged to make continual changes, since everything is growing and blossoming. And I was so hoping to paint Creuse as we saw it [in February]! . . . In short, all these changes mean I am just chasing nature without being able to catch it. And then there's the river, which falls and rises, is green one day, then yellow and just recently dried up altogether,' complained Monet to Geffroy.

In contrast to the luminosity and tenderness of the Antibes pictures of the year before, Monet had here wanted to render the stern mood of winter. But the constant rain delayed his work, and buds started to appear on a tree he wanted to paint. Instead of abandoning his original plan, he at once had two farmhands remove these first signs of spring so that he could continue with his work. Not for the first time is nature here made the subject

and servant of art. The 23 landscapes which have survived from this Creuse stay can be subdivided into a number of different groups, each containing several variations of an almost identical motif. *Ravine at La Creuse, Sun Effect* (p. 156) belongs to a series of another eight identical compositions deviating only slightly in format and angle. They are differentiated chiefly by their lighting, varying according to weather and time of day. The concept of serial painting, which began in the paintings of the *Breakup of the Ice* (p. 115) and was developed in the seascapes of *Belle-Ile* (p. 148/149) and the Giverny *Rowing-Boats* (p. 154/155), now appears to be crystallizing.

Ravine at La Creuse, Sun Effect (p 156) is characterized by large bodies of rock thrusting inwards from left and right, whereby the brightest area of the painting, the water, forces itself between them from the right-hand foreground. This area alone catches the light from the narrow strip of sky at the top of the picture, as the clouds part for a brief moment. The drama of the scene is reinforced by the relatively dark palette of brown, blue and violet, whose sole justification seems to be the fissured ravine walls. Once again these landscapes bring alive both the relationships of the elements and the dramatic play of light staged both in the heavens and on the surfaces of objects, whose forms in turn provide the radical mood with its pictorial counterweight. The astonishing expressiveness with which the paint is applied, and the power of the colours employed, can well be seen as a pointer towards future Expressionism.

Contemporary critics, however, commenting on these pictures upon their exhibition at Petit's gallery in June 1889, blamed Monet's departure from naturalistic colour on eye trouble – a historically unjustifiable accusation which, incidentally, can be found repeated in criticism of Impressionist art even today. Petit's exhibition, coupling Monet and August Rodin and offering an overview of the years 1864 to 1889 in a total of 145 works, was nevertheless a huge success. The majority of the Creuse landscapes were sold direct to America, where Monet's fame was growing steadily. This was due in part to the agencies of John Singer Sargent, the Anglo-American painter who was in close contact with Monet. This year saw Monet reach one of the pinnacles of his artistic career. He was represented by three works at the Paris World Fair, which was simultaneously celebrating the centenary of the French Revolution and featured the specially-built Eiffel Tower. The exhibition provided a retrospective of the last 100 years of French art; the Impressionists, whose style now enjoyed general recognition, were also included.

Manet's *Olympia* (1863; Paris, Musée d'Orsay) was also on display. Sargent had discovered that this picture was to be sold to America. Alerted to this danger, Monet resolved to organize a collection of funds with which to purchase the picture from Manet's widow and donate it to the Louvre. Antonin Proust and

Zola were among a number of Monet's friends who disapproved of the idea. Monet was subsequently caught in the crossfire of a public dispute which lasted for almost a year and in the course of which Proust challenged Monet to a duel. Fortunately this never took place. Not surprisingly, Monet could muster little enthusiasm for painting during this period; it was not until November 1890 that the Louvre accepted the donation and the debates it had provoked subsided.

Monet was also prevented from working by a summer of continuous rain. The damp weather gave him severe rheumatism, which he blamed on his punishing earlier outings in the snow, frost and rain and which made painting a struggle. He was also worried about his son Jean, who had fallen seriously ill while on military service. Monet now devoted all his energies to mobilizing his contacts in order to secure Jean's release. Guests such as Morisot and Mallarmé therefore provided a welcome distraction.

Monet thus felt compelled to work in and around Giverny even as summer drew to a close. He later recalled how, during one of his late summer walks through the countryside in the company of Blanche, he was struck by a row of grain stacks in neighbouring Clos Morin. These were a local method of storing grain, whereby ears of cereal were covered with hay to protect them from external weather conditions. Monet wanted to record this sunny picture and asked Blanche to fetch him a canvas. 'At the start, I was just like everyone else: I thought two canvases would be enough, one for cloudy weather and one for sunshine. But no sooner had I begun to paint the sunshine than the lighting changed, so that two canvases were no longer enough if I was to render a truthful impression of a specific aspect of nature and not end up with a picture compiled from a number of different impressions,' remembered Monet. And so Blanche had to fetch several more canvases to enable him to record different atmospheric effects face to face with nature, in a style of painting which was inevitably sketchy and rushed. He devoted himself to this new motif from the late summer of 1890 until the winter of 1890/91. When, finally, he assembled all the pictures together in his studio, he decided they needed further work, both in the elaboration of their detail and the coordination of their colours, with the result that every picture in the *Grain Stacks* series both determines and anticipates the next. This involved not only a new method of working, but also a new understanding of reality, according to which a holistic vision of nature can only be achieved through the combination of several of its different aspects.

At this point, however, Monet's work reveals a paradox. On the one hand, he sought to remain true to nature; on the other hand, his elaboration of pictures in the studio increasingly allowed his imagination to play a role. Monet explained the problem to Geffroy: 'I'm plugging away at a series of different effects [of Grain Stacks], but the sun goes down so quickly at this time of

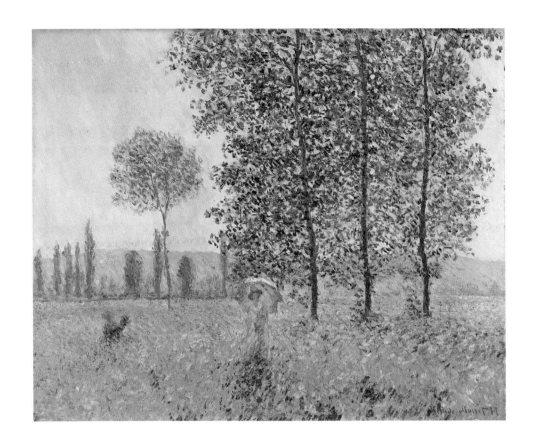

Under the Poplars, Sun Effect, 1887
Sous les Peupliers, effet de soleil
Oil on canvas, 74 x 93 cm
Wildenstein III. 1135
Stuttgart, Staatsgalerie Stuttgart

year that I can't keep up with it . . . I despair at how slow I'm becoming, but the more I do, the more I see what a lot of work it takes to render what I am looking for: "instantaneity," above all the *enveloppe,* the same light diffused everywhere. I'm all the more disgusted with the things that succeed at first go. In short, I am driven more and more by the need to render what I experience.'

Monet uses more or less the same format throughout the Stacks series. They all show one or two grain stacks, although there may be small modifications to their locations. Monet chiefly uses weather and lighting conditions to differentiate his paintings, as reflected in their corresponding associative colouring. He painted the motif on a snowy morning (p. 162 below), in late summer (p. 160), during the thaw (p. 163 below) and at sunset (p. 161), as well as in fog, ice, rain and bright sunshine. Monet frequently worked against the light (p. 164/165), with the glittering, silhouetted shapes of the ricks casting long, coloured shadows (p. 163 above).

The Stacks series, and thus the year 1890, marked a turning-point in Monet's work. The idea of creating several pictures from one motif was logically exploited from now on. It may be noted in passing that Monet was following an example set by two Japanese artists he greatly admired, namely Hokusai in his *One Hundred Views of Mount Fuji* and Hiroshige in his *One Hundred Views of the City of Edo.* He had seen these works both at Samuel Bing's in 1888 and at the World's Fair of 1889. Hiroshige was Monet's favourite artist and his prints decorated the dining room at Giverny.

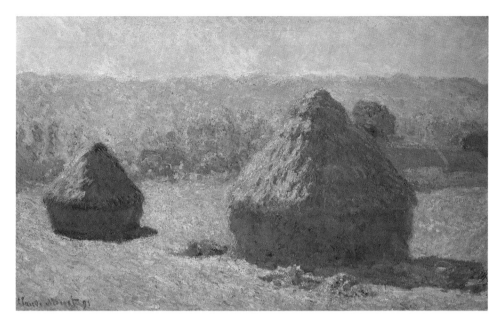

Grain Stacks, End of Summer, Morning Effect, 1891
Meules, fin de l'été, effet du matin
Oil on canvas, 60.5 x 100.5 cm
Wildenstein III. 1266
Paris, Musée d'Orsay

While the idea of painting several versions of the same motif was not new – it had been suggested in the Gare Saint-Lazare pictures (p. 94/95) –, it was now linked to an increasing restriction of objects and a growing sense of magnification. Then as now, science-loving art critics sought to equate Monet's serial procedure with scientific method. Some went so far as to find parallels with serial mathematical theories of the times. But Monet abhorred the idea of painting based on theory. 'I have always had a horror of theories,' he said. The family nature of these serial pictures – a factor Monet continued to stress in his later series – was illustrated by Durand-Ruel's exhibition of fifteen Grain Stacks in May 1891. The exhibition made an enormous impact. All the pictures were sold within just a few days, leading Monet's colleagues – including Pissarro – to accuse him of mass-producing art for commercial reasons and of being corrupted by success. There is no historical evidence to support these viewpoints, however.

The Grain Stacks were a particular success with young independent painters such as Piet Mondrian, André Derain and Maurice Vlaminck. Wassily Kandinsky saw one in a Moscow exhibition in 1895 and recognized – in its representational reduction – the first abstract picture without object: 'Suddenly, for the first time, I saw a picture. I only learned that it was a grain stack from the catalogue. I couldn't recognize it myself . . . I vaguely realized that the object was missing from this picture . . . What it made fully clear to me, however, was the unimaginable power of the palette, a power I had never even suspected.'

One consequence of the widespread recognition which Monet now enjoyed was the arrival in Giverny of numerous American artists wishing to be near the 'great master.' One of these was the painter Theodore Robinson, who was given the privilege of working with Monet. Another American, Theodore Butler, even-

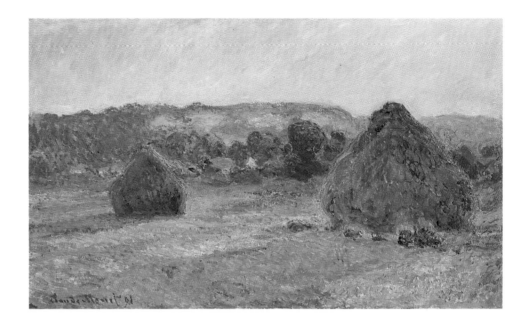

Grain Stacks, End of Summer, Evening Effect, 1891
Meules, fin de l'été, effet du soir
Oil on canvas, 60 x 100 cm
Wildenstein III. 1270
Chicago, The Art Institute of Chicago,
Arthur M. Wood in memory of Pauline
Palmer Wood, 1985.1103

Grain Stacks
Meules
Pencil drawing, 15 x 24 cm
Private collection

PAGE 162 ABOVE:
Grain Stack, Snow Effect, Morning, 1890
Meule, effet de neige, le matin
Oil on canvas, 65.4 x 92.3 cm
Wildenstein III. 1280
Boston, Museum of Fine Arts, Gift from
Misses Aimée and Rosamond Lamb in
memory of Mr. und Mrs. Horatio A. Lamb
Courtesy, Museum of Fine Arts, Boston

PAGE 162 BELOW:
*Grain Stack, Snow Effect, Overcast
Weather*, 1891
Meule, effet de neige, temps couvert
Oil on canvas, 66 x 93 cm
Wildenstein III. 1281
Chicago, The Art Institute of Chicago,
Mr. und Mrs. Martin A. Ryerson Collec-
tion, 1933.1155

tually became a member of the Monet-Hoschedé family when he married Suzanne Hoschedé in 1892. This relationship was perpetuated even after the early death of Suzanne in 1899 through his marriage to Marthe Hoschedé. Sargent was also often in Giverny. Monet's relations with America were intensified by one-man shows in New York in 1891 and in Boston in 1892. Increasing numbers of private American collectors were also descending upon Giverny in person.

The financial successes of the last few years enabled Monet to buy his house and garden in Giverny, which he was then able to lay out according to his own designs – a task in which he was assisted as from 1892 by six gardeners. His relationship with Alice Hoschedé, whose husband Ernest had died in 1891, was also legalized through their marriage on 16 July 1892. Alice, a resolute and determined woman, now had absolute authority over the household, and indeed at times over Monet himself. As he left his home on fewer and fewer occasions, so the number of visitors grew: his painter friends, including Caillebotte and Pissarro plus family, writers, collectors, and above all the statesman Clemenceau, who was deeply attached to Monet and who commemorated this friendship in a book published in 1926.

From spring until autumn 1891, Monet dedicated himself to the Giverny countryside in a series of poplars which stood on the right bank of the Epte, near Limetz. The parish council had unfortunately given permission for these trees to be auctioned off. Monet sought to persuade the mayor to postpone the sale, but in vain. He therefore struck an urgent deal with the most likely buyer, a timber merchant. He offered to make up the difference between the price the merchant wanted to pay and the actual auction price on condition the trees were not felled until he had finished his pictures. The scheme worked. From his boat, Monet painted these poplars on the far side of the Epte both

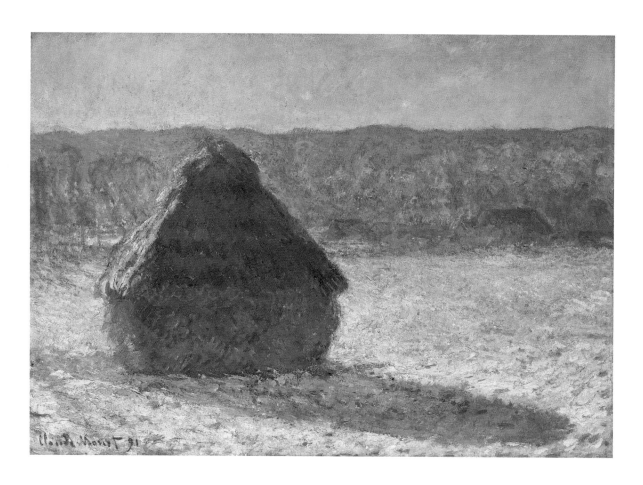

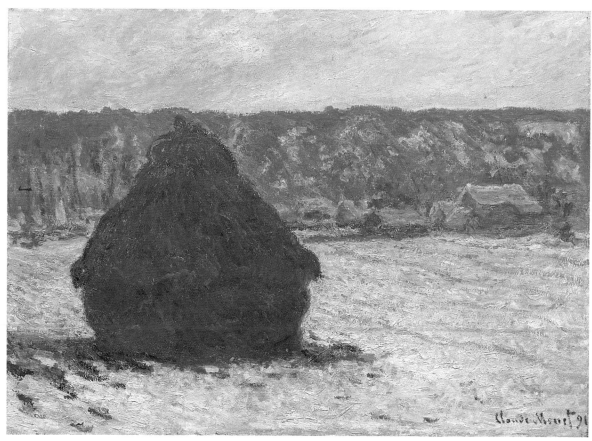

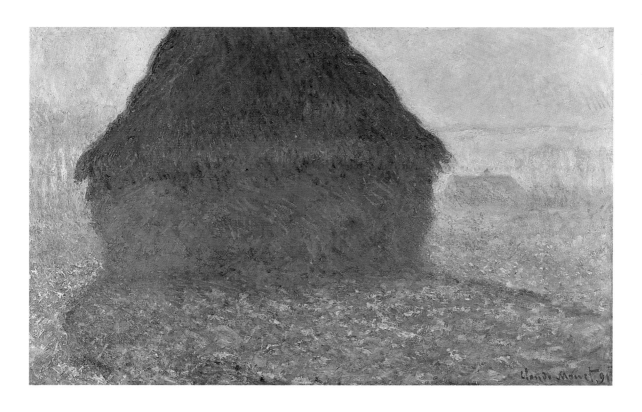

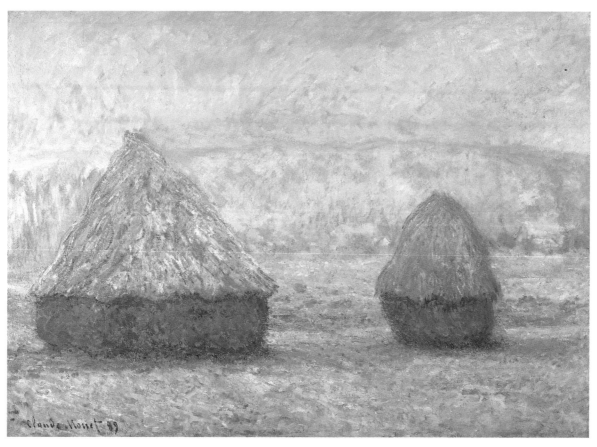

PAGE 163 ABOVE:
Grain Stack in Sunshine, 1891
Meule au soleil
Oil on canvas, 60 x 100 cm
Wildenstein III. 1288
Zurich, Kunsthaus Zürich

PAGE 163 BELOW:
Grain Stack, Thaw, Sunset, 1891
Meule, Dégel, soleil couchant
Oil on canvas, 65 x 92 cm
Wildenstein III. 1284
USA, private collection

Grain Stack, Sunset, 1891
Meule, soleil couchant
Oil on canvas, 73.3 x 92.6 cm
Wildenstein III. 1289
Boston, Museum of Fine Arts,
Juliana Cheney Edwards Collection
Courtesy, Museum of Fine Arts, Boston

in a regular diagonal row from further away and frontally from very close up, as in the *Four Poplars* (p. 168), where the trunks of the trees divide the surface of the picture into vertical strips. These are interrupted only by the horizontal shore zone, whose real image joins seamlessly with its reflection. The boundary between reality and reflection seems meaningless, and the picture offers no sense of space in the traditional sense. It is here quite clear that Monet's abstract forms – such as horizontals and verticals – were merely the starting-point and framework for design based solely on colour. Nature thus corresponded to a particular degree to Monet's own artistic intentions. Here, small dabs of paint in related and complementary pairs of colours such as blue-violet and yellow-orange communicate in miraculous manner the shimmering atmospheric light which cloaks the landscape, diffuses throughout the whole and envelops each and every object.

The strongly decorative tendency of these pictures, reminiscent of the later landscapes of Art Nouveau, met with widespread approval above all at the exhibition of 15 Poplars at Durand-Ruel's gallery in March 1892. Monet travelled back to see the exhibition from Rouen where, since February, he had been tackling his first views of the cathedral. He returned to Giverny in mid-April, resuming the Cathedral series between February and April of the following year. The dating of all of these pictures to 1894 points to another period of reworking. This third series, dedicated to the façade of Rouen's Gothic cathedral, contains 31 works and reflects an entirely new confrontation with the motif.

In February 1892 Monet rented a room opposite the cathedral; from here he painted a small number of frontal views (p. 172/173). A change of lodgings shifted his angle somewhat to the right, only to move further right still in 1893. A total of five different angles can be identified, three from windows opposite the façade and two from the cathedral square. Monet painted either the portal alone (p. 172 right) or with its towers, left the Tour d'Albane (p. 172 left) and right the Tour Saint-Romain. His choice of cropped views, and the previously unknown proximity at which he recorded the monumental Gothic façade, struck his artist contemporaries as entirely new, while his renunciation of spatial distance between painter and object was considered both alienating and revolutionary.

The vital design component of these works is not architectural detail but coloured light. Monet's paintings progressed from dawn to midday and then to afternoon, when the light reached the entire façade, and finally to evening, whose blue and brown hues transformed the stone once more. Here, as in the Grain Stacks, Monet explored the effects wrought by changes in atmospheric conditions and lighting on an unchangeable, solid object. Its parts are thereby caused to project, recede and even melt entirely. The Stacks series (p. 160-165) had already shown how different moods

Poplars on the Banks of the Epte, Seen from the Marshes, 1891
Peupliers au bord de l'Epte, vue du marais
Oil on canvas, 88 x 93 cm
Wildenstein III. 1312
USA, Private collection

Four Poplars, 1891
Les quatre arbres
Oil on canvas, 81.9 x 81.6 cm
Wildenstein III. 1309
New York, The Metropolitan Museum of Art,
Bequest of Mrs. H.O. Havemeyer, 1929.
H.O. Havemeyer Collection (29.100.110)

Poplars, Sunset, 1891
Peupliers, coucher de soleil
Oil on canvas, 102 x 62 cm
Wildenstein III. 1295
USA, Private collection

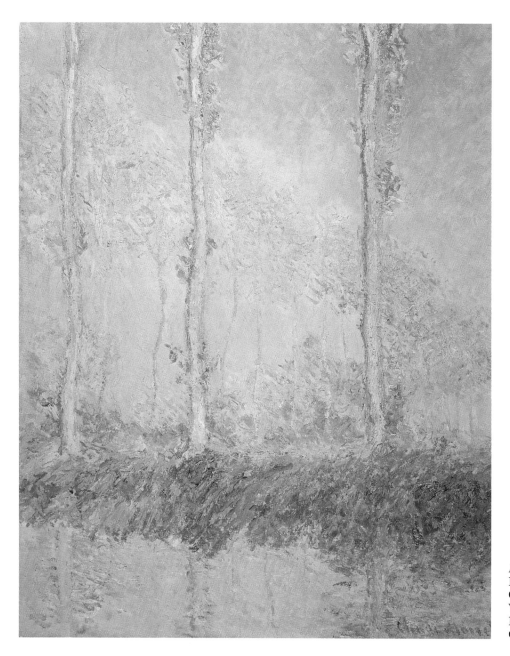

could be expressed through associations of colour. In the Cathe-
drals, too, colour – cheerful, harmoniously cool or warm – reflects
the different impressions received by the artist before his subject.
The pictorial object, described under metamorphosis, is stripped
of its concrete definition. The coloured, modelling light both
moderates the threatening proximity of the architecture and
dematerializes its monumentality. This relates closely to the
Symbolist thinking of Mallarmé, according to which the objects
of the real world cannot be definitively named, but only approxi-
mately described. Monet formulated his underlying metaphysical
view of nature to Clemenceau: 'While you philosophically seek
the world itself, I simply direct my efforts towards a maximum
of appearances, in close correlation with the unknown realities.
When one is on the plane of concordant appearances, one cannot

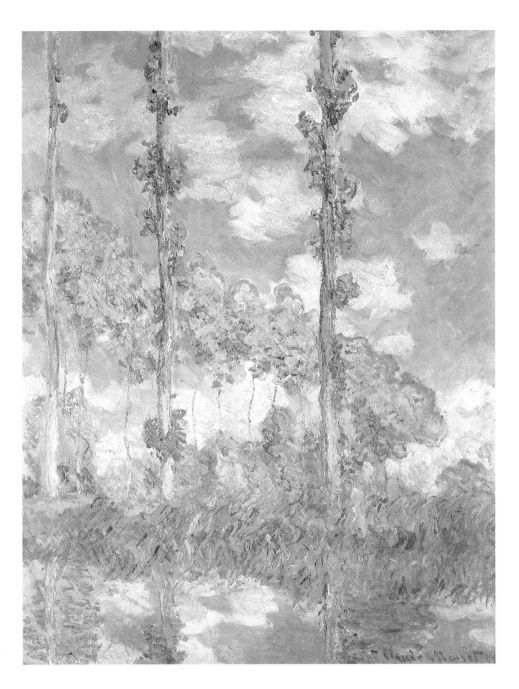

Three Poplars, Summer, 1891
Les trois arbres, été
Oil on canvas, 92 x 73 cm
Wildenstein III. 1305
Tokyo, The National Museum of Western
Art, The Matsukata Collection

be far from reality, or at least from what we can know of it. I have simply observed what the universe has shown me, in order to bear witness to it with my brush Your mistake is to want to reduce the world to your own scale, whereas with a greater understanding of things you would find a greater understanding of yourselves.' This approach was thus far removed from the scientific procedure which positivist art critics, citing contemporary theories from the worlds of biology, mathematics and physics, have sought to identify in Monet's serial painting even in modern times.

Monet's mature painting – seen in Symbolist terms – does not stop at the mere reflection of life, but rather crosses the boundaries of reality to open up new, visionary horizons. It is in this sense that Monet's call for a holistic view of nature and reality should

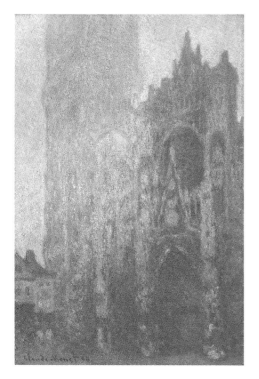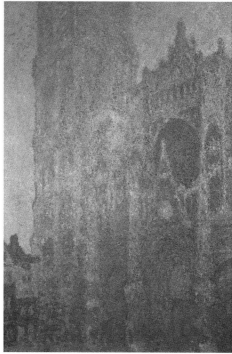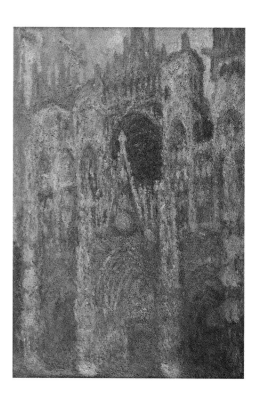

Rouen Cathedral, Portal and Tour d'Albane in the Morning, 1894
La Cathédrale de Rouen, le portail et la tour d'Albane à l'aube
Oil on canvas, 106.1 x 73.9 cm
Wildenstein III. 1348
Boston, Museum of Fine Arts, Tompkins Collection, Purchase, Arthur Gordon Tompkins Residuary Fund, 1924
Courtesy, Museum of Fine Arts, Boston

Rouen Cathedral, Portal, Morning Sun, Harmony in Blue, 1894
La Cathédrale de Rouen, le portail, soleil matinal. Harmonie bleue
Oil on canvas, 91 x 63 cm
Wildenstein III. 1355
Paris, Musée d'Orsay

Rouen Cathedral, Portal and Tour d'Albane, Morning Effect, Harmony in White, 1894
La Cathédrale de Rouen, le portail et la tour d'Albane, effet du matin. Harmonie blanche
Oil on canvas, 106 x 73 cm
Wildenstein III. 1346
Paris, Musée d'Orsay

PAGE 174:
Rouen Cathedral, Portal and Tour d'Albane in the Morning, 1894 (See above)
La Cathédrale de Rouen, le portail et la tour d'Albane à l'aube

be understood. Monet came to recognize, as it were through the intensity of his attitude and attachment to nature, nature *per se*, with the result that it increasingly lost its importance for him as a concrete, specific motif. It had been clear from an early stage – in his Breakup of the Ice paintings, for example – that nature offered him close analogies and parallels with his own spiritual state. The increasing distance between naturalistic painting and Monet's late work, a distance which critics compared unfavourably with his early work, was no more than a logical development which dated back to around 1880 and the dramatic interpretation of the same motif in larger numbers.

In his series of façades, in which fugitive effects are fixed solely by means of an architectural framework, Monet also proved a forerunner of Cubism. The works of Georges Braque and Pablo Picasso from around 1910 similarly transform architectural subjects into autonomous compositions. In 1969, looking back to Monet's Cathedral and Stacks series, Roy Lichtenstein produced his own lithograph series of *Grain Stacks* and *Cathedrals*; he thereby acknowledged Monet as the first artist to have logically exploited the serial principle so important for 20th-century art, and thus the first to have negated the idea of the unique masterpiece by producing a repeatable series of pictures of comparable value. But it was his later Water Lilies which were to demonstrate above all Monet's outstanding importance for the development of modern art.

Monet kept his Cathedral paintings in Giverny for a long while, relinquishing them to Durand-Ruel and Bernheim only after some hesitation. As Monet had intended, this merely heightened the interest and debate surrounding the pictures. After initial doubts,

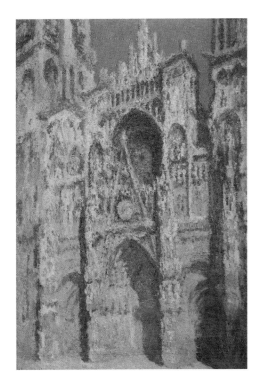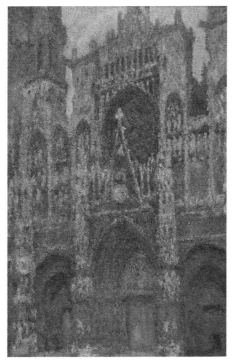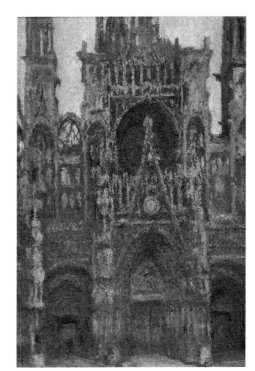

he had become thoroughly convinced of the importance and quality of his paintings, and he set their price at 15,000 Francs and, later, 12,000 Francs. The exhibition of 20 views of Rouen in May 1895 at Durand-Ruel's gallery was an overwhelming commercial success and once again confirmed that Monet had made his breakthrough.

While finishing the Cathedrals over the summer of 1894, Monet found a change of scene in the meadows bordering the Seine around Giverny. Blanche Hoschedé had now become his indispensable assistant. Monet was suffering from severe rheumatism, and it was she who carried all his work materials. Cézanne's arrival in the autumn of 1894 brought further agreeable distraction. He rented accommodation in a hotel in Giverny in order to paint the countryside, and was a frequent guest at the Monet home. It was here, on the occasion of a famous dinner whose guests included Rodin and Clemenceau, that he first met Geffroy, whose portrait he was later to paint. Cézanne was a great admirer of Monet. Monet was the only Impressionist painter he respected and who he felt belonged in the Louvre. This admiration was mutual; Monet owned no less than twelve pictures by Cézanne.

The winter of 1894/95 was, like its predecessor, very mild, and Giverny had thus yet to give Monet a decent opportunity for snowscapes. This may have been one of the reasons for his trip to Norway in the spring of 1895, accompanied by Jacques Hoschedé. After a period of deep depression, which almost led him to return to Giverny, he settled near Sandvika in Björnegaard, in the house of Karoline Reimer, wife of the Norwegian writer Björnstjerne Björnson. A number of other artists were already staying here, including the Danish writer Herman Bang. From

Rouen Cathedral, Portal and Tour d'Albane, Full Sunlight, Harmony in Blue and Gold, 1894
La Cathédrale de Rouen, le portail et le tour d'Albane, plein soleil. Harmonie bleu et or
Oil on canvas, 107 x 73 cm
Wildenstein III. 1360
Paris, Musée d'Orsay

Rouen Cathedral, Portal, Overcast Weather, 1894
La Cathédrale de Rouen, le portail, temps gris
Oil on canvas, 100 x 65 cm
Wildenstein III. 1321
Paris, Musée d'Orsay

Rouen Cathedral, Portal, Front View, Harmony in Brown, 1894
La Cathédrale de Rouen, le portail vu de face. Harmonie brune
Oil on canvas, 107 x 73 cm
Wildenstein III. 1319
Paris, Musée d'Orsay

PAGE 175:
Rouen Cathedral, Portal and Tour d'Albane, Full Sunlight, Harmony in Blue and Gold, 1894 (See above)
La Cathédrale de Rouen, le portail et la tour d'Albane, plein soleil. Harmonie bleu et or

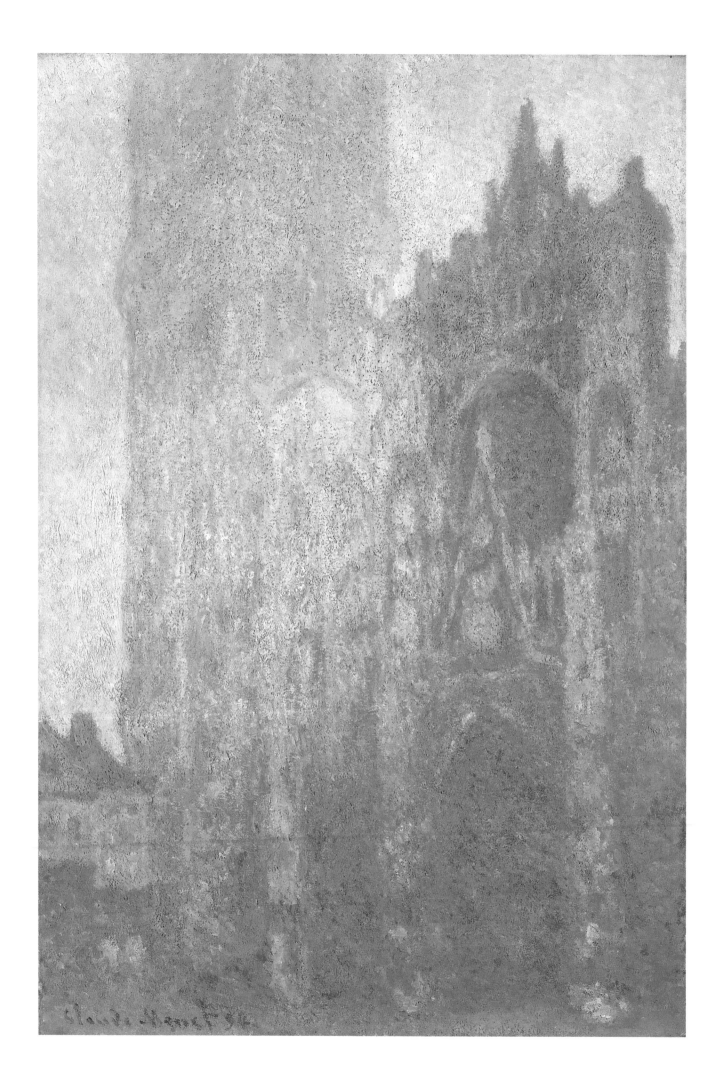

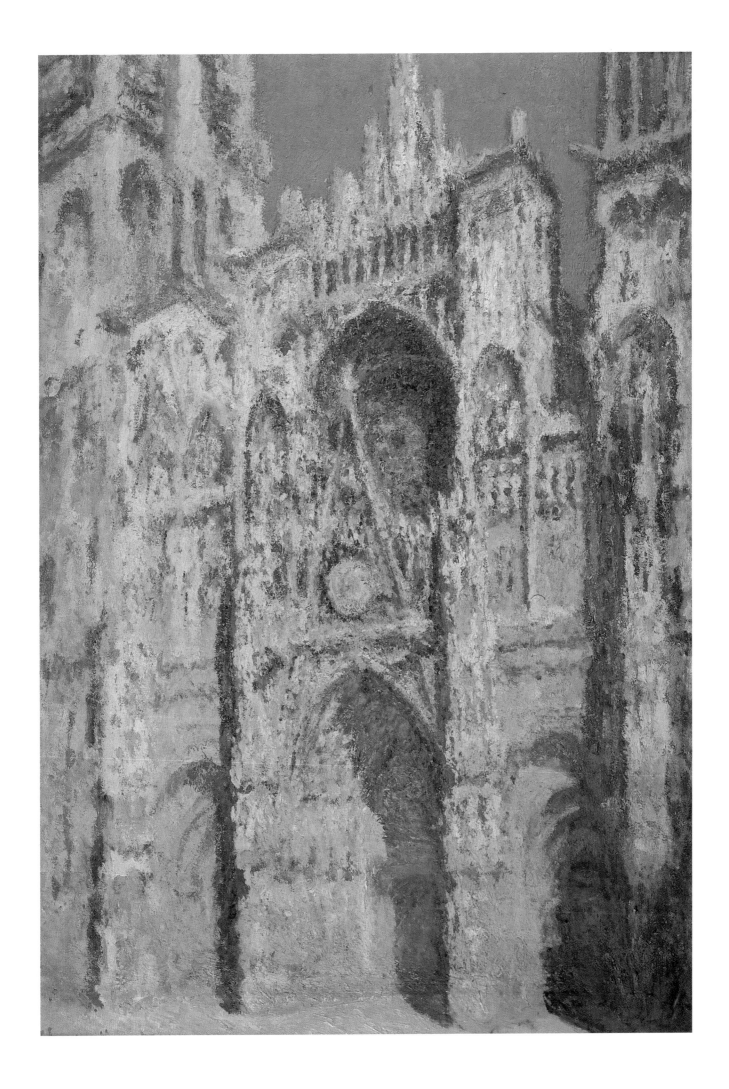

here he painted views of the fjords and houses of Sandviken and Björnegaard, in which he explored in particular the colour effects of light on snow-covered surfaces. He painted a large number of pictures of Mount Kolsaas to the north of Björnegaard (p. 177), which was visible from all around and which reminded Monet of Fujiyama.

In these pictures, which employ strong tonal contrasts, Monet's style is raw and at times close to the nature of preliminary sketches, where parts of the white paper were left bare to represent snow and sky. The artist's own thoughts on his mountain series were printed in the *Dagbladet* In April that year: 'I no longer see the motif as a significant factor; what I want to reproduce is what lies between the motif and me.' Here, as in his earlier series, Monet reveals a trend towards a style of painting which replaces reality in the naturalistic sense with increasingly subjective impressions and recollections of the motif.

The trips that he made, as from 1896, to the places he had painted many years before may also be seen in this context. A sort of nostalgia led him to return and review his impressions of the past. Starting in February 1896, this nostalgia was to take him back to Pourville, Dieppe and Varengeville. In contrast to 1882, he now produced serial views of the same motif under different conditions, as in the *Coastguard's Cottages*, the *Cliffs at Dieppe* and in the *Rough Sea at Pourville* (p. 185). He painted as if seeking to secure the characteristic traits of the landscape; while the permanent shapes of nature remain the same in each picture, their appearance is modified by time, changes in the light and atmospheric conditions. As the memory amalgamates impressions from different periods into a new whole, so Monet conceived each of these series, with their individual paintings, as a unit. Only in this way, he believed, could they communicate a comprehensive impression of their subject.

Monet's serial procedure has rightly been compared with Proust's literary cycle, *In Remembrance of Things Past*. The true subject of Proust's novels is not a linear event, but the juxtaposition of multiple chronological levels. Both Monet and Proust take as their subject the alteration of perception over time. This enabled the painter to evoke the characteristic state of the section of nature under study. In contrast to his earlier paintings of these areas, Monet is no longer interested in topographical observation and the structure of objects, but in the surface which integrates them. He modifies the handling of his materials accordingly. Colour harmonies come increasingly to the fore, while powerful colour contrasts with a potentially isolating effect are extensively avoided. Unifying, homogenizing colour sequences also characterize the Vétheuil landscapes of 1901. Here, too, Monet returned to subjects of the past, although now in a sweeter rendition of blue and pink harmonies, as in the *View of Vétheuil* (p. 179). This entailed a dilution of colour which was fully in line with

Mount Kolsaas, Pink Reflections, 1895
Le Mont Kolsaas, reflets roses
Oil on canvas, 65 x 100 cm
Wildenstein III. 1415
Paris, Musée d'Orsay

contemporary taste, and thus the prices for Monet's latest paint-ings shot up. Despite Zola's scathing condemnation of Impression-ist painting in 1896, Monet's work continued to attract increasing numbers of admirers. At an international level, he received in-vitations to exhibit in Berlin, Brussels, Stockholm and Venice in the following year.

Zola rose briefly in Monet's esteem when, in 1897 and 1898, he went to the public defence of the Jewish French officer Alfred Dreyfus. Like Monet, Zola was convinced that Dreyfus had, in 1894, been wrongly accused of high treason, not least as the result of anti-Semitic prejudice. Despite heated debate, Dreyfus was not declared innocent until 1906.

1897 brought changes within the family. Monet's son Jean had decided to marry his step-sister Blanche. Monet had difficulty accepting the idea, but it was Alice who had the final word. The young couple moved to Rouen, where Jean worked for his uncle Léon. In 1897 Monet moved into a second studio which had been set up in a separate building in the garden. Here he was able to finish the paintings begun in the spring and summer. These included the series of Early Mornings on a side arm of the Seine near Giverny which he had begun in the summer of 1896 and to which he returned in 1897.

Despite his advancing years (he was soon to be sixty), Monet maintained a strict daily routine which in the summer months involved getting up long before sunrise. Only in this way was he able to capture, in a new series, the moment at dawn when the sky changed colour and the mist still lay on the river. In the *Early Mornings* series, each picture is dominated by a single atmospheric colour, as in the *Branch of the Seine near Giverny* (p. 181). Here, too, the broken brushwork of early Impressionism

gives way to a homogeneous brush-stroke which integrates the separate areas of the work and assigns all of them equal value. As Monet allegedly said to Lila Cabot: 'When you go out [to paint], remember that each leaf of a tree is as important as the features of your model.' Monet's view ties up with the Romantic notion of a universal harmony in which the world is an organic, dynamic whole and where the experience of landscape can thus become an experience of the self. The tranquility and motion-lessness of these pictures are intensified by the predominantly square format of the series. Water, light and reflections are the determining themes here as in the water lily landscapes of Monet's late works. Reflection and reality, truth and illusion intertwine, harmonize and seem interchangeable. This was ultimately to resolve the paradox identified earlier in Monet's work, since it allowed him to combine adherence to reality with increasingly predominant elements of imagination. Misty landscapes such as those of the *Early Mornings,* with their concentration upon almost intangible effects of atmosphere, were to play a dominant role in the numerous series of the nineties. Seventeen of these paintings were exhibited with great success within the framework of a large one-man show of Monet's works held in Petit's gallery in June 1898.

The death of Mallarmé that same year robbed Monet of a loyal friend. The next year brought further sorrow and mourning; the death of his friend Sisley was followed shortly afterwards, in February 1899, by that of Suzanne Hoschedé-Butler. She had suffered severe symptoms of paralysis since the birth of Lily, her second child, in 1894. To safeguard a caring home for his two children, Jim and Lily, Theodore Butler married Suzanne's older sister, Marthe, in the very same month. The tragedy sent Alice into a deep depression from which she was not to recover. Even her trips with Monet to Venice, Madrid and, in autumn 1899, to London failed to revive her spirits.

Monet knew London from earlier visits, exhibitions and artist contacts. The city fascinated him most of all in the foggy seasons of autumn and winter. 'I only love London in winter . . .without its fog, London would not be a beautiful city. It is fog which gives it its wonderful breadth. Its massive, regular blocks become grandiose in this mysterious cloak,' he told René Gimpel. Views of Charing Cross bridge arose in conjunction with the London trips of autumn and winter 1899/1900, but remained unfinished; Monet returned to them during later visits in the winters of 1901 and 1904. But even then he felt compelled to finish his London paintings from memory in his studio in Giverny. This evidently proved a considerable headache and sometimes led him to despair. To Durand-Ruel, who had been waiting for the pictures for quite some time, he wrote in 1903: 'I can't send you a single London canvas because for the work I'm doing it is vital I have them all in front of me . . .I'm working on all of them together.'

View of Vétheuil, 1901-02
Vue de Vétheuil
Oil on canvas, 90 x 93 cm
Wildenstein IV. 1648
Tokyo, The National Museum of Western
Art, The Matsukata Collection

The London series which resulted is composed of three different groups: *Charing Cross Bridge, Waterloo Bridge* (p. 183) and *The Houses of Parliament* (p. 182). Whereas Monet's previous paintings of fog – with the exception of his misty Early Mornings – had usually been treated in rapidly-executed isolation, his serial painting in the nineties offered him a means of creating something permanent from this ephemeral phenomenon. Fleeting effects were no longer his chief interest; instead, he concentrated upon a single aspect and sought to give his paintings a more serious quality. As in the eighties, he did so by finishing his canvases in the studio and by emphasizing their colour harmonies. Although he still began his paintings mainly in the open air in front of his subject, he treated fleeting impressions in such a way that it was almost impossible to finish them on site. Back in the studio, he would often enrich his canvases through comparisons and references to other works in the same series, until they were far from being a rendering of immediate experiences of their object. Rather, they convey the changing properties of sunlight in fog through the subtlety of their colour harmonies; indeed, 'harmony' for a while appeared in their titles. It comes as no surprise to learn of Monet's admiration for Turner around this time, despite his later denials to Gimpel in 1918: 'Once I admired Turner greatly, but now I like him less . . . He didn't lay out his colour properly and he used too much of it; I've had a good look.' The

179

London pictures no longer display the fresh colours which earned the Impressionist works of the seventies their fame. Instead they do no more than suggest their subjects, and are thereby closely related to the Symbolism of the poet Stéphane Mallarmé.

When these new works were presented at Durand-Ruel's gallery in the spring of 1904, public opinion was divided. One camp recognized in them the logical height of Impressionism, while the younger generation viewed them as the testament to a movement already out of date. The loss of form was deplored above all, since the new generation of painters, and in particular the future Cubists, were seeking to return to geometric shapes following the example of Cézanne. 'A solidity, a framework needs to be introduced into these pictures of Monet's, into the vanishing of all things . . .'. Monet was also accused of basing his views of the Houses of Parliament on a photograph. Monet had indeed obtained such a photograph from Sargent and had used it to refresh his memory. This caused such an uproar that Monet felt obliged to offer Durand-Ruel an explanation: 'It simply doesn't matter; whether my Cathedrals, my London pictures or indeed any others are painted after nature or not is no one's business and is entirely unimportant. I know a lot of artists who paint from nature and produce nothing but rubbish . . . It's the result that counts.'

Early Morning on the Seine, 1897
Martinée sur la Seine
Oil on canvas, 81 x 92 cm
Wildenstein III. 1477
Amherst, Mead Art Museum,
Amherst College, Bequest of
Miss Susan Dwight Bliss

The confrontation with architecture, water and light which characterizes the London series was pursued in Venice in 1908 and 1909. Here, too, the structure of stone architecture was sacrificed to light. In the years between 1904 and 1908 Monet had devoted himself increasingly to his water garden in Giverny, taking only a short break in Madrid with Alice in autumn 1904. Monet and the Impressionist painters were less interested in Italy than the academic painters of the 19th century, for whom Rome in particular had formed a major centre of attraction. Venice, however, had enchanted the Romantics, and above all Romantic writers such as Théophile Gautier and Honoré de Balzac, whom Monet admired more than any other. For the Impressionists, Venice was important not simply for its place within a Romantic tradition, but for the school of painting it had nurtured, for whose protagonists – Titian, Giorgione and Paolo Veronese – colour had played an outstanding role. As before, Monet and Alice travelled down to Venice with their own car and chauffeur. As guests of a friend of Sargent's, they stayed first in the Palazzo Barbaro and later, until December 1908, in the Hotel Britannia. Monet returned to Venice again in 1909, but his worsening eye trouble and the death of his wife in 1911 made further trips impossible. Finishing work on his pictures was thus carried out from memory in his studio in Giverny. The Venice pictures can be subdivided according to location: views of the Grand Canal, the Rio de la Salute, the Church of San Giorgio Maggiore (p. 186) and various palaces, including *The Palazzo Contarini* (p. 187).

Branch of the Seine near Giverny, 1897
Bras de Seine près de Giverny
Oil on canvas, 75 x 92.5 cm
Wildenstein III. 1487
Paris, Musée d'Orsay

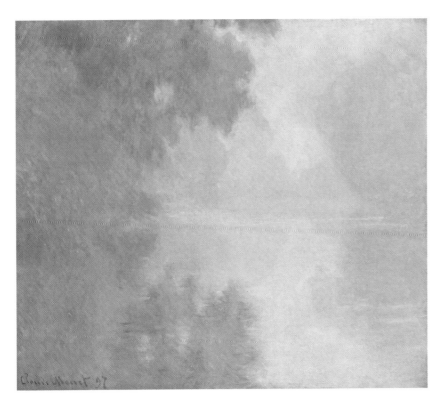

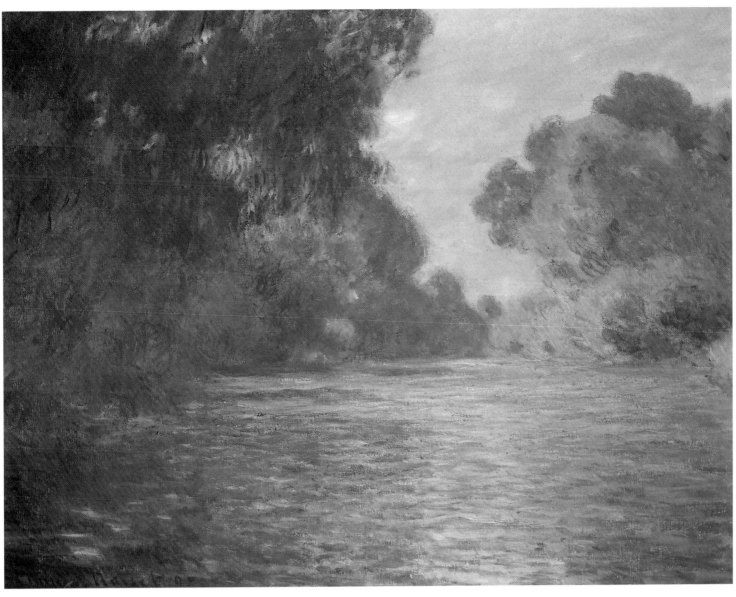

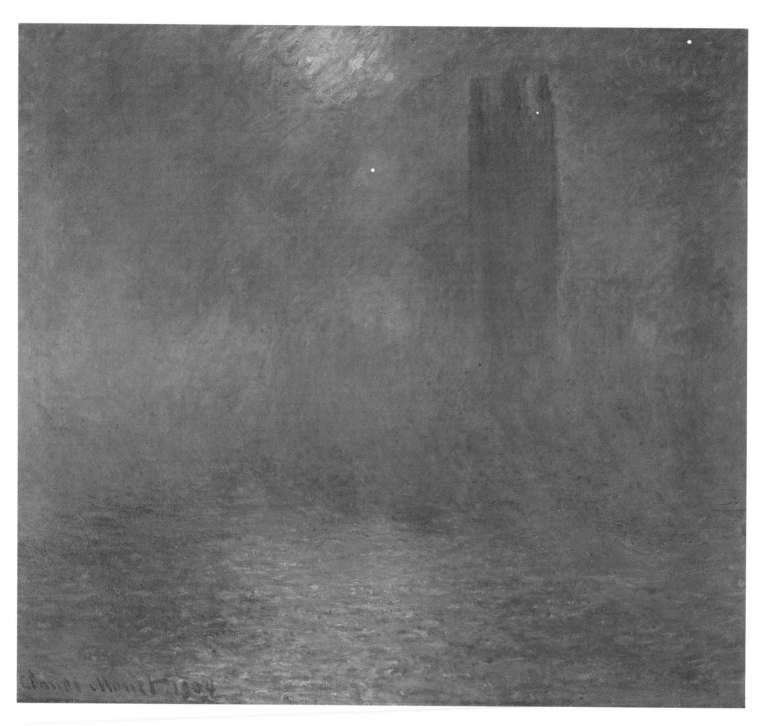

London, Parliament with the Sun Break-ing through Fog, 1899-1901
Le Parlament, trouée de soleil dans le brouillard
Oil on canvas, 81 x 92 cm
Wildenstein IV. 1610
Paris, Musée d'Orsay

ABOVE RIGHT:
Waterloo Bridge, Mist, 1899-1901
Waterloo Bridge, effet de brouillard
Oil on canvas, 65 x 100 cm
Wildenstein IV. 1580
Leningrad, Ermitage

BELOW RIGHT:
Waterloo Bridge, c. 1900
Pastell, 30 x 47 cm
Paris, Musée Marmottan

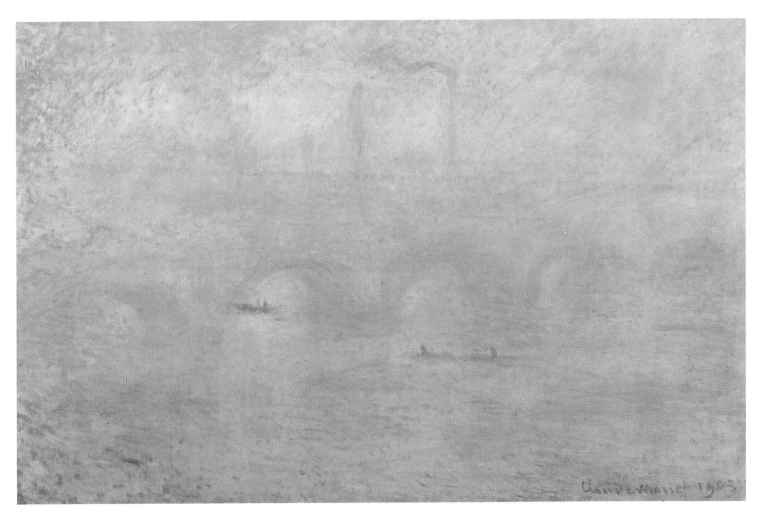

The Venetian palaces were the last architectural motifs Monet painted, although here, too, architectural forms were transformed into phenomena of nature. Monet, like Turner before him, was captivated by the magical quality of Venetian light. Proust's descriptions of Venice in his *In Remembrance of Things Past* are brought alive by Monet's paintings, where the 'rows of palaces . . .reflected light and hour on their rosy fronts and thereby changed to appear even less as private houses and famous buildings, [but rather as] . . .views of nature, a nature who has, to be sure, brought forth her works with the means of human imagination.' Although Monet was himself uncertain of the quality of his works, having often had to abandon the most elementary rules of painting – if indeed such exist – in order to express his feelings on paper, they were rapturously received. The neo-Impressionist Signac, who had seen the show of 29 Venice paintings at the Bernheim-Jeune gallery in the early summer of 1912, wrote to him enthusiastically: 'And these paintings of Venice, more beautiful, more powerful than ever, in which everything conforms with the expression of your will, where no detail runs contrary to the emotion and in which you have achieved that happy act of self-denial which Delacroix recommends – these I admire as the highest manifestation of your art.' This praise also reflected Monet's status as one of the last surviving representatives of the original Impressionist movement; Pissarro had died in 1903 and Cézanne in 1906. Of Monet's former comrades only Renoir remained.

Following the death of his wife Alice in May 1911, Monet suffered increasing bouts of depression, and the situation was worsened in February 1914 by the death of his son Jean after a serious illness. Blanche, who had returned to Giverny, looked after Monet from now on. Monet's health deteriorated noticeably over the following few years. His eye complaint, whose earliest symptoms had appeared as far back as 1867, now grew steadily worse. This was compounded by increasing dizzy spells and rheumatism. He now left Giverny only rarely, and no longer travelled to the monthly dinners at the Café Riche in Paris which he had previously attended so regularly. These dinners had, in former days, attracted Impressionist painters, critics, and literary figures such as Mallarmé and Huysmans, all of whom were now dead. As a means of distraction, Monet now invited guests to Giverny with ever greater frequency. More or less regular visitors included the artists Rodin and Sargent, the writer Paul Valéry, the dealers Durand-Ruel and Bernheim, Sacha Guitry and his actress wife Charlotte Lyses, numerous Japanese friends such as the Kurokis family, and above all Clemenceau.

Monet was a gourmand of the highest order and food was, along with gardening, one of his favourite topics of discussion. Unlike the dark and cluttered salons of the turn of the century, Monet's house was decorated in simple rustic style. Everything was light,

Rough Sea at Pourville, 1897
Mer agitée à Pourville
Oil on canvas, 73 x 100 cm
Wildenstein III. 1444
Tokyo, The National Museum of West-
ern Art, The Matsukata Collection

bright and colour-coordinated. Monet's aestheticism even ex-
tended to his designing a dinner service in blue and yellow to
match the yellow of the dining-room walls on which his Japanese
prints were hung. The Giverny household was thoroughly 'bour-
geois': in addition to six gardeners, Monet employed a chauffeur,
cook, laundress and maid. Monet kept up with technical inno-
vations even from the isolation of his Giverny refuge, as indicated
by his running a car and setting up a photographic darkroom. He
did, however, bemoan the increasing Americanization of the
times as an impoverishment of the old way of life.

Monet took only limited interest in the currents of contemporary
modern art. He adopted a reserved attitude towards Cubism, and
only Vuillard and Bonnard, with their decorative and subtly
colouristic style and intimate subjects, met with his unqualified
approval. Indeed, Monet was himself to pursue a growing dec-
orative-illusionist tendency in his project for a decorative scheme
of water lily landscapes. These became the main theme of the
last thirty years of his creative life and a final pinnacle in his
art, a pinnacle which was to ensure him enduring fame.

Venice at Dusk, 1908
Crépuscule à Venise
Oil on canvas, 73 x 92 cm
Wildenstein IV. 1769
Tokyo, Bridgestone Museum of Art,
Ishibashi Foundation

The Palazzo Contarini, 1908
Le Palais Contarini
Oil on canvas, 92 x 81 cm
Wildenstein IV. 1767
St. Gallen, Kunstmuseum, Foundation
Ernst Schürpf

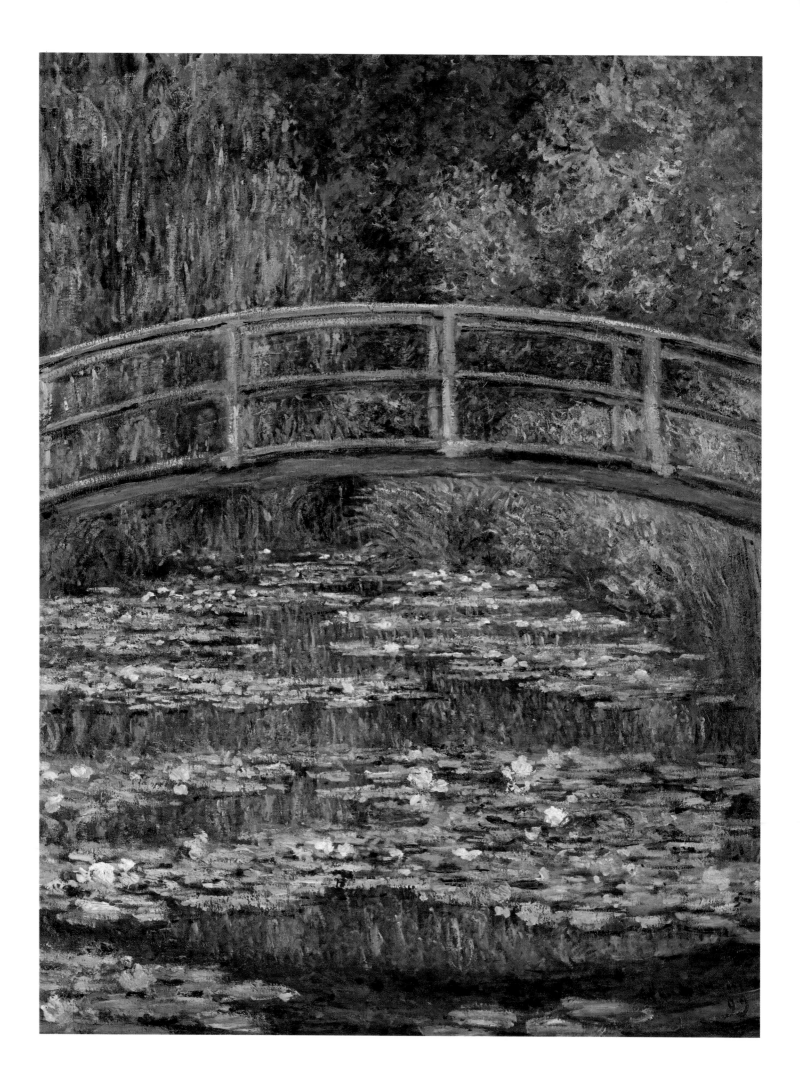

Monet's *Water Lilies* Decorations and the 'Sistine Chapel of Impressionism'

Maurice Guillemot had seen 14 views of the Giverny water garden in Monet's studio in as early as August 1897. Monet had mentioned his plan for a large-scale decoration series involving such pictures. The motif of the water lily pond and its surroundings was to occupy him from now until the end of his life.

Over the past few years Monet had invested a great deal of time in redesigning not only his house, but also his garden in Giverny. He was aided in this task by a head gardener and five assistants. To the house and garden he had purchased three years earlier Monet added, in February 1893, the piece of land on the other side of the railway line and directly opposite his own property. This meadow, which contained a small pond through which the Ru stream flowed, was subsequently extensively re-landscaped, as can be seen in Monet's paintings of the water garden that was the result.

In a first phase, which lasted from 1893 to 1901, the temperature of the pond had to be raised to suit the sensitive waterlilies which Monet had specially imported from Japan. To this end, sluices were built east and west of the marshy pool. This caused considerable outcry among the inhabitants of Giverny, who did their washing in the waters of the Ru. They were afraid the exotic foreign plants might poison or at least heavily pollute the water. An arched wooden bridge in Japanese style was built across the narrowest part of the pond. This and its Japanese vegetation subsequently led to Monet's garden being dubbed the 'Japanese garden,' although some of the most central characteristics of traditional Japanese gardens – such as a rock-garden – were lacking.

Monet first turned to the motif of the Japanese bridge in winter 1895. His earliest consistent series on the subject was not painted till 1899, however. It was exhibited at Durand-Ruel's gallery in the winter of 1900, and included *Bridge over a Pool of Water Lilies* (p. 188, 191) with the pond in the foreground. Beyond the span of the Japanese bridge can be seen the far banks of the pond, their luxuriant and seemingly impenetrable vegetation reflected on the surface of the water. The sky has been deliberately excluded, and the eye focussed upon the flora and the surface of the water;

Bridge over a Pool of Water Lilies,
September 1900
Photograph by Joseph Durand-Ruel

Bridge over a Pool of Water Lilies, 1899
Le Bassin des nymphéas
Oil on canvas, 92.7 x 73.7 cm
Wildenstein IV. 1518
New York, The Metropolitan Museum of Art, Bequest of Mrs. H.O. Havemeyer, 1929. H.O. Havemeyer Collection (29.100.113)

Monet's Water Garden and the Japanese Footbridge, Giverny, 1900
Le Bassin aux nymphéas
Oil on canvas, 89.2 x 92.8 cm
Wildenstein IV. 1630
Boston, Museum of Fine Arts, Given in memory of Governor Alvan T. Fuller by the Fuller Foundation, 1961
Courtesy, Museum of Fine Arts, Boston

these pictures are thus the logical forerunners of the later series of *Water Lilies* with their magnified views of water lilies on the water's surface.

In the bridge paintings, too, different colour impressions are dedicated to direct experiences of nature. Finishing was performed in the studio. Further building work was carried out on the garden in 1901. It was enlarged and – following lengthy negotiations – the Ru diverted with the approval of the local council. The Japanese bridge acquired an additional overhead arch, later planted with succulent wisteria. In this form it was to become the starting-point for the extraordinarily expressive and abstract bridge paintings from the years 1923 and 1925 (p. 216, 217) which seem to look ahead to the Abstract Expressionism of the fifties.

This garden, so carefully laid out to Monet's own designs and where even the shapes and colours of the plants were coordinated, became a work of art in itself. One gardener was employed solely to maintain the water lilies in the compositional order that Monet wanted. This artfully arranged and self-contained world, with its water lilies, bridge, willowed banks, irises, African lilies and rose portal, became the chief source of Monet's inspiration. In 1908, referring to the water lily landscapes to which he had now devoted himself, he admitted to Geffroy: 'These landscapes of water and

The Water Lily Pond; Harmony in Green,
1899
La Bassin aux nymphéas, harmonie verte
Oil on canvas, 89 x 93 cm
Wildenstein IV. 1515
Paris, Musée d'Orsay

reflections have become an obsession. They are beyond the strength of an old man like me, and yet I still want to succeed in rendering what I experience . . . I hope that something will come of all my efforts.'

The first pure water lily pictures – omitting the banks of the pond (p. 195) previously included – appeared around 1897 and again, in larger numbers, between 1904 and 1908. Here the entire pictorial surface is given over to water. From 6 May to 5 June 1909 Durand-Ruel exhibited these unusual views of Monet's water garden as a 48-part series, subdivided by location into six groups. Monet was aware of the originality of his works and had set his prices correspondingly high. However, the fact that the entire canvas in these works was occupied by the surface of the water, with its water lily forms and reflections of trees, clouds and sky, also produced a sense of disorientation.

In creating pictures without the horizon found in traditional landscape painting, Monet cut his last links with the Barbizon school. Reflections enabled him to free himself from the organizational dependence on horizon. Monet applies his paint in a gestural, highly abstractive style. The representational forms of nature, such as the leaves and petals of the water lilies, the grass rippling below the surface and the reflections of the willows and

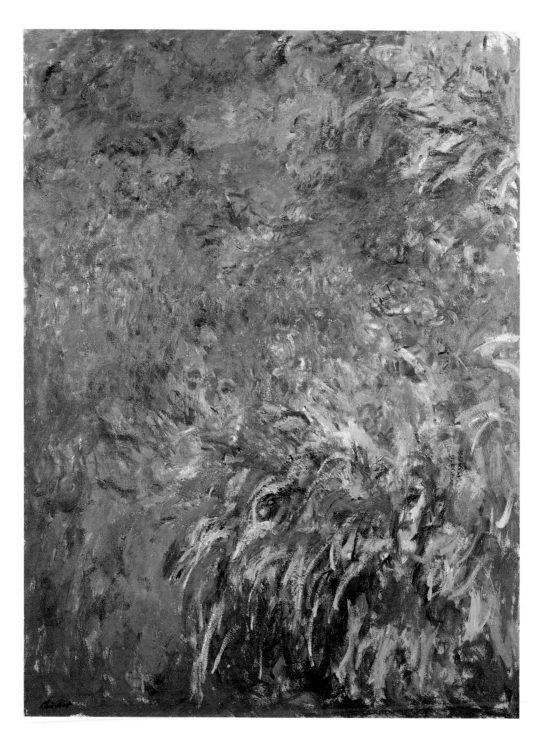

Irises by the Pond, 1914-17
Iris
Oil on canvas, 199.4 x 150.5 cm
Wildenstein IV. 1832
Richmond, Virginia Museum of Fine Art,
Museum Purchase: The William Fund, 1971

The Water Lily Pond with Irises, 1922-24
Le Bassin aux nymphéas avec iris
Oil on canvas, 200 x 600 cm
Wildenstein IV. 1980
Zurich, Kunsthaus Zürich

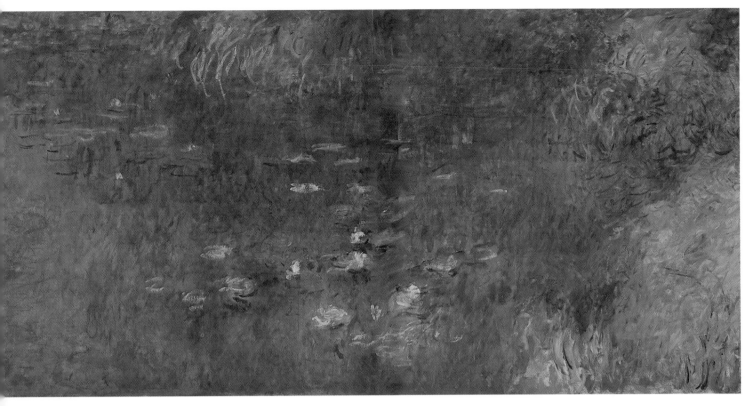

BELOW:
Morning with Willows, 1916-26
Le Bassin aux nymphéas avec saules: Le
Matin clair aux saules
Oil on canvas, three sections,
each 200 x 425 cm
Wildenstein IV. S.329, 4a-c
Paris, Musée de l'Orangerie

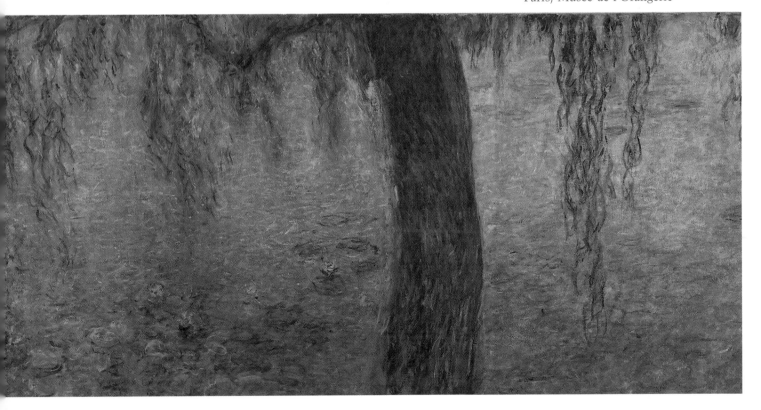

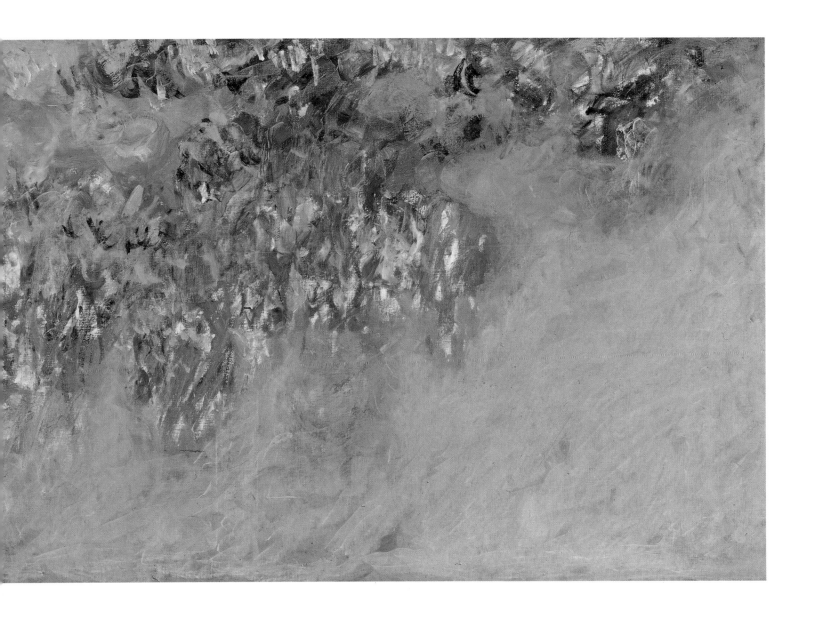

agreed that the *Water Lilies* Decorations should be installed in the existing Orangerie in Paris. Monet was thus presented with a space that was entirely different to the Hôtel Biron rotunda, and he now rejected the idea of a panorama-type reproduction of his water garden. The certificate of donation which was finally signed by Monet and the Ministry of Fine Arts one year later spoke of 19 pictures. Monet planned four canvases for the first of the two rooms, *Sunset* (six metres wide), *Morning* (p. 200-202 above) and *Clouds* (p. 207-209 below), both twelve metres long, and *Green Reflections* (eight metres long). The following room was also to contain four works, namely, *Reflections of Trees* (eight metres long), *Morning with Willows* (p. 200-202 below) and *Clear Morning* (both over 12 metres long) and *The Two Willows* (17 metres long).

These landscapes represent a synthesis of Monet's confrontation with the theme of the water lily since the turn of the century, and all the reflection landscapes should be understood in terms of this apotheosis of Monet's water garden. The composition and

215

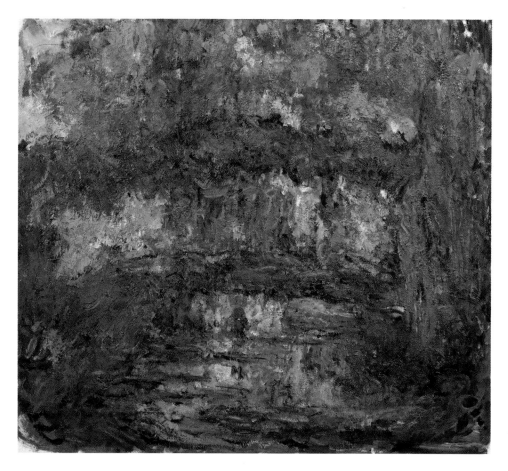

The Japanese Bridge, 1918-24
Le Pont japonais
Oil on canvas, 80 x 100 cm
Wildenstein IV. 1923
Paris, Musée Marmottan

finishing of the Decorations was subject to repeated interruptions due to Monet's eye trouble and his cataract operation in 1923. His eyesight having been sufficiently improved by a pair of glasses, he returned to the Orangerie project in 1924. In this same year he was able to attend, at Petit's gallery, the largest retrospective of his painting held in his own lifetime.

The stabilization in his condition was short-lived. By now almost blind, a respiratory illness left him bedridden as from the end of the summer of 1926. When he finally passed away on 5 December 1926 at the age of 86, it was with Clemenceau, his friend for so many years, as ever at his side. Monet was thus not to attend the inauguration of his *Water Lilies* Decorations in the Paris Orangerie in May 1927. This artist of genius thereby bequeathed the public a masterly creation whose influence extends far into the art of our own century. André Masson was later to describe it as the 'Sistine Chapel of Impressionism' and recommended every modern artist to see it. In his *Water Lilies*, Monet made a final break with traditional painting; in the conscious openness and ambiguity of his pictures and the abstraction and expression of his style, he was to have a decisive influence on the modern art of the 20th century.

For the generation before the Second World War – painters such as Kasimir Malevich, Henri Matisse, Robert Delaunay, František Kupka and Piet Mondrian – it was above all the aspect of the series in Monet's work which proved significant. For the

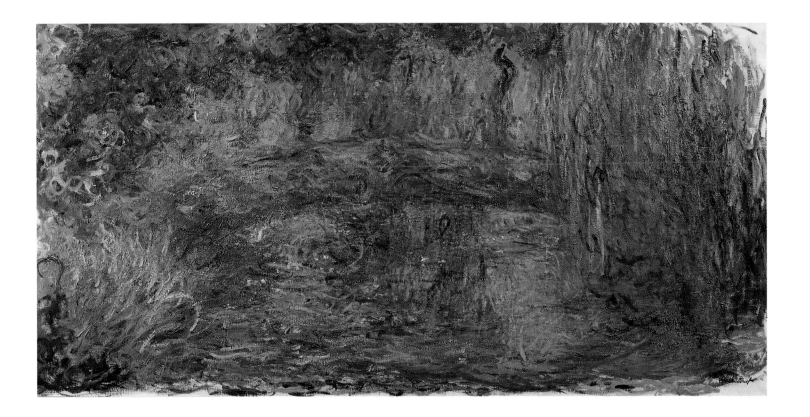

generation of Abstract Expressionists, such as Jackson Pollock, Sam Francis, Mark Rothko and others, the serial element had become banal. What they recognized and appreciated in Monet's late painting, with its origins in impressions of nature and its logical progression to abstraction, were its expressive and abstract qualities, its promotion of colour and gesture to subject. It is in this spirit that Monet's painting remains important for art right up to the present day.

The Japanese Bridge, 1918-24
Le Pont japonais
Oil on canvas, 100 x 200 cm
Wildenstein IV. 1913
Paris, Musée Marmottan

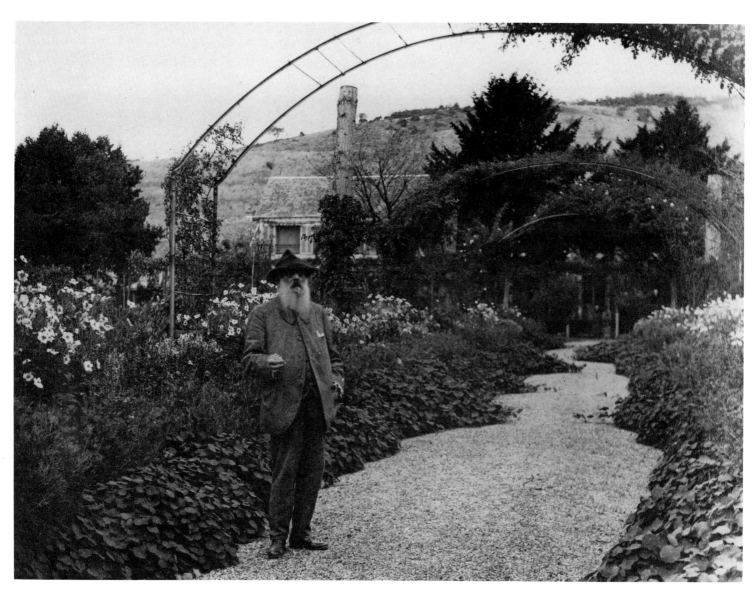

Claude Monet on the *Rose Path* leading
to the house in Giverny.

Monet in his garden at Giverny,
c. 1823-24.

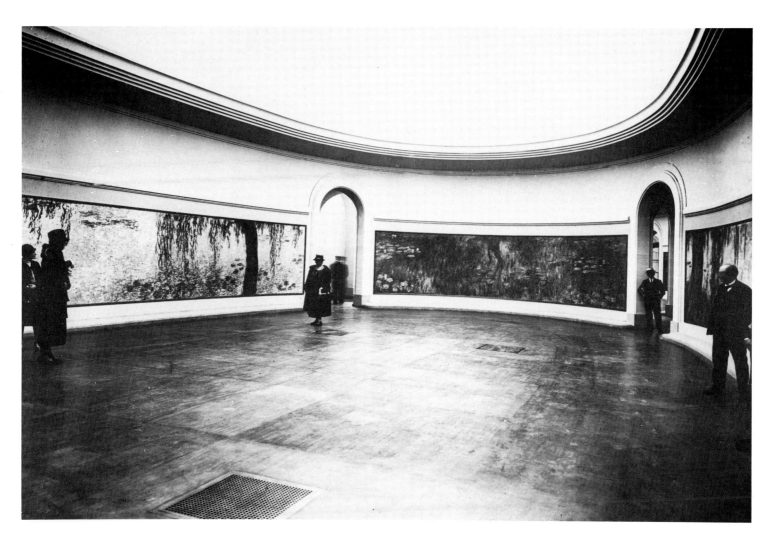

Monet in June 1921 on the Japanese
Bridge in Giverny, with Lily Butler and
Georges Clemenceau, who, as head of
state, supported the installation of the
Water Lilies decorations in the Orangerie.

Room II of the Musée de l'Orangerie with
the painting *Reflections of Trees* (Reflets
d'Arbes) on the far wall. At the right and
left Willow compositions.

Claude Monet:
Biographical summary

Pierre-Auguste Renoir
Monet Painting in his Garden at Argenteuil, 1873
Monet peignant dans son jardin à Argenteuil
Oil on canvas, 46.7 x 59.7 cm
Hartford, Wadsworth Atheneum, Bequest of Anne
Parrish Titzell

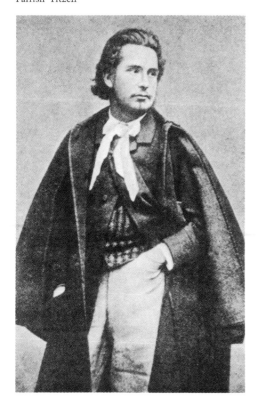

Claude Monet, c. 1875

1840 Oscar Claude Monet born on 14 November at 45, Rue Lafitte, Paris, as the second son of shopkeeper Claude Adolphe Monet and his wife Louise Justine Aubrée (née Lecadre).

1845 For financial reasons the family move to Le Havre, where Monet's father joins his brother-in-law Jacques Lecadre in his ship chandlery and colonial goods business. The Lecadres also own a house on the coast in neighbouring Sainte-Adresse. Monet spends his childhood and school years in Le Havre.

1855 Monet succeeds in selling his caricatures for the handsome sum of 10 or even 20 Francs per head – his first self-earned income.

1856 Drawing lessons from François-Charles Ochard, a teacher in Le Havre and a former pupil of the painter Jacques-Louis David (1748–1825). Meets the painter Eugène Boudin (1824–1898) who subsequently becomes a good friend and who persuades him to work outdoors and to try painting in pastel and oils.

1857 His mother dies on 28 January. His aunt, Marie-Jeanne Lecadre, now looks after him.

1858 His first oil painting, *View of Rouelles,* is shown in exhibition in Le Havre, with four pictures by Boudin. The two work together on the Normandy coast. Death of Jacques Lecadre on 30 September. His childless widow, Monet's Aunt Marie-Jeanne, now devotes herself to Monet.

1859 With the money earned from his caricatures he goes to Paris to study painting. Impressed by the paintings by Constant Troyon (1810–1865) and Charles-François Daubigny (1817–1878)

which he sees in the Salon. Joins the 'Académie Suisse' run by Charles Suisse, where young artists worked from living models. There he meets Camille Pissarro (1830–1903) and, in the popular Brasserie des Martyrs, Gustave Courbet (1819–1877).

1861 Called up for military service. He chooses a posting with the 'Chasseurs d'Afrique' in Algeria, attracted by its southern atmosphere. Conditions prove too hard for him and he falls ill; as a result he is sent back to France.

1862 Six months' convalescence in Le Havre. There he meets Boudin and, by chance, the Dutch painter Johan Barthold Jongkind (1819–1891), with whom he soon becomes close friends. Attends the Atelier run by Charles Gleyre (1808–1874) together with Jean-Frédéric Bazille (1841–1870), Pierre-Auguste Renoir (1841–1919) and Alfred Sisley (1839–1899).

1863 Sees paintings by Edouard Manet (1832–1883) in the Galerie Martinet on the Boulevard des Italiens and is profoundly influenced. His previously generally dark palette now brightens noticeably. Spends Easter at Chailly-en-Brière with his fellow students and devotes himself to *plein-air* painting. Only returns to Paris in August.

1864 Spends Easter in Chailly-en-Brière and May with Bazille on the Normandy coast near Honfleur, where he stays at the Saint-Siméon guesthouse, very popular among artists in Boudin and Jongkind's day. Visits his family in Sainte-Adresse; after heated argument, his modest allowance is cut off. Le Havre shipowner Gaudibert, who had earlier supported Boudin, becomes his first patron.

ABOVE:
Water Lilies, Formerly Agapanthus, 1916-26
Nymphéas, jadis Agapanthus
Oil on canvas, three sections, each 200 x 425 cm
Wildenstein IV. 1975, 1976, 1977

Left: Cleveland, The Cleveland Museum of Art, John L. Severance Fund, 60,81
Middle: St. Louis, The Saint Louis Art Museum
Right: Kansas City, The Nelson Atkins Museum of Art (Nelson Fund), 57-26

The Artist's Garden, Irises, 1900
Le Jardin de Monet, les iris
Oil on canvas, 81 x 92 cm
Wildenstein IV. 1624
Paris, Musée d'Orsay

grasses above, are so intricately entwined that the viewer can no longer tell whether the nature he sees is real or reflected. It remains unclear whether the darker-coloured areas of the canvas represent reflections of the surrounding landscape or the grass swaying below the surface of the water. These reflection landscapes no longer contain spatial orientation in the classical sense of a top and bottom, front and back, figure and ground. Rather, the water lily forms appear to float in infinitely open space. Indeed, Monet originally intended these pictures to remain unframed, to enable these extracts of nature to extend beyond their boundaries and demand continuation in the other members of the series. Colour alone recalls the original natural model, with green standing for vegetation and blue for water and sky.

The underlying tendency in these paintings to merge the objects of nature has rightly been related to the Romantic desire for a harmonious unity of Nature. Monet was well-versed in Romantic thought through the medium of French Symbolism, and thus the critic Roger Marx imagined Monet as saying: 'My only virtue is to submit to instinct; it has been by rediscovering intuitive and secret forces and allowing them to predominate that I have been able to identify with Creation and give myself up to it . . . I have arrived at the final degree of abstraction and imagination allied to reality.' This empathetic description, written on the occasion of the exhibition of 1909, is also important for its explicit reference to Monet's project for a series of Water Lily Decorations.

Monet had been planning to decorate a round dining room with a water lily series in as early as 1897. It was an idea inspired by more than just the financial success of his series and their benevolent reception by both press and public. Monet's decision was undoubtedly also influenced by the fact, lamented both by himself and frequently by others, that the series which he planned as wholes were subsequently split up. The decoration of interiors with large-format pictures on a floral theme was not foreign to Monet; he had already executed such commissions for Hoschedé in 1876 (ill., p. 91) and Durand-Ruel in 1882-1885. There was a large interest in painted interiors around the turn of the century; the vogue for Japanesery, which was overflowing into the domestic field, was just one of its facets. Decorative interior designs were a means of fusing the fields of life and art; one symptom of this was the revaluation of artist craftsmanship as seen in Art Nouveau and *Jugendstil.* Bonnard and Vuillard, both from the Symbolist group of artists calling themselves 'Les Nabis,' sought to achieve this fusion in large numbers of commissions.

Since these paintings were created for specific spatial environments, they necessarily abandoned the picture frame and the classic easel format as well as any attempt at naturalistic representation. In this, too, they bear direct relationship to Monet's late works. Monet's closeness to Symbolist thought emerged on multiple occasions in his mature phase. Art was thus no more

Water Lilies, 1904
Nymphéas
Oil on canvas, 90 x 93 cm
Wildenstein IV. 1664
Le Havre, Musée des Beaux-Arts

the phenomena which arose purely from his own visual experience. Monet believed we have only visual access to objects; their relationships, even when we think we intellectually comprehend them, ultimately escape our knowledge. He had always reacted with protest, therefore, to theories and scientific interpretations of his works.

The turning away from an illusionistic reproduction of reality precipitated the need for a formal as well as conceptual renewal of art, and was ultimately to lead to the modern art of the following century. The new art was to remain open to the mysterious powers of the viewer's imagination and was thus unable to commit itself to precisely-defined form. Monet pursued such ideas from the nineties onwards in the ambiguity of the series, in which the individual picture became an extract from a larger, superior and extendable whole. The same effect was achieved through his increasingly abstract and expressive style of painting, which no longer described the object but instead evoked its image. Pictorial content was rendered ambiguous and robbed of definitive interpretation. The theme of the water landscape in Monet's work also reveals an intellectual reference to the various artistic currents prevalent at the turn of the century, including Symbolism and *Jugendstil*.

Monet applied his artistic beliefs to the design of his water garden in Giverny and created a garden of forms and colours which was a masterpiece in itself. The garden was both a translation of nature into art and a longed-for inner landscape. Such enclosed and artificial gardens became particularly popular in the art of the turn of the century as ideal, unspoilt images of nature. It was in this context that the motif of the water lily, with its feminine associations, made its appearance. The water lily, a flower which flourishes only in warm, swampy waters, symbolized – not just in Mallarmé's poem *The White Water Lily* (1895) – the mysterious sources of life and the undividedness of being.

The decoration of a dining room with water lily landscapes had been planned since at least 1897 and was still under discussion in 1909. The fact that this project was never executed was due to more than just Monet's poor health. His wife Alice, who had steered the family's fortunes for so many years, died in 1911, and her absence left a great emptiness in Monet's life. His depression and apathy towards painting can be read in his many letters to Clemenceau. The death of his son Jean in February 1914 was an added blow. From now on, Blanche, Jean's widow, became the indispensable mainstay of life, enabling Monet to find his way back to painting. Blanche, who had also taken up painting, left several works of her own; some of these are now in the possession of the Musée Marmottan in Paris. After Monet's death, she devoted herself to the selfless preservation of his legacy, maintaining house and garden in their original condition – a task

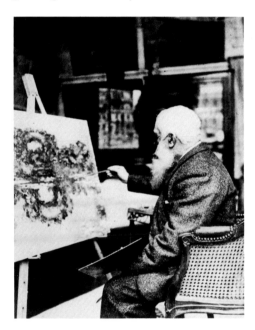
Monet reworking a *Rose Portal* painting in his studio, 1920

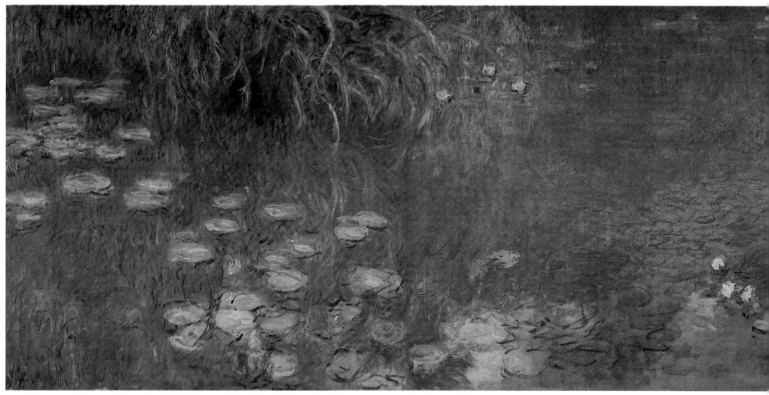

ABOVE:
Morning, 1916-26
Le Bassin aux nymphéas sans saules:
Matin
Oil on canvas, four sections, 200 x 200,
200 x 425, 200 x 425, 200 x 200 cm
Wildenstein IV. S.328, 4a-d
Paris, Musée de l'Orangerie

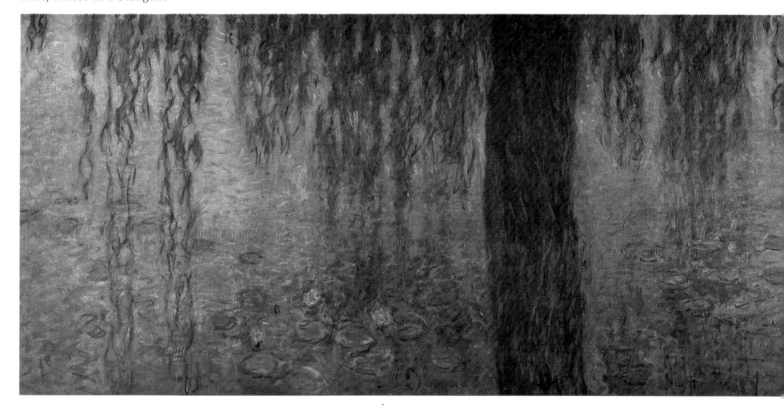

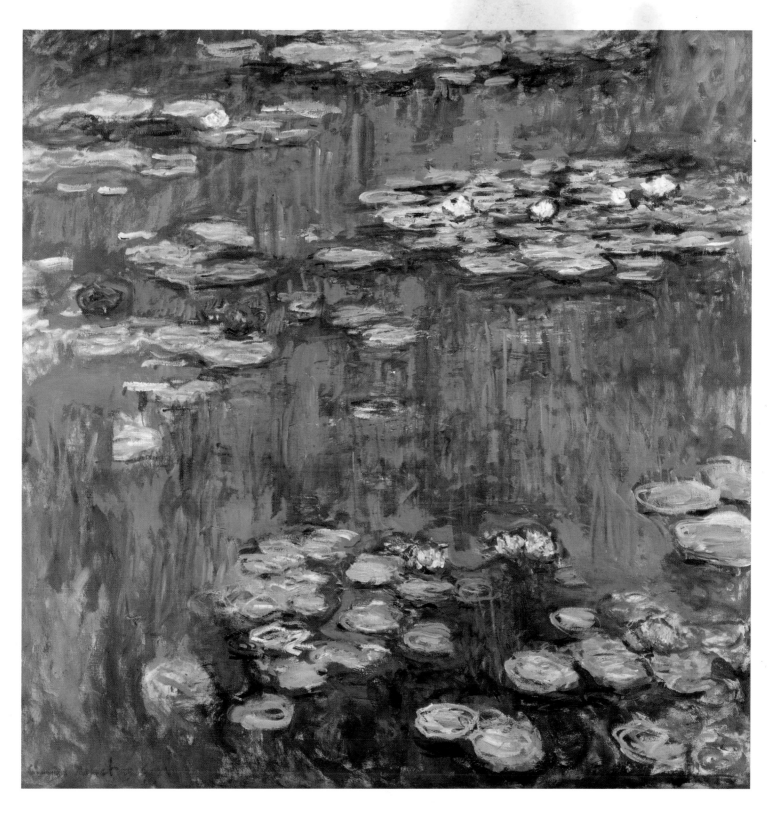

Water Lilies, 1914
Nymphéas
Oil on canvas, 200 x 200 cm
Wildenstein IV. 1800
Tokyo, The National Museum of Western
Art, The Matsukata Collection

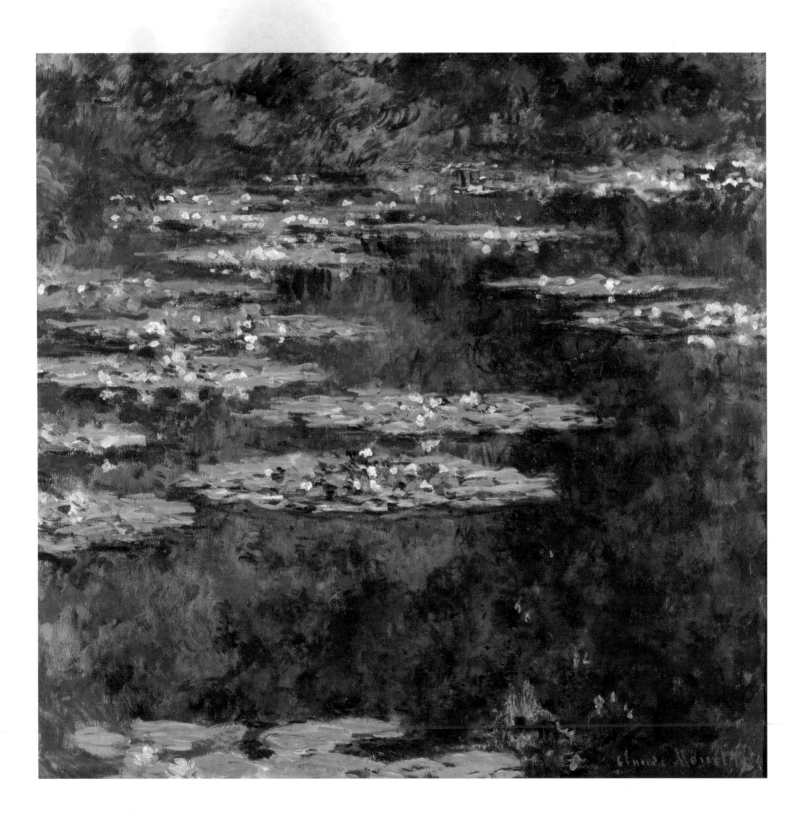

Corner of the Pond at Giverny, 1918-19
Coin de l'étang à Giverny
Oil on canvas, 117 x 83 cm
Wildenstein IV. 1878
Grenoble, Musée des Beaux-Arts

Rose Portals, Giverny, 1913
Les Arceaux fleuris, Giverny
Oil on canvas, 81 x 92 cm
Wildenstein IV. 1779
Phoenix, Phoenix Art Museum, Gift of
Mr. and Mrs. Donald D. Harrington

to be an illustration of reality. The objects of everyday experience had become so distorted and fragmented by habituation that they themselves were no longer able to point to a holistic 'archetype,' true nature. Art now needed to free itself from assumed knowledge and rigid notions. The analogy of world and self seemed to make this possible. Ambiguity, unclearness and alienation now became decisive design components of the artistic product; at the same time, they reflected the conscious reaction to the growing dominance of the natural sciences now seeking to apply their laws to art. This artistic goal, and the claim to truth which it bore, allowed the modern artist to become the cosmic creator of a new reality in the Romantic sense. In his late reflection landscapes, Monet correspondingly sought to express the connection between

BELOW:
Clouds, 1916-26
Le Bassin aux nymphéas sans saules:
Les Nuages
Oil on canvas, three sections,
each 200 x 425 cm
Wildenstein IV. 328, 2a-c
Paris, Musée de l'Orangerie

which was assumed after her own death by Jean-Pierre Hoschedé and subsequently Michel Monet. When Michel was fatally injured in a car accident in 1966, leaving no children, the property fell into neglect. Thanks to a private initiative, the estate was restored in the eighties and is today open to the public as the Musée Claude Monet.

Monet's health had deteriorated considerably since 1908. In 1912, the cause of his eye trouble was finally diagnosed: Monet had cataracts in both eyes. He was terrified of going blind, a fate which had already overtaken Degas, forced to abandon painting in 1908. He was afraid that he, too, would be forbidden to paint. Fortunately, this was not the case. Monet had lost virtually all sight in his right eye before it was finally decided to operate in 1923, thanks to which his vision was considerably restored. As from 1924, however, Monet had to wear special glasses to improve his sight. He also complained that his eye trouble was causing him to use increasingly darker colours and that he could only tell what paint he was using from the name on the tube. He

Water Lily Pond in the Evening, 1922-24
Le Bassin aux nymphéas, le soir
Oil on canvas, 200 x 300 cm
Wildenstein IV. 1964/65
Zurich, Kunsthaus Zürich

consequently destroyed a large number of paintings and fell into depression. As a result of these fateful events, there exist virtually no pictures by Monet from the years 1909 to 1914. His resumption of painting after 1914, and in particular his return to the *Water Lilies,* was due above all to the moral support provided by Blanche and Clemenceau.

The formats of his water lily landscapes now grew considerably wider, whereby the pre-1909 water landscapes served as parts of these larger compositions. Individual composition types were now resumed on a larger scale and incorporated as central sections within new works. His later pictures are thus far removed from any claim to naturalistic representation. Rather, they are syntheses of different responses to the water-garden landscape. As Monet told François Thiébault-Sisson: 'Ever since entering my sixties [since about 1900], I had had the idea of attempting a sort of synthesis of each of the categories of motif to which I had successively turned my attention, of summarizing in one picture, perhaps in two, my earlier impressions and sensations. I had

Avenue in the Artist's Garden, Giverny,
1901-02
Une Allée du jardin de Monet, Giverny
Oil on canvas, 89 x 92 cm
Wildenstein IV. 1650
Vienna, Österreichische Galerie

given up the idea. It would have meant travelling far and wide, revisiting all the places to which my life as a painter had taken me and verifying my former impressions. I said to myself, as I made my sketches [for the *Water Lilies*], that a series of general impressions captured at the times of day when my eyes had the best chance of seeing accurately would not be without interest. I waited for the idea to take shape, for the grouping and composition of themes to slowly sort themselves out in my brain of their own accord . . .' The late *Water Lilies* may thus be understood as a synthesis of impressions fed from both memory and accurate observation. Painting becomes the projection of subjective feelings, nature a metaphor. In these descriptions of landscape Monet arrives at the multiple juxtaposition of chronological levels, of inner and outer reality. The repetition of individual composition types in constantly new combinations plays just as much a role here as the serial concept. Monet's work is thereby closely related to contemporary literature, and above all Mallarmé and Proust, in whose *In Remembrance of Things Past* the figure of the painter Elstir bears close resemblance to Monet in his late painting.

Since the new water lily paintings were up to five metres wide, Monet was obliged to build a third and larger studio in his garden in Giverny. The outbreak of the First World War posed this

Avenue of Rose Trees, Giverny,
1920-22
L'Allée de rosiers, Giverny
Oil on canvas, 89 x 100 cm
Wildenstein IV. 1934
Paris, Musée Marmottan

undertaking with a number of problems. It was only with the help of friend and Minister Etienne Clémentel that Monet was able to acquire sufficient oil for his paints and to transport his canvases to and from Paris. It was also through this contact that the requisition order on his car was lifted and that he was able to obtain sufficient building materials for his new studio.

By the summer of 1915 he was already showing visitors round the new building, although he personally found it decidedly ugly and never liked it. At 24 metres by 12 metres, however, it gave him the space he needed to undertake larger numbers of reflection landscapes. He attached his pictures to mobile easels so that he could experiment with their grouping. This was significant in view of his decision, taken at the end of the War on the encouragement of Clemenceau and Geffroy, to present the French nation with a large *Water Lilies* series as a symbol of peace.

Clemenceau, whose principled stance throughout the War had earned him a high reputation, championed the project in his role as Prime Minister. At one stage the possibility was discussed of housing the series in a specially-built rotunda in the garden of the Hôtel Biron, the present Musée Rodin. Plans for the rotunda provided for the installation of twelve canvases, each over four metres wide. These were to depict different themes from the

Wisteria, 1919-1920
Glycines
Oil on canvas, 100 x 300 cm
Wildenstein IV. 1904
Paris, Musée Marmottan

Giverny water garden: *Willows*, *Iris*, and *Agapanthus*, i.e. the trees and flowers on the banks of the pond, as well as pure reflections of *Clouds*. As in a panorama, the viewer was to experience the illusion of walking through Monet's water lily garden.

This original project had to be abandoned, however, both for financial reasons and following Clemenceau's failure to win the presidential elections of 1920. Monet saw his hopes dashed and sought, against Clemenceau's wishes, to go back on his agreement with the State. Indeed, his Decorations were for a while in danger of being sold to Japan, where Monet's Water Lilies were extremely popular. At 30,000 Francs per picture, Monet's prices had now risen to astronomical heights. In 1921 he sold his *Women in the Garden* to the French nation for no less than 200,000 Francs.

Clemenceau had strongly opposed the withdrawal of Monet's original offer. He continued to urge Monet on over the following years, persuading him to carry on at times when Monet's eye trouble led him to give up on both himself and his work. The idea of a donation was thus kept alive, and in April 1921 it was

214

1865 In Bazille's studio he is visited by Paul Cézanne (1839–1906), Courbet, Manet and Pissarro. Monet shows two seascapes at the Salon for the first time. Begins a large *plein-air* painting in Chailly, *The Picnic*, using Camille Doncieux and Bazille as models. It is strongly criticized by Courbet and later seized in lieu of unpaid debts. Works in Trouville in Normandy together with Boudin, Courbet and Daubigny.

1866 His portrait of *Camille, or The Woman in the Green Dress* is excellently received in the Salon. Emile Zola (1840–1902) writes a glowing review in *L'Evènement*; he and Monet become friends. The model is Monet's mistress, Camille Doncieux. Goes in autumn to Sainte-Adresse, where he paints *Terrace at Saint-Adresse*, and then to Honfleur, where he meets Boudin and Courbet and begins a large seascape.

1867 Bazille offers him accommodation in his Paris studio, where Renoir is already living. Monet's *Women in the Garden* is rejected by the Salon. Latouche exhibits it in the window of his shop for artist's materials, but Monet considers it a failure. Bazille buys the painting and pays for it in instalments. Claude and Camille's son Jean is born in Paris on 8 August. The couple are again in financial difficulties.

1868 Takes a room in Bennecourt on the Seine, where his financial worries lead him to attempt to drown himself. Only one of his two large paintings of Le Havre harbour is accepted for the Salon; this is again praised by Zola. In summer, goes to Fécamp in Normandy with Camille and Jean in order to work undisturbed. His patron, Gaudibert, buys back the paintings seized by creditors and commissions a portrait of his wife. Encouraged by Gaudibert's support he paints *The Luncheon*, but subsequently abandons figure painting.

1869 Latouche once again exhibits the paintings rejected by the Salon, this time views of Paris and Saint-Adresse. In summer Monet goes to Saint-Michel near Bougival on the Seine where, together with Renoir, he paints colourful scenes of bathing and boating at La Grenouillère.

1870 His pictures are again rejected by the Salon. On 26 June he marries Camille Léonie Doncieux, the mother

Portrait Camille Monet, 1866/67
Red chalte drawing
Private collection

of his son Jean. In Trouville in Normandy, where Monet is painting with Boudin, news arrives of the death of his aunt, Marie-Jeanne Lecadre, on 7 July and of the outbreak of war between France and Germany on 19 July. His friend Bazille is killed in action in November. Monet goes to London. Encounters the work of William Turner (1775–1851) and John Constable (1776–1837). Daubigny introduces him to the Parisian art dealer Paul Durand-Ruel, who ex- hibits works by French artists in London. He now also supports Monet and shows his *Harbour Entrance at Trouville*.

1871 In London learns of the death of his father on 17 January and of the truce between France and Germany on 28 January. Durand-Ruel submits two of Monet's paintings to the international exhibition at the South Kensington Museum. Monet travels to Holland. Purchases Japanese prints in Amsterdam. In autumn, an inheritance from his father and Camille's dowry enable him to rent a house in Argenteuil on the Seine with a flourishing garden, where he begins a more comfortable lifestyle.

1872 Takes part in an exhibition in Rouen. Durand-Ruel buys numerous paintings, some of which he exhibits in London. Monet buys a boat and converts it into a floating studio. In Le Havre, paints *Impression – soleil levant*; returns to Holland in summer and to Argenteuil with Renoir in autumn.

1873 Meets Gustave Caillebotte (1848–1894), who paints as a hobby; already supporting other artists, Caillebotte now also helps Monet. Together with friends, Monet plans a society of independent artists wishing to exhibit their works separately from the Salon. The 'Société anonyme coopérative d'artistes peintres, sculpteurs, graveurs' was founded towards the end of the year. Monet becomes the leading figure within this group of artists and takes over the role that Manet had played up till 1870.

1874 First group exhibition in the former studio of the photographer Félix Nadar on the Boulevard des Capucines in Paris. Monet's *Impression – soleil levant* prompts the critic Louis Leroy to call the show an 'Exhibition of Impressionists.' Since Durand-Ruel is in financial difficulties and unable to purchase paintings, Monet once again suffers a financial crisis. In summer he paints in Argenteuil with Manet and Renoir. At the end of the year the 'Société Anonyme' goes bankrupt and has to be dissolved.

1875 Monet's finances allow him to live only a very meagre existence in Argenteuil. Paints snowscapes.

1876 Becomes friends with the department-store magnate and art speculator Ernest Hoschedé, who invites him and Manet to his country house at Montgeron near Paris. Monet's wife Camille falls seriously ill, possibly following an abortion attempt. Towards the end of the year he returns to Paris and starts the *Gare Saint-Lazare* series (1876 and 1877).

1877 Caillebotte rents Monet a small studio near the Gare Saint-Lazare, from where he continues his series. Of the 30 pictures which Monet shows in the third Impressionist exhibition in April, seven belong to this series; they again attract Zola's praise. The Impressionists publish their own journal, *L'Impressioniste*. In August Hoschedé is forced to declare himself bankrupt. Monet and his family are once again in severe financial difficulties.

1878 Manet and Caillebotte help the Monet family to move from Argenteuil to Paris. Monet's second son, Michel, is born on 17 March. Hoschedé's art collection is auctioned, whereby works by Monet and his friends fetch the lowest prices. In August the family move to a house in Vétheuil on the Seine. They are joined

Alice Hoschedé

by Hoschedé's wife Alice and her six children. Monet seeks buyers for his paintings in Paris, but can barely cover his day-to-day expenses. Camille's health deteriorates.

1879 The fourth Impressionist exhibition held in April and May, supported by Caillebotte, shows 29 paintings by Monet, including a number of Seine landscapes from the countryside around Vétheuil. After a prolonged period of suffering, Monet's wife Camille dies on 5 September at the age of just 32. Alice Hoschedé takes over the care of Monet's two sons in addition to her own six children. During the very hard winter which follows, Monet paints numerous pictures of the snow-covered landscape and the breakup of the ice on the Seine.

1880 Monet, Renoir and Sisley fall out with Edgar Degas (1834–1917) and do not take part in the fifth Impressionist exhibition. Since only one of Monet's paintings is accepted for the Salon, Georges Charpentier, Renoir's patron and owner of *La Vie Moderne*, a magazine dedicated to art and social life, holds in his offices a one-man show featuring 18 of Monet's works; the exhibition is highly successful and Monet's financial situation is improved.

1881 Numerous painting trips to the Normandy coast (Dieppe, Fécamp, Pourville, Varengeville, Etretat, Trou-

ville). Monet's expenses are advanced by Durand-Ruel, whose economic situation has now improved. Towards the end of the year, Monet moves from Vétheuil to Poissy on the Seine; he is accompanied – contrary to her husband's wishes – by Alice Hoschedé and children.

1882 Works on the Normandy coast despite reductions in his allowance from Durand-Ruel. Shows 35 works at the seventh Impressionist exhibition. Takes his two families with him to Pourville from June to October; subsequently returns to Poissy.

1883 Paints in Le Havre and Etretat at the beginning of the year. Retrospective of 56 paintings at Durand-Ruel's in Paris in March. Positive response from critics, but few sales. Rents a house in Giverny, where the Epte flows into the Seine. Durand-Ruel commissions him with floral decorations for his apartment in Paris.

1884 'Salon des Indépendants' founded in Paris, and the 'Société des Vingt' (Les XX) in Brussels. Paints on the Riviera (Bordighera, Dolce Acqua, Ventimiglia, Menton) from January to April. Returns with over 50 canvases, half of them studies and sketches. In November Durand-Ruel introduces him to author Octave Mirbeau, who has strongly supported Monet's works in articles in *La France*.

1886 Zola publishes his novel 'L'Oeuvre,' which alienates the Impressionists with its allusions to their careers. Monet protests. Artist Berthe Morisot (1841–1895) introduces Monet and Renoir to poet Stéphane Mallarmé (1842–1898). Sales of Monet's work increase and reviews by critics improve. Les XX show 10 paintings by Monet in Brussels in February. In April and May he visits Holland for the third

Paul Durand-Ruel

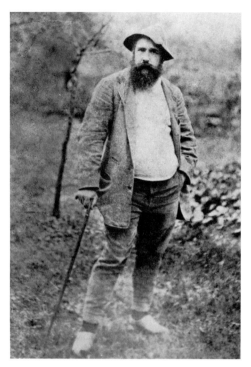

Claude Monet at Giverny, c. 1889/90
Photograph by the American painter
Theodore Robinson

time, including Haarlem and The Hague; paints tulip fields in bloom. Monet does not participate in the eighth and final Impressionist group exhibition. Pointillist Georges Seurat (1859–1891) exhibits *La Grande Jatte*. In summer Monet returns to open-air figure painting. Visits Etretat in autumn and paints in Belle-Ile-en-Mer in Brittany. Meets Gustave Geffroy, who has championed him in reviews in *La Justice*, the magazine run by statesman Georges Clemenceau (1841–1929). Geffroy later writes Monet's biography.

1887 Durand-Ruel opens a gallery in New York at the home of art collector H.O. Havemeyer. 15 works by Monet, including 10 views of Belle-Ile, enjoy great success at the 6th Exposition Internationale at Petit's gallery in Paris in May. 12 paintings by Monet are shown in Durand-Ruel's 2nd Impressionist exhibition at the National Academy of Design in New York in May and June.

1888 Paints in Antibes and Juan-les-Pins on the Côte d'Azur during the first months of the year. Ten of these pictures are shown with great success in a one-man show at the Boussod and Valadon gallery in Paris, organized by art dealer Theo van Gogh (1857–1891), brother of Vincent van Gogh (1853–1890). Revisits London in July. Following his return, refuses to accept the

Cross of the Legion of Honour. Paints in Giverny in summer and begins Grain Stacks series (until 1893).

1889 Paints in Fresselines on the Creuse in the *département* of the same name in central France. A chronological retrospective held at Petit's in Paris in June, featuring 145 paintings by Monet coupled with works by his contemporary Auguste Rodin (1840–1917), proves a huge success. Mirbeau writes the introduction to the catalogue, where he denounces the blindness of the Salon Jury to Monet's art. Monet organizes a private collection with the aim of purchasing Manet's *Olympia* from the latter's widow and presenting it to the Louvre as a gift to the nation. In October Theo van Gogh obtains a record price of over 10,000 Francs for a Monet painting.

1890 Further work on the Grain Stacks series, partly in his studio. Starts new series of poppy fields and poplars on the banks of the Epte (until 1891). Purchases the house and its grounds in Giverny where he has been living since 1883 and devotes himself to the garden.

1891 Ernest Hoschedé dies on 18 March. The ambiguity previously surrounding Monet's relationship with Alice Hoschedé can now be resolved. An exhibition of 22 paintings at Durand-Ruel's in May, including 15 Grain Stacks, is a tremendous success.

1892 Begins Rouen Cathedral series (until 1894), which he paints from the window of a nearby house. On 16 July he marries Alice Hoschedé, née Raingo. Only a few days later, his step-daughter Suzanne marries the American painter Theodore Butler, one of Monet's pupils.

1893 During another very hard winter he paints the breakup of the ice on the Seine at Bennecourt and Port-Villez. In February purchases a larger piece of land near his house in Giverny; it contains a watercourse and a pond which he gradually develops into a water garden with water lily pond. In Rouen from February to April he resumes the Cathedral series, with which he is still unsatisfied. He continues working on it in his studio throughout the remainder of the year. The World's Fair in Chicago exhibits paintings by foreign artists from American collections, including a number by Monet and other Impressionists. The 'Société des Vingt' in Brussels is dissolved.

1894 Durand-Ruel refuses to pay the 15,000 Francs which Monet is asking for each picture in his Cathedral series. Collector Count Isaac de Camonde buys four versions, however. Together with Cézanne, the American artist Mary Cassatt (1845–1926) visits Monet in Giverny in November; he introduces her to Rodin, Clemenceau and Geffroy.

1895 From January to April, visits his step-son Jacques Hoschedé in the village of Sandvika near Oslo on the slopes of Mount Kolsaas; paints Norwegian landscapes. In spring builds a Japanese-style bridge in his garden at Giverny and paints it for the first time.

1896 In February and March Monet undertakes a form of pilgrimage to the places in Normandy where he had worked fifteen years earlier, and paints again in Dieppe, Pourville and Varengeville. Begins series of *Early Mornings on the Seine* (until 1897) near Giverny.

1897 Has a second studio built in his garden where he can paint in winter. Paints the Normandy cliffs and beaches in Pourville from January to March. His oldest son Jean marries his step-daughter Blanche Hoschedé on 9 June; the couple live in Rouen. In summer the Second Biennale in Venice shows 20 paintings by Monet. After lengthy opposition from the authorities, the paintings from Caillebotte's bequest are finally hung in the Musée de Luxembourg, whereby Impressionism receives its first official recognition.

1898 In his article 'J'accuse' in Clemenceau's paper *L'Aurore*, Zola enters the public debate surrounding the trial of the French captain Alfred Dreyfus (1859–1935) and is subsequently himself attacked. Monet supports Zola's Dreyfus campaign and signs the intellectual's manifesto in *L'Aurore*.

1899 The death of Sisley on 29 January, and above all the sudden death of Alice's daughter Suzanne Butler on 1 February, plunge the Monets into deep mourning. In summer, in his water garden at Giverny, Monet begins the series of Water Lilies (*Le Bassin aux Nymphéas*) and Japanese Bridges to which he is to dedicate himself until his death, i.e. for the next 27 years. In London in autumn he starts a new series of Thames paintings (until 1905) which he paints from his hotel room in the Savoy.

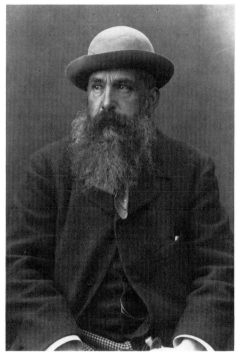

Claude Monet c. 1900

1900 Resumes the Thames series in London and is visited there by Clemenceau and Geffroy. Subsequently paints in Vétheuil on the Seine. Following an accident in the summer he temporarily loses his sight and has to take a month's rest. On 31 October, Theodore Butler, Suzanne's widower, marries her sister Marthe, who has looked after his children since Suzanne's illness in 1894.

1901 Paints Thames series in London for the last time, but continues finishing work in his Giverny studio until 1905. Purchases land in order to cultivate further exotic plants and to enlarge his water garden, through which he is permitted to divert a side arm of the Epte. An arched espalier for wisteria is added to the Japanese bridge.

Giverny, September 1900
From left to right: Germaine Hoschedé, Lily Butler, Madame Joseph Durand-Ruel, George Durand-Ruel and Claude Monet

1902 In February the Bernheim-Jeune gallery in Paris shows new works by Pissarro and Monet, including six pictures from the Vétheuil Seine series. Brief trip to Brittany at the end of February.

1903 Continues working on the Thames series from memory, a practice he previously rejected. First dated picture from the second *Nymphéas* series (until 1908). His old friend Pissarro dies on 12 November in Paris.

1904 Buys a car and travels to Madrid with Alice for three weeks in October, in order to study the works of the Spanish masters, in particular Velázquez, in the Prado.

1905 Continues work on the Thames and *Nymphéas* series. December sees the publication of the first photographs of Monet's water garden in Giverny in an article by Louis Vauxcelles in the magazine L'*Art et les Artistes'*.

1906 In February Durand-Ruel exhibits 17 pictures by Monet from the Faure collection. Monet writes to him that work on the *Nymphéas* series is proceeding only slowly and unsatisfactorily. He frequently paints over his pictures, destroys others in despair and postpones the planned exhibition of the series. His friend Cézanne dies on 22 October in Aix-en-Provence. His friend Clemenceau is elected Prime Minister in October (until July 1909 and from November 1917 to January 1920).

1907 Works almost exclusively on the *Nymphéas* series. The State buys one of Monet's Rouen Cathedral pictures for the Palais du Luxembourg.

1908 Suffers in spring from weakening eyesight – the first symptoms of his grey cataracts – and occasional illness. Lengthy painting trip to Venice with Alice from September to December. His Venice series is painted between 1908 and 1912, in part from memory. Only resumes work on his *Nymphéas* paintings in his studio in December.

1909 Informs Durand-Ruel in January that his wife Alice is suffering from an apparently chronic illness. Durand-Ruel exhibits 48 pictures from the second *Nymphéas* series, painted between 1903 and 1908, in his Paris gallery. Monet returns to Venice in autumn.

1911 Monet's eyesight deteriorates. He oversees the final work on the enlarging of his water garden. His wife Alice dies on 19 May. A long period of mourning and loneliness begins. Only in autumn does he resume work (from memory) on the Venice pictures and on paintings of his water and flower garden.

1912 Completes the Venice series from memory. The exhibition of 29 of these pictures at the Bernheim-Jeune gallery in Paris in May and June is an enormous success. Mirbeau writes the introduction to the catalogue. Following a further deterioration in Monet's vision, a Paris eye specialist diagnoses grey cataracts in both eyes.

1914 Clemenceau and others suggest Monet should paint a group of large water lily mural decorations and present them to the State. This project is to occupy him until his death. His eldest son Jean dies on 10 February after a long illness. His widow, Monet's step-daughter Blanche, takes over the running of his household and becomes his close companion. France enters the First World War on 3 August. Monet's younger son Michel and the husbands of his step-daughters are called up for military service.

1915 Builds a new, third studio which is 23 m long, 12 m wide and 15 m high, in order to be able to paint his over 4-m wide large-format mural decorations.

1918 Armistice declared on 11 November. This occasions Monet's donation to the State of eight of his *Nymphéas* paintings. Clemenceau, once more Prime Minister, and Geffroy visit him in Giverny in order to select the pictures.

1919 Continues work on motifs from his water garden despite his worsening eyesight. He is nevertheless afraid of having his cataracts removed by operation since it involves a risk of blindness. Renoir, the last of his friends from the Atelier Gleyre in Paris, dies in Cagnes-sur-Mer on 17 December.

1920 Dealers Georges Bernheim and René Gimpel visit Monet in Giverny, but find the price he is now asking per picture too high. On 15 October the *Chronique des Arts* officially announces Monet's wish to present twelve large mural paintings of his water garden to the nation. A pavilion is to be built for them in the garden of the Hôtel Biron, which houses the Musée Rodin. Monet refuses membership of the prestigious 'Institut de France,' the highest official body for science and art in France.

1921 Continues painting in his garden in Giverny despite his eye trouble. Is again depressed and unsatisfied with his work, and wishes to rescind his donation to the State. He thereby angers Clemenceau, who has supported the

Promenade at Giverny
From left to right: Madame Kuroki, née Matsukata, Claude Monet, Lily Butler, Blanche Monet and Georges Clemenceau

idea from the beginning. Spends a week in Brittany in December.

1922 In April, not far from Giverny in Vernon on the Seine, Monet and a representative of the State sign an official agreement governing the donation of the *Nymphéas* Decorations. These are now to be housed in two specially-built rooms in the Tuileries Orangerie, an annex of the Louvre.

1923 Regains part of his eyesight following two cataract operations in January and July and begins painting again in November.

1925 Continues work on the*Nymphéas* Decorations in almost complete isolation both outdoors and in his studio. Is again often depressed and discouraged, since some of his works fail to meet his high standards; a number are once more destroyed or burned.

1926 In June the dealer René Gimpel buys two paintings of women in rowing-boats for 200,000 Francs each. In summer Monet can hardly see at all and by November is so weak that he is confined to bed. He dies on 6 December at the age of 86 in his house in Giverny, with Clemenceau at his side. He is buried on 8 December, at his own request without ceremony or speeches.

1927 On 17 May the*Nymphéas* Decorations are officially opened in the Musée de l'Orangerie des Tuileries. They are arranged in oval form, giving the viewer the impression of standing on an island in the centre of Monet's water lily pond.

Claude Monet, c. 1920

Claude Monet in his 'Water Lily-Studio', c. 1923

Alphabetic list of paintings

The numbers that appear in the captions (Wildenstein I.-IV.) are taken from the following catalogue of Claude Monet's paintings: *Daniel Wildenstein*: Monet, biographie et catalogue raisonné, I (1840-1881), II (1882-1887), III (1888-1898), IV (1899-1926). Lausanne and Paris, 1974, 1979, 1979, 1985

The publisher wishes to thank the museums and institutions
mentioned in the captions for their kind permission to use
and reproduce the illustrations.
Thanks are also due to the following archives, libraries and institutions:
Aquavella Galleries, New York: 163 below, 166, 169
Artothek, Peissenberg: 40, 55, 64, 82
The Bridgeman Art Library: 30, 47, 50, 53, 101
Document Archives Durand-Ruel: 52 left, 96, 120, 125, 142, 189, 223 below
Document Archives Durand-Ruel, all rights reserved: 218 below, 222 below, 222 above right,
223 above, 225 above and below
Archiv Held, Ecublens: 66
Colorphoto Hans Hinz: 85 above
© Réunion des Musées Nationaux, Paris: 2, 11, 12, 13, 14, 17, 18, 20 left, 21 above, 23, 24 left,
26, 27, 29, 39, 41, 45, 48, 55 above, 59, 61, 62 above, 62 below, 63 below, 67, 68/69, 70/71, 76, 81 below, 83,
87, 89, 91, 94, 107, 108, 109, 115, 116, 129, 130 above, 145, 148, 149, 155 below, 160, 172 middle and right,
173, 175, 177, 181 below, 182, 191, 193, 199, 200-202, 207-209 below, 212 above, 213
H. Roger-Viollet, Paris: 219 above
Archiv Walther, Alling: 6, 72, 79, 183 above, 220, 222 above left, 224
Archives of the publishers: 52 above right, 52 below, 123, 144, 161 below, 221
Photograph © 1990, The Art Institute of Chicago, all rights reserved: 37 below, 42, 73, 95, 127,
137, 141, 143, 161, 162 below
Photo Luiz Hossaka: 155 above
Photo A. Morrin: 197
Photo Ebbe Carlsson: 106, 146
Photo Michael Bodycomb: 19